ORGANIZING FOR OUR LIVES

			,	
	•			
·				

Street, Richard Steven.
Organizing for our
lives: new voices from
1992.
33305218726978
CU 02/05/10

ORGANIZING FOR OUR LIVES

NEW VOICES FROM RURAL COMMUNITIES

by Richard Steven Street

Interviews by Samuel Orozco
Foreword by Cesar Chavez

NEWSAGE PRESS AND CALIFORNIA RURAL LEGAL ASSISTANCE

ACKNOWLEDGEMENTS

This book is indebted to the generous cooperation of men and women who willingly sacrificed their time and privacy so that we could bring their organizing activities to light. Our most profound thanks go to the immigrants in the canyons of San Diego County. Their faith and trust will enable us all to better comprehend their dilemmas and their pain, and to clear away the thicket of myths surrounding their lives.

On the road, we received guidance and support from dozens of people. Millie Trevino-Saucedo, Leo Trevino and Sylvia Berrones guided us through the Coachella Valley. Espy and Jose Maya, and Ramon and Marylou Mares shared coffee and stories in Kettleman City. Sophie Karet educated us about the special problems of Cambodian women. Pedro Illic and Inta Phakhonekham arranged contacts with the Southeast Asian refugee community of the Central Valley. Hector de la Rosa introduced us to the Santa Elena Cooperative. Surinder Chahal acted as our liaison to the parents of Yuba City. And Belen Rosas, founder of the *Union de Trabajadores Agricolas Independientes*, showed us a thousand points of light in the campfires of the San Diego canyons.

Finally, we would like to thank our families for their loving support during our long absences.

Richard Steven Street and Samuel Orozco

Copyright © 1992 by NewSage Press and California Rural Legal Assistance

By Richard Steven Street Photographs by Richard Steven Street Interviews by Samuel Orozco Additional interviews by Richard Steven Street

Book concept by Ann Weinstone Edited by Ann Weinstone and Maureen R. Michelson Designed by Sarah Levin

Designed by Sarah Levin Translations by Graciela Orozco

All rights reserved. No part of this book may be reproduced or utilized in any form or by any means without permission in writing from the publisher.

Address inquiries to NewSage Press, 825 N.E. 20th Ave., Suite 150, Portland, Oregon 97232

First Edition 1992

Printed in Korea through Print Vision, Portland, Oregon

ISBN 0-939165-18-X

Library of Congress Cataloging-in-Publication Data

Street, Richard Steven.

Organizing for our lives: new voices from rural communities / by Richard Steven Street: interviews by Samuel Orozco: foreword by Cesar Chavez. -- 1st ed.

p. cm.

ISBN 0-939165-18-X: \$24.95

1. Rural development--California.

2. Rural poor--California. 3. Minorities --California. I. Orozco, Samuel, 1955-. II. Title.

HN79.C23C67 1992 92-38005 307. 1'412'09794--dc20 CIP Dedicated to
Sebastian Carmona, Diana, Betty Boren
and the hundreds of thousands of other clients
who inspired us to pursue justice
during these 25 years,
and to

Tony del Buono	Stan Gunterman
(1900 - 1975)	(1945 - 1976)
	(== == == == == == == == == == == == ==
Dorothy Refsell	Al Chapa
(1918 - 1979)	(1925 - 1985)
(=>====================================	(1723 1703)
Ricardo Villalpondo	Richard Sevilla
(1930 - 1991)	
(1930 - 1991)	(1954 - 1992)

...who worked tirelessly on their behalf...

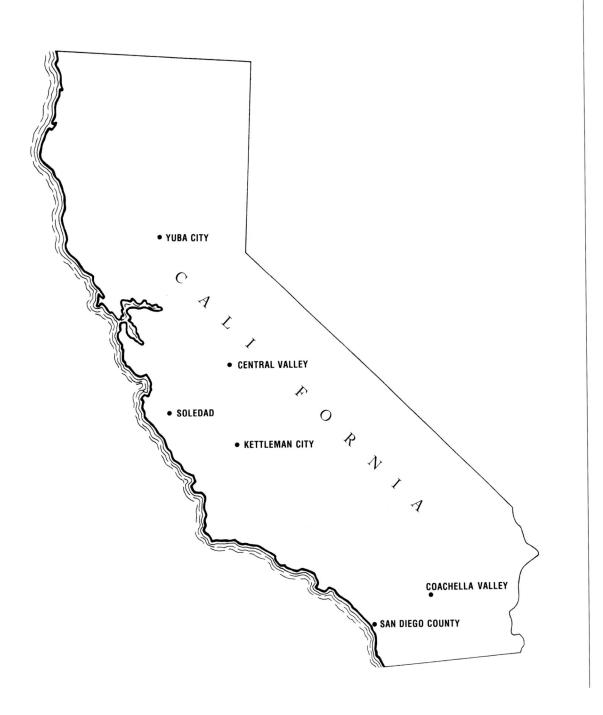

CONTENTS

About California Rural Legal Assistance	ix
Foreword	xi
Introduction	13
BATTLING TOXIC RACISM El Pueblo para el Aire y Agua Limpio Kettleman City	20
STRANGERS IN A STRANGE LAND Asian Refugees Central Valley	34
A CULTURE OF SURVIVAL The Canyon Campers San Diego County	50
TRANSFORMING COMMUNITY LIFE Las Mujeres Mexicanas Coachella Valley	66
FIGHTING FOR THE CHILDREN The Migrant Parents Advisory Committee Yuba City	82
COOPERATING FOR THE COMMON GOOD The Santa Elena Housing Cooperative Soledad	98
About the Contributors	115

ABOUT CALIFORNIA RURAL LEGAL ASSISTANCE

California Rural Legal Assistance was founded in 1966 as a nonprofit legal services program with a mission to strive for economic justice and human rights on behalf of the rural poor. Today, CRLA has 17 offices, many in rural communities from the Mexican border to Northern California.

Each year, we provide more than 20,000 poor rural Californians with no-cost legal services, legislative representation, and a variety of community education and outreach programs. Half of our resources are committed to multiclient cases that grapple with the root causes of poverty. The impact of CRLA's litigation has touched the lives of literally millions of poor Americans, improving conditions for farm workers, new immigrants, welfare mothers, school children, the elderly, the physically challenged, and entire communities.

Organizing for Our Lives: New Voices from Rural Communities, published on the occasion of our twenty-fifth anniversary, is a tribute to the people of rural California. Through photographs and words, this book illustrates the diversity, complexity, and courage of rural farm workers, mothers, teachers, activists, artists, and entrepreneurs. By focusing on the people whose examples have given us fortitude and hope for a quarter century, Organizing for Our Lives serves as an important historical document and learning tool for educating people about the realities of poverty in all rural communities today. The images of their daily lives give us courage to continue forward "towards the light" on this road for social change.

Jose Padilla Executive Director

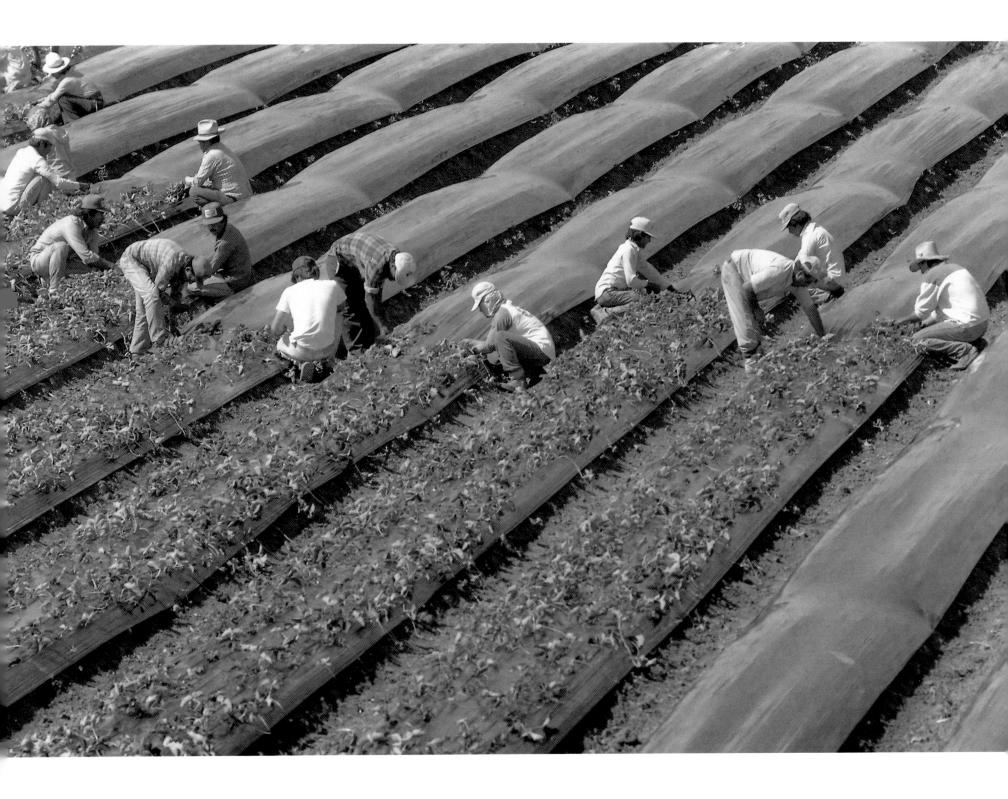

FOREWORD

This book is about change, and about hope, within self and family. It is also about those who have been oppressed coming into their own through collective struggle and winning a place for themselves politically and even economically.

As these stories and photographs reveal, within the crucible of a community undertaking the deep work of organizing, there are no leaders distinct from followers. The most humble lead the highest, and we are all transformed as a result. This is the heart of the lesson that we have learned in the United Farm Workers. Our struggle has indelibly changed all of our lives. We will never look back. We will always fight back.

The pictures and words in *Organizing for Our Lives* have sharply captured the relationship between the struggle that is community organizing and the victory that is community and personal transformation. If you take it slowly, this book will find a place in your heart and your head, moving you to a clearer vision of your own transformations. It is in this place, that we glimpse another life, a life of hope and equality for all. In this place, together we can say, "Si, se puede."

Cesar Chavez

INTRODUCTION

wenty years ago, Cesar Chavez alerted the people of the United States to the dire poverty of America's farm workers. Since then, profound changes have occurred in rural North America, changes brought on largely by an influx of new immigrants and refugees from Mexico, Central America, and Southeast Asia. Arriving from such diverse places, this new influx is forcing profound, often traumatic transformations, turning rural areas, especially in California, into one huge crucible of change.

While working on *Organizing for Our Lives*, much of what we saw among California's rural poor remains unforgettable: an undocumented worker holding up a small placard stating, "I Want Work,"

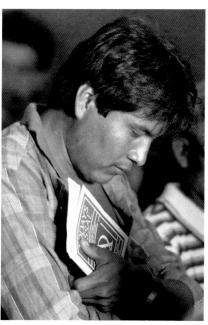

mented worker holding up a small placard stating, "I Want Work," while he stands just beneath a looming steel billboard urging, "Don't Hire Undocumented Workers"; a Guatemalan refugee

waving to tourists floating by in a hot air balloon above his

creek-bottom shanty camp; older Laotian women in traditional peasant garb dressing their grandchildren in Bart Simpson T-shirts and Levi jeans; a ten-year-old boy from Guadalajara studying survival English in an abandoned van—or his four-teen-year-old sister climbing barbed-wire Cyclone fences along the way on her two-mile hike to school; a lone Oaxacan organizer advocating basic human rights for farm workers living in shanty encampments hidden on the Camp Pendleton Marinc base; and hundreds of *campesinos* crowding the bandstand during a speech by Jesse Jackson.

The photographs and words in this book capture these changes as they are happening—immigrants emerging as community leaders, shy women becoming assertive and self-confi-

An outdoor Mass for farm workers in a canyon camp in San Diego County.

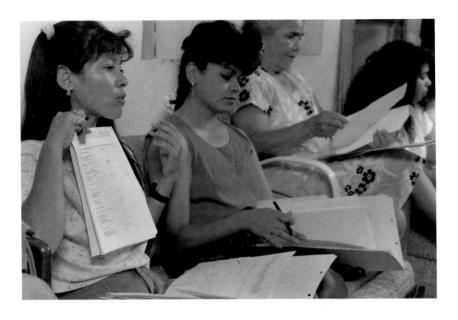

cultural isolation and poverty that has traditionally kept the rural poor from effectively participating in public life.

Since the late 1970s the rural poor have created dozens of community organizations and multiracial coalitions. They have launched broad-based efforts to provide services, influence politics, and defend civil rights. They have carried out their efforts calmly, working within the system to win a

voice and a place in American society. In the schools, farms, shops, housing projects, labor camps, and shanty towns, from San Diego to Yuba City, their campaign is growing with astonishing speed. Collectively, they have organized to change both the cultural and political landscapes of their communities.

For example, Mexican women farm workers in the Coachella Valley near the Mexican border have formed their own organization, *Mujeres Mexicanas*, to address the needs of their community, in particular women's needs. Their efforts include disseminating health-education information, lobbying school boards, electing supportive politicians, curbing domestic violence, and bringing together *campesinas* for statewide conventions. Four-hundred miles north in Yuba City, Mexican-American and East Indian mothers have come together to become observers in their children's schools, influencing and participating in migrant educational programs. These parents have forced the school district to hire bilingual counselors, improve transportation for rural children, and retain breakfast and lunch programs.

Gaining international attention, field hands in Kettleman City in the Central Valley have formed a unique coalition with farmers, environmental organizations, and civil rights groups. To-

Our focus is on rural activism, on giving rural people an opportunity to describe, define, and propose, in their own words, the dilemmas and the solutions that may lead to lasting change for their communities.

Mujeres Mexicanas at a strategy meeting in Coachella Valley.

gether, they are fighting to prevent construction, by one of the biggest toxic waste disposal corporations in the world, of a toxic incinerator in their town.

Confronted by horrible housing conditions, farm workers in Soledad have built the most successful cooperative mobile home park in California. Santa Elena stands as an example of how the rural poor have organized to create a safe environment where children have the opportunity and freedom to dream about the future. One-hundred miles to the west, in the Salinas Valley, near Fresno, Asian refugees nurture a community in exile, preserving their heritage and encouraging economic self-sufficiency.

And in the canyons of north San Diego County, recent immigrants from rural areas of Mexico and Guatemala have built a vast network of shantytown canyon camps. While their labor is exploited

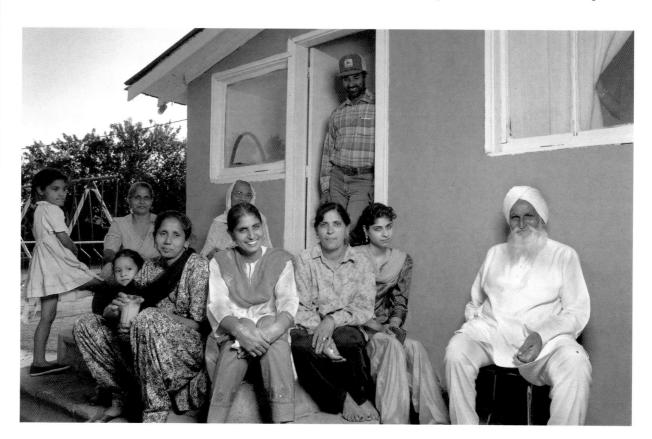

An East Indian family in Yuba City.

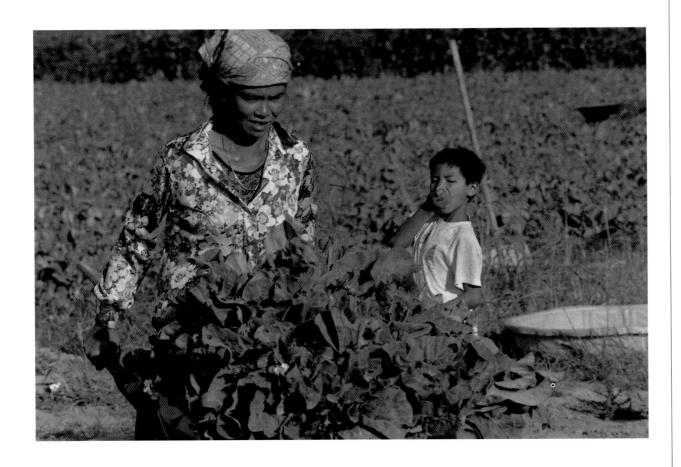

to support U.S. agribusiness, the residents of the canyon camps have managed to create a bare-bones culture of survival that imports the values of kinship and support found in traditional village life in their homelands.

This book makes rural poor people visible. In attempting to accomplish this task we must necessarily depict the poverty that is real and deepening. Our focus is on rural activism, on giving rural people an opportunity to describe, define, and propose, in their own words, the dilemmas and the solutions that may lead to lasting change for their communities. As we listen, their words touch on universal themes—family, community, religion, dislocation, anger, revelation, pride.

Organizing for Our Lives speaks to people interested in the worldwide struggle for human rights;

Harvesting Chinese cabbage at Asia Farms in Fresno.

to community organizers and to others seeking viable models for affecting rural change. Both the creators of this book, and the people on whom it focuses, hope that it will serve as a vehicle for transferring the expertise, innovative spirit, and courage of rural Californians to rural people and their advocates everywhere. *Mujeres Mexicanas* member Millie Trevino-Sauceda echoes our vision for this book: "I hope that this documentary is useful so that people in the future will see that not only educated people can do something. Any person can do something if they choose to unite and organize themselves."

Richard Steven Street and Samuel Orozco

			•	
	8			

ORGANIZING FOR OUR LIVES

BATTLING TOXIC RACISM

EL PUEBLO PARA EL AIRE Y AGUA LIMPIO
KETTLEMAN CITY

VERY DAY HUNDREDS OF SEMITRAILERS rumble in and out of Kettleman City, an isolated farming town just off Interstate 5, midway between Los Angeles and Sacramento. Many of those trucks are packed full of fruit and vegetables, the bounty of the San Joaquin Valley on its way to people around the world. However, other trucks contain a different cargo—a deadly cargo. These trucks deliver toxic waste bound for burial three miles outside of Kettleman City at the largest landfill west of Louisiana.

The residents of Kettleman City detest this dangerous traffic. Nevertheless, Chemical Waste Management, the owner of the landfill, is targeting the town for the site of a new toxic waste incinerator. The residents are calling it "a landfill in the sky" and have banded together to stop Chem Waste from building any more toxic facilities in their town. "Do you think we'd have this toxic mess here if we were a community of rich white people?" asks Mary Lou Mares, a lettuce cutter who has lived in Kettleman City for fifteen years. "Our rights have never been taken seriously."

Led by poor farm workers, hundreds of citizens of Kettleman City have formed *El Pueblo para El Aire y Agua Limpio* (People for Clean Air and Water), a multiethnic coalition whose aim is to stop the proposed incinerator. Many people are comparing the David-and-Goliath struggle of *El Pueblo* to the United Farm Workers (UFW) organizing campaigns of the 1960s. Similar to the UFW campaigns, the anti-incinerator coalition in Kettleman City must confront multimillion-dollar corporations, law enforcement and hostile government agencies.

El Pueblo's most effective tactic to date has been a lawsuit filed on their behalf by California

Kettleman City residents Mary Lou and Ramon Mares surveying toxic materials near Chem Waste's toxic dump.

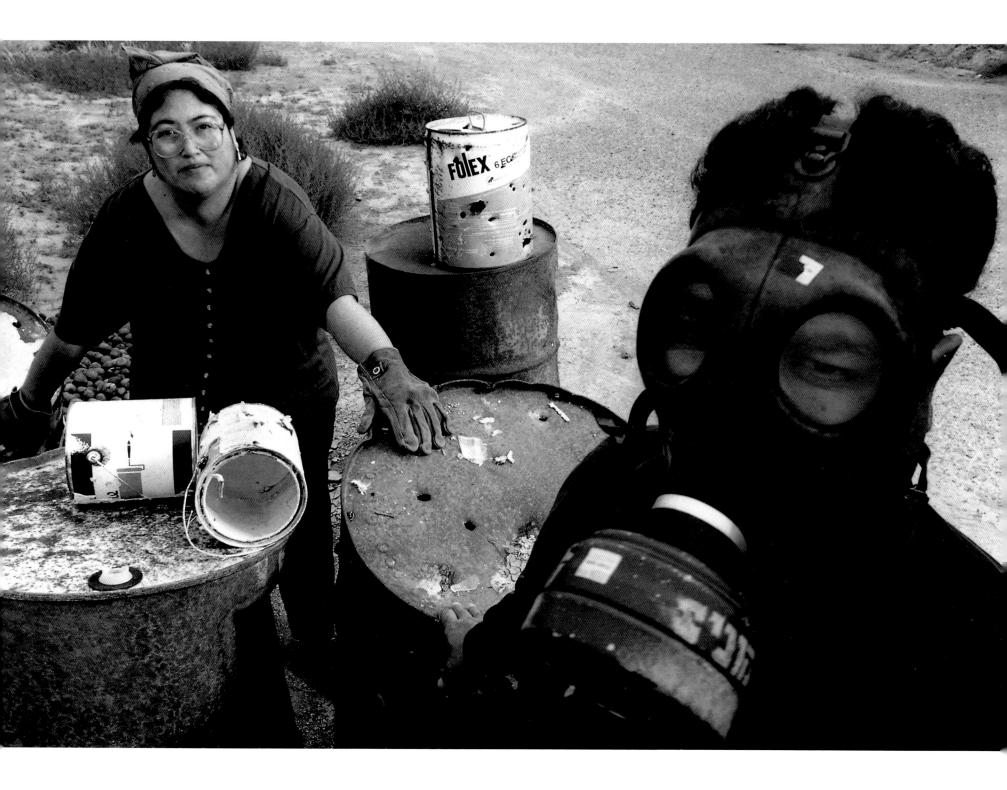

Rural Legal Assistance, a poverty law program that has been operating in rural California since 1965. This lawsuit is the first in the nation to charge that "environmental racism" played a role in a corporation's decision to build a toxic waste facility in a low-income community. The lawsuit accuses Chem Waste of targeting Kettleman City because it is largely a community of poor, monolingual, Spanish-speaking Mexican field hands. Kettleman's 1,300 residents are 95 percent Latino. The suit also discloses a nationwide pattern of building toxic facilities in low-income communities. All of Chem Waste's incinerator facilities are located in communities that are more than 75 percent poor people of color—communities such as Sauget, Illinois, Port Arthur, Texas, and the south side of Chicago.

When Chem Waste built its toxic landfill in Kettleman City in 1979, the corporation did not have to obtain approval from the local community because Kettleman City is unincorporated. There is no mayor, city council, planning commission or newspaper. All Chem Waste had to do was buy an existing oil disposal company and apply for permits with the state and federal governments. Within a year it was not only operating a full-scale toxic landfill in Kettleman City, but it was using Interstate 5 as a kind of toxic runway for fleets of top loaders heaped with contaminated solids, tankers full of toxic liquids, and flatbeds stacked high with 55-gallon drums of cyanide, benzene, asbestos, cleaning solvents, heavy metals, and hundreds of other chemicals.

"We noticed all the trucks rolling through and assumed they were going to some kind of construction project," explains Adela Aguilera, a teacher's aide and mother of three. "We didn't know what was going on." Strange, oily-garlic odors drifting into town with the evening winds first signaled that something nasty was brewing out in the Kettleman hills. Unexplained, nagging health problems ranging from nosebleeds to fainting spells led a small group of citizens to uncover the frightening truth; a truth that no government official had bothered to tell the largely Latino population who were being affected by it. With more than 200,000 tons of poisons rolling in every year, Kettleman City had been transformed overnight, with no public notice, from a rural backwater into the toxic capital of the Western United States.

In 1988, Chem Waste applied for permits from Kings County to build an incinerator near the existing landfill. The corporation held its public hearings on the incinerator in Hanford, thirty-five miles from Kettleman City and the proposed site. Residents of Kettleman City were not told about the hearings. "We found out through Greenpeace," explains Ramon Mares. "They asked us

if we knew that an incinerator was going to be built. We said no. We didn't know anything. Greenpeace began to educate us so we could fight it."

Although they were unfamiliar with the concept of environmental social justice, several Kettleman City residents had read about the community coalitions blocking hazardous dumping or incinerators in Emelle, Ala-

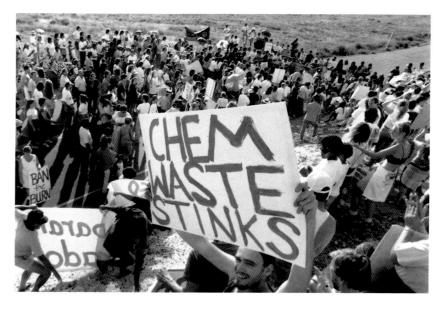

bama and in East Los Angeles. With the help of Greenpeace, residents learned the basics of grassroots activism—phone trees, meetings, and door-to-door organizing. "We began to understand our rights," recalls Bertha Martinez, who has lived in Kettleman for twenty-four years. "We saw we weren't alone."

After forming *El Pueblo*, Kettleman City's residents launched a campaign that has become a model for community organizations across the nation. They have created a unique coalition that cuts across racial and economic boundaries, pulling together Latino farm managers, migrant farm workers, and Anglo residents who own larger farms in the area. By linking up with civil rights organizations and environmental activists, *El Pueblo* publicized its cause, lobbied, marched, and gained the attention of activists and politicians nationwide.

"Chem Waste never imagined we'd fight," says Espy Maya, a mother of four who is a leader in *El Pueblo*. "The company just thought we were a bunch of dumb little hicks and illegals, so hard-up for work that we'd be tickled to death to get some menial jobs burning their poisons or burying them at their dump."

Some of the group's most surprising allies turned out to be former opponents. Downwind from the proposed incinerator, farmers like Jose Maya and Dick Newton, who usually had little patience

A march and rally blocking the entrance to Chem Waste's toxic dump.

23

for environmental causes supported by Greenpeace or the Sierra Club, found their interests to be in perfect alignment. "If just one head of lettuce is contaminated, I'll lose the entire crop, and I'll be ruined," explains Maya, who grows 3,000 acres of lettuce, tomatoes, and cantaloupes. "All the farmers in this area will be ruined." As for Chem Waste's claims that its incinerator would be 99.99 percent effective in burning 100,000 tons of toxic material a year, *El Pueblo* notes that even if they accepted that, which they don't, the incinerator would still put ten tons of deadly ash into the air annually. "Chem Waste says that's acceptable," protests farmer Dick Newton, a resident of the nearby town of Stratford. "What right does it have to force me to breathe highly toxic dust?"

El Pueblo has hammered away at local authorities who have denied the mostly Spanish-speaking members their rights. In addition to charging Chem Waste with discriminatory siting of the incinerator, El Pueblo's suit also charged the Kings County Board of Supervisors with running a discriminatory public participation process. "The Kings County Board of Supervisors likes to hold public hearings in Hanford, thirty-five miles away from Kettleman City because they know that field hands can't get off work and make the long drive to attend the daytime meetings," says Espy Maya. "And when they did attend in the evenings, the farm workers couldn't understand anything because the meetings were always conducted in English, and the critical documents, some 3,000 pages of them, were never translated into Spanish."

El Pueblo protested these undemocratic hearings in a mass rally last fall when more than 1,000 people packed into Kettleman City. The Reverend Jesse Jackson and Congresswoman Maxine Waters led the community in a march on Chem Waste and shut down the landfill for a day. Officials from Kings County claimed that Greenpeace and other "outside agitators" orchestrated the march, manipulating residents for their radical goals.

This accusation infuriates Apolonia Jacobo, a farm worker and member of *El Pueblo*. "Chem Waste is the outsider. Nobody from Chem Waste lives in Kettleman City. Their lawyers and representatives all drive in from Fresno and Hanford. The only reason why supervisors bow to them is money. Chem Waste's taxes pay for about 8 percent of the Kings County budget."

In December 1991, Kettleman residents scored a major victory in court. State Superior Court Judge Jeffrey Gunther ruled that Chem Waste and Kings County had failed to provide adequate information on the air pollution effects of the toxic burner. The judge also ordered county officials to prepare and translate an extended summary of the environmental impact report into Spanish so that

Of our elected officials, 99.9 percent vote their pocketbook. We need people to vote their conscience. I don't feel we have officials with moral fortitude.

JOSE MAYA
Kettleman City

Kettleman residents could study it. In 1992 bids by Chem Waste to begin contruction have twice been rejected by the judge. Construction on the incinerator is already years behind schedule. Now it may never be built. The people celebrated their victory with a mariachi party. "We Mexican people have made a difference," says Mary Lou Mares. "We have changed. Five years ago you would never have seen us challenging a big company like Chem Waste. Now we're not afraid. We know how to fight. We're in this for the long haul."

The campaign organized by *El Pueblo* to stop the toxic incinerator signals an important change in the nation's controversy over hazardous waste disposal. The group's actions have garnered coverage in numerous national magazines and newspapers, as well as on national television news programs.

In other countries, such as India and Brazil, poor people have long spearheaded movements to stop harmful development and environmental destruction. Now, in the United States, the contribution of poor people to environmental social justice, once seen by the public as the exclusive province of white middle-class activists, is no longer invisible. Mares explains, "We're in a country where we can be heard if we speak up. Many of us still believe that we can't talk, that we have to stay quiet, that we can't beat the government. But we can win. If we speak as a group, we can be heard."

When I came to this city, I thought this little town was appropriate to spend my last days in. I lived peacefully. I thought everything was hunky-dory.

I remember coming home from Hanford, where we do our shopping and finding on my door a flier with a skull and bones on it. It said "INCINERATION. Go to this meeting." I went. I began to put one and two together. You sort of wake up and see this company trying to push this incinerator on you. You see that life isn't like you thought it was.

I have changed a lot. I used to be a sleepy, let-everything-happen-to-you person. I used to not fight anything. I've found out that one can do more with one's life.

Now I'm going to college. I would like to be a waker-upper, if there is such a word. I would like to make a difference in getting young people to want more for themselves, and fight wherever there is some injustice done to them instead of accepting it.

MARY LOU MARES
Kettleman City

The road to Kettleman City.

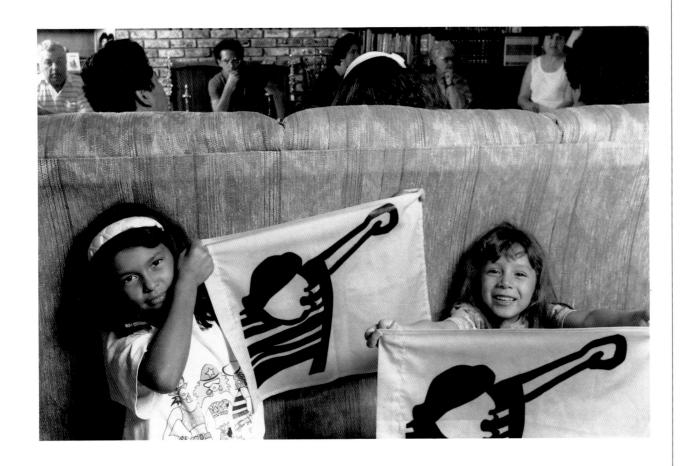

Chem Waste has come into our little town knowing that we're poor Mexicans, farm workers, migrant workers, uneducated, don't know English. So what we've done is gone door-to-door, held small meetings in my home, in the school, in church, and talked to people in English and in Spanish about what is going on.

RAMON MARES Kettleman City

Left: An organizing meeting with Greenpeace members, farm workers, and farmers in Kettleman City.

Right: Kettleman City children at a rally against Chem Waste's toxic incinerator.

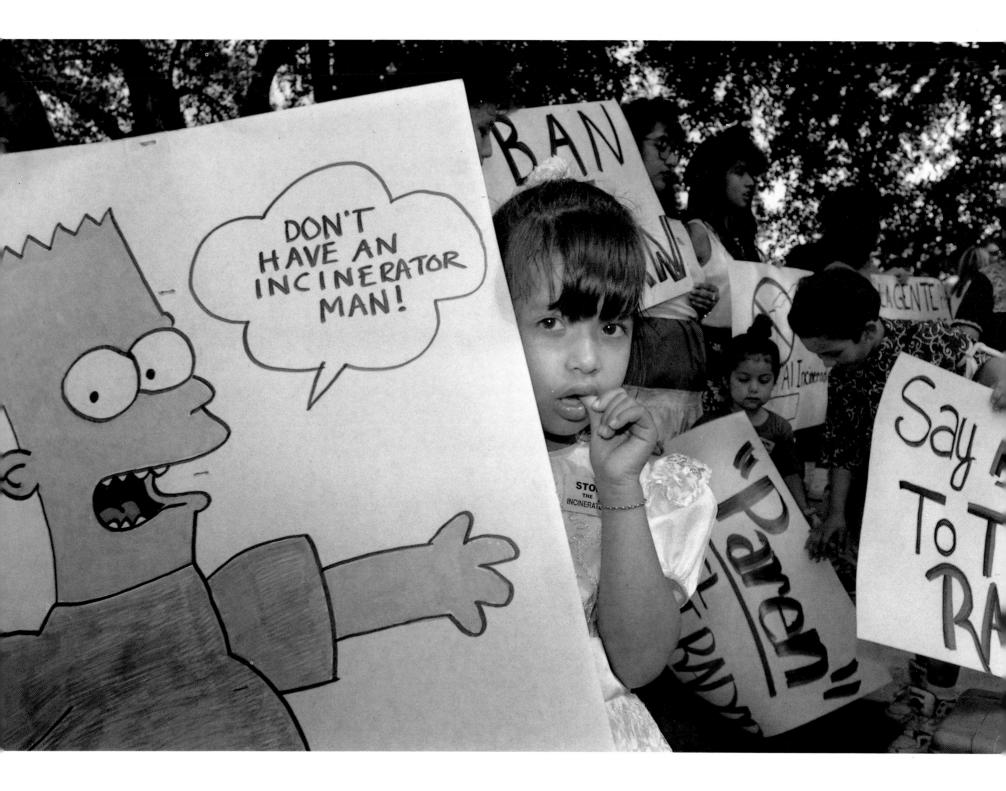

We've asked the state or health agencies to come in and make a health survey, which they have denied because of the fact that they are afraid that there is already something happening here. So we have taken upon ourselves to conduct a health survey and the preliminary report is out now. There is some systematic illness and symptoms like skin rashes, respiratory illness, all sorts. This was not here before the toxic dump.

They're using us as guinea pigs. When are they going to pay attention to us? When we're dropping off like flies? It's time government takes responsibility and does what it's there for, to protect the people, not to protect their pocketbooks.

ESPERANZA MAYA Kettleman City

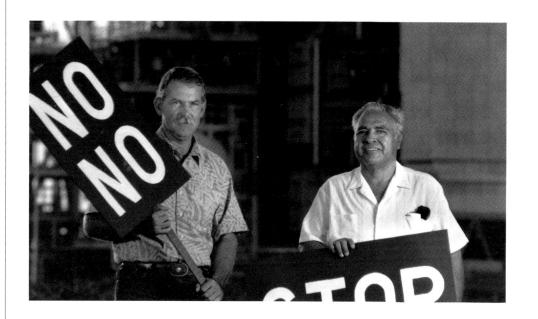

It's documented that toxic waste sites, not only here but throughout the country, are deliberately in areas of low socioeconomic status. That's the easiest way for these companies to obtain permits without any political opposition.

Not only do they do that, but they have consulting firms that go around and profile the elected officials they know won't do anything to stop the permit process of these dumps or incinerators.

JOSE MAYA Kettleman City

Farmers Dick Newton and Jose Maya protesting licensing of a coal-burning power plant in nearby Hanford.

My worst nightmare is Chernobyl.

MARY LOU MARES Kettleman City

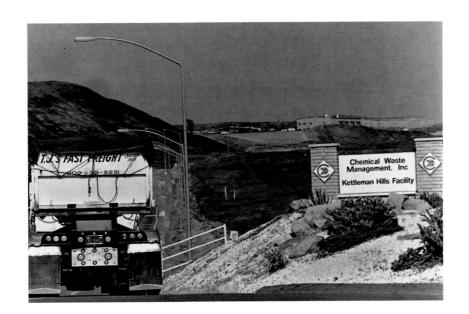

Left: The entrance to Chemical Waste Management, Inc.

Right: Farm worker Apolonia Jacobo and her son Celestino pointing towards Chem Waste's facility from the toxic selenium evaporation ponds north of Kettleman City.

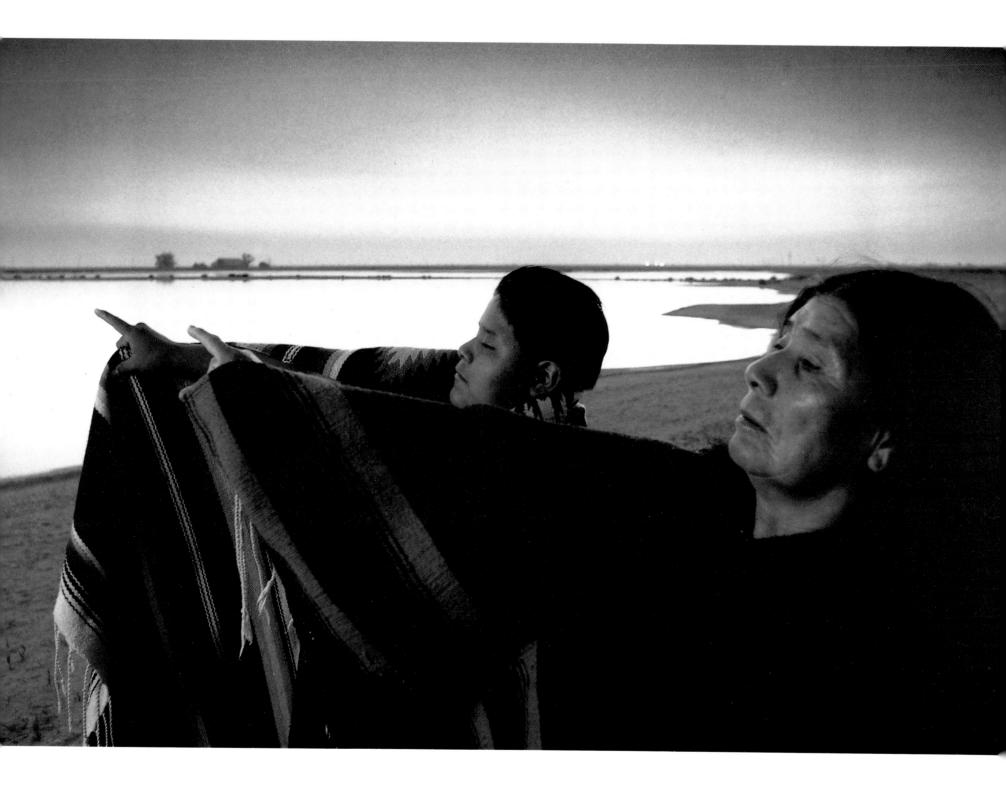

STRANGERS IN A STRANGE LAND

ASIAN REFUGEES
CENTRAL VALLEY

<u>୭୦୭୦୭୦୭୭୭୭୭୭୭୭</u>୭୭

ALKING INTO THE HMONG ARTS SHOP IN FRESNO, visitors are immediately drawn to the huge tapestry hanging on the wall. At first glance the colorful five-by-six-foot cloth seems to depict a procession: men in black peasant garb, bright sashes, and traditional head caps; women wearing multicolored skirts, babies in baskets strapped to their mothers' backs, children in tow. A lush jungle gives way to farmlands bursting with crops. But the story this tapestry records is not a happy one. It depicts one of many massacres visited on the people of Southeast Asia during the past three decades.

The Hmong, an isolated community of rural mountain people from southern Laos, did not have a written language until the latter part of this century. "Hmong people are storytellers," explains Mao Vang at the Hmong Arts Shop. "Our ancestors didn't know how to read or write, they just drew pictures. Tapestry makers would tell the story over and over again while they were making the tapestry. They see themselves in the tapestry."

This particular tapestry records a day in 1975 when Vietnamese soldiers invaded Van Vieng, a city in southern Laos. "The Vietnamese and Laotian armies are fighting in a Hmong village," explains Vang, pointing to the intricate stitching. "The people run to the bridge to escape. The Vietnamese shoot. The people run back. They are trapped. There's a massacre. The Hmong people try to cross the Mekong River. Some cross in inner tubes. Some swim. Some drown. The Thai police pick up the people and take them to a hospital. They stay in camps and get signed up to go to the United States. The bus takes them to the airport. America is in the lower-right corner.

Mao Vang and her grandmother, Son Vang, owners of the Hmong Arts shop in Fresno, display traditional Hmong crafts.

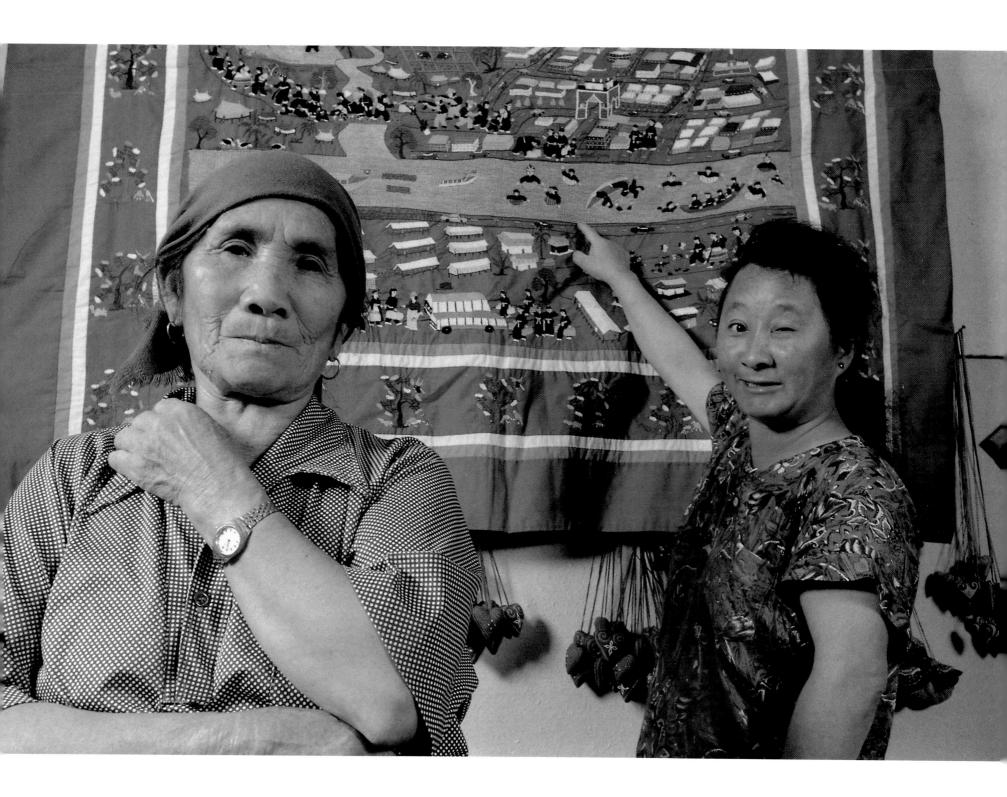

That's us coming here." In the world of the tapestry, America is pictured as a land of two-story homes, television antennas, and big automobiles.

Like exotic, multicolored butterflies alighting in California's Central Valley, hundreds of *paj ntaub* story cloths or tapestries capture in succinct detail the violent end of Hmong life in Southeast Asia. These story cloths are the markers of a forced 10,000-

mile migration of Hmong, Laotians, Mein, Vietnamese, and Cambodians into dozens of cities across the U.S. Some 75,000 of these survivors traveled with their children, parents, aunts, uncles, and cousins to California, with half of them settling in Fresno County.

This exodus has thrust Southeast Asian refugees into that uncertain territory demarcating postindustrial California from the ancient lifeways of preindustrial Indochina. Suffering from the trauma of dislocation, haunted by the unspeakable horrors of war and one of the most terrible holocausts of this century, the newcomers have created a new way of life and preserved their cultural identity. In the process, they have formed a rich Indochinese rural network that has assisted them in taking the necessary, irreversible steps away from the Mekong. The refugees all say the same thing about their arrival in the Central Valley. Etched into their psyches, this memory is second in importance only to the day they escaped from their home villages in Asia. Absolutely nothing prepared them for what they encountered here.

A tapestry of their American initiation might depict scenes of Laotians, confused by modern conveniences such as light switches, locked doors, and refrigerators. There would be pictures of rural women cleaning rice in toilet bowls, or Mien people converting living rooms into gardens, building open cooking fires in bedrooms and scalding themselves trying to take hot showers. Or Cambodian women learning to shoulder the responsibilities of heads of households for the first time in genera-

Tiem Van with his daughters, who do not like to wear traditional clothes. tions because three-fourths of their husbands, fathers, and brothers were killed by the Khmer Rouge. Or Vietnamese men bewildered by a society that has no jobs for them, and the Hmong man who, after being arrested for a traffic accident, hung himself in his jail because he feared he might be tortured and did not understand that he was being held for a minor offense.

To overcome their disorientation, refugees withdraw into themselves. They become quiet, invisible, their poverty forcing them to live out of the way, in run-down neighborhoods. But in some respects their physical isolation contributes to a sense of freedom and safety. Here, amid a network of families and village allegiances, they learn to function as a community in exile. Sophie Karet, director of the Cambodian Women's Association in Modesto, expresses both the obstacles and the hopes of her community. "The nightmare that keeps haunting the Cambodian people is the holocaust," Karet explains. "The holocaust, a repeated tragedy, creates painful memory. The people who can escape after the holocaust classify themselves as born again. They give thanks that they're still alive and, hopefully, that they have a better future. But when they come to the United States, they are forgotten in the mainstream. We feel proud of the civilization that we come from. That keeps us alive, for the preservation of our culture, starting from the clothes, the costume, the language, the food. We like to recreate the glory of the country. We can recreate something that we can be proud of in the history of mankind. We have that in mind."

Perhaps one out of a hundred have become farmers and started growing strawberries, sugar peas, and Asian vegetables for sale at roadside stands or by a handful of small produce brokers. "We came believing, 'We'll work hard, we'll grow things, just like in the old country,'" says Leng Lee, manager of Cherta Farms. But back home, Lee and others practiced slash-and-burn agriculture. In Fresno, farming corporations rule the landscape, enriching thousands of acres with fertilizers and dousing crops with pesticides and herbicides. Lee didn't understand any of this. "We'd get sick from applying pesticides without any protective gear. We didn't know how to irrigate. We'd think it would rain like in Laos. But it doesn't rain here in the summer." Despite these problems, Southeast Asian farmers are building their farms in the Central Valley, one acre at a time. They work cooperatively, sharing what little they have. They band together to buy a used tractor, recycle old equipment, and work twelve hours a day, seven days a week. Collectively, they are producing millions of dollars worth of crops, largely on their own, without government subsidies or bank loans.

Asian refugee businesses, like the Hmong Arts Shop, follow similar cooperative business prac-

tices. None of the newcomers have any credit history; they rely on relatives to save and sacrifice for the family. "We will scrape up \$1,000 or \$2,000 each and maybe get fifteen family members to pitch in," explains Tony Vang, executive director of the Fresno Center for New Americans. "Profit margins are small, but we stick with it until we get established."

Through this collective system, Southeast Asians have rehabilitated entire city blocks. Cafes, used furniture outlets, grocery and specialty stores become community havens for refugees. Wearing traditional dress, they patronize tiny shops fragrant with smells of boiled pig, garlic, and incense. Consumers shop for everything from Laotian rice noodles and chrysanthemum crystals to pickled bear testicles and special Thai vitamin drinks.

To prevent the extinction of their traditional culture, refugee associations have established centers where elders instruct the younger generations in the language and customs of traditional village life. Arts and crafts are an especially important aspect of this development. Vang Yang, a counselor at the Hmong Council in Fresno, works directly with the senior population. "Old folks gather in the center once a week. They come with their language, do old type of things, practice bamboo pipe flute. They bring rice and chicken, the main dish we have at home. It may not be the best, but it's our food."

Seamstresses have created small home businesses specializing in creative fashions based on traditional Southeast Asian designs. Increasingly recognized for their brilliant stitchery, the seamstresses are role models whose art is appreciated not only by other refugees but by the general public. Although most of this work is sold through personal contacts, a dozen shops in the Central Valley have begun specializing in Indochinese quilts, dresses, and tapestries.

The seamstresses work with memories of their homeland traditions and the exodus from war still fresh in their minds. "Through my work and creation, I like to reach out to my people, focusing on women, young and old," explains Saroeurp Tes, a respected Cambodian clothing designer. "Since we lost everything during the war, we have to preserve something that was left behind." Mao Vang, owner of the Hmong Arts shop in Fresno, also wants to preserve the traditional ways but appreciates her new American life. "I liked life in my homeland. But it's a lot of hard work. In California it's much easier. You don't have to get water from a well and go farming for food. All you have to do is go to a store."

Like other refugee and immigrant communities, Southeast Asian parents and their American-

You apply all your knowledge when you decorate clothing. You have to think. It is like writing a letter. You make new ideas when you make those quilts.

CHONG YANG
Hmong American Women's
Association, Fresno

born children experience a painful generation gap. This gap was evident one December at the annual Hmong New Year's celebration at the Fresno Fairgrounds. Among the 30,000 Hmong celebrating were thousands of men in tunics and women in traditional skirts. But for every group of old-timers selling dried bugs and handmade jewelry, there were also youngsters in cowboy hats, serapes, high heels, black tights, and

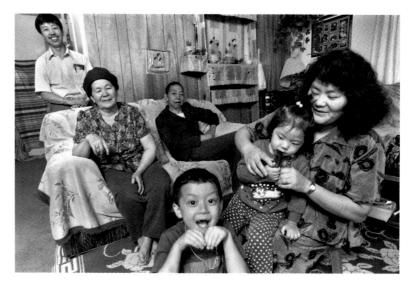

orange sunglasses. The strain of being different and the desire to blend in play a big part in the younger people's choice of dress. "In my homeland," explains Mae, a high-school graduate from Fresno, "they wear traditional clothing for everyday chores, for farming, and to play. Here, it's only for special occasions. If you wear it, people stare at you, they call you bad names. 'Chinks, go back to your country.' That's why I don't like to wear them."

The stress of Americanization has inevitably set in. But the Indochinese culture runs strong. In a parking lot, lines of teenagers still practice ancient courtship rituals in which they bounce balls between them for many hours. However, there is one difference. Instead of the black, cloth-covered balls, the youngsters use florescent yellow tennis balls. Traditionally, this is how they get to know each other and select a life partner.

The Cambodian seamstress, Saroeurp Tes, believes that Indochinese culture and the people who embody it will survive the assaults of war, dislocation, and even the stress of assimilation into American society. "Since I arrived in the United States, the original feeling like when I lived in Cambodia came back. New creations, and a lot of influence through the American culture and the creation of fashion design that gives me more ideas and makes me enjoy my work better. Whatever my creation and with all the people, I make them understand that preservation of the culture is the main focus. I dedicate my work to the heritage of the Cambodian culture. It is still alive."

While working, Fred and Mai Vang rely on Fred's parents to care for their two children.

39

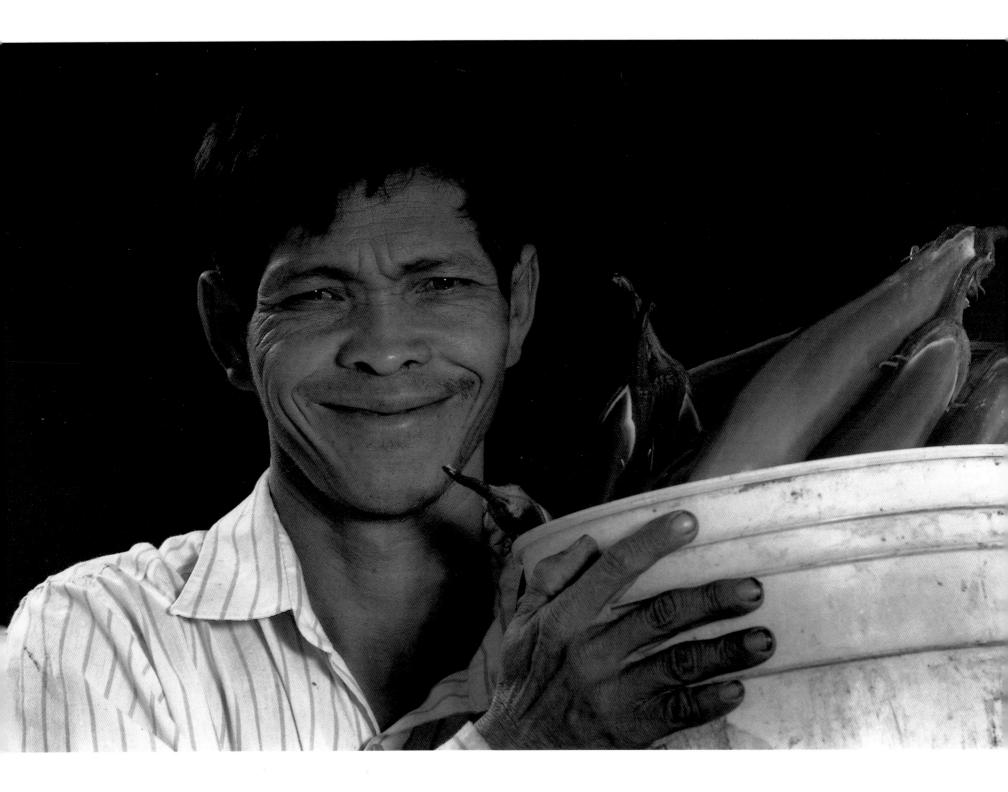

When the Vietnamese came to Cambodia, I wound up running all the tin-can factories. The Vietnamese said I did a good job, and they were going to give me a big reward. They were going to send me to the Soviet Union.

So I ran to Thailand. The communists catched me and put me in a camp. In midnight, I say I go to the bathroom. I run away. They catched me again. They line us up along the road and walk behind and chop, chop, chop. . . chop our heads off. But they make us dig our graves first. Three, four, five miles, nothing but blood.

The soldiers hit me on the head with a machete. I fell. I pretend I was dead. I hide in the reeds beside a boat in a canal. I put mud and ash and urine on my wound. I cross through the jungle at night into Thailand. Church group bring me here. I haven't seen my family since 1979. But now I just heard they are alive. My mom and dad were killed by the Khmer Rouge.

At night, when I dream, I worry and wake up. I worry about my family and my country.

ROUETH PEN Farmer, Fresno

Roueth Pen harvesting Chinese eggplant east of Fresno.

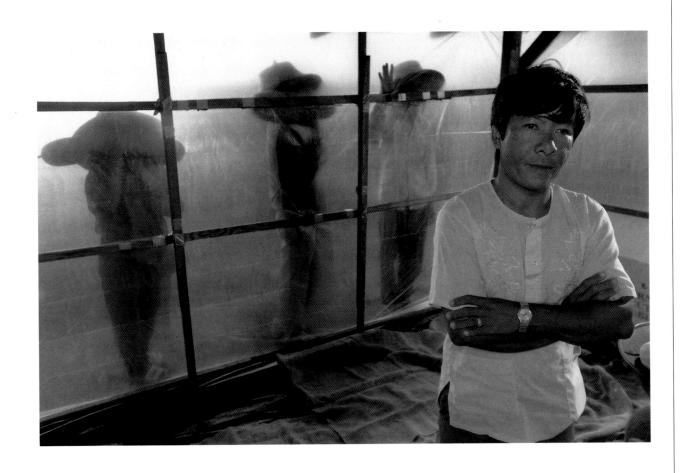

Joe Khamvongsa in his packing shed at Asia Farms in Fresno.

The kids come home in the afternoon and do their homework in the packing shed. The older people study for their citizenship and the children quiz them.

"Where was Adolf Hitler born?" They ask. "Germany or Austria?" The kids know it's Austria. But I wasn't so sure.

The kids also read from the history books. I like it when they read about the Native American Indians. They are like the Laotians. They have lost their country.

JOE KHAMVONGSA

Founder of Asia Farms, Fresno

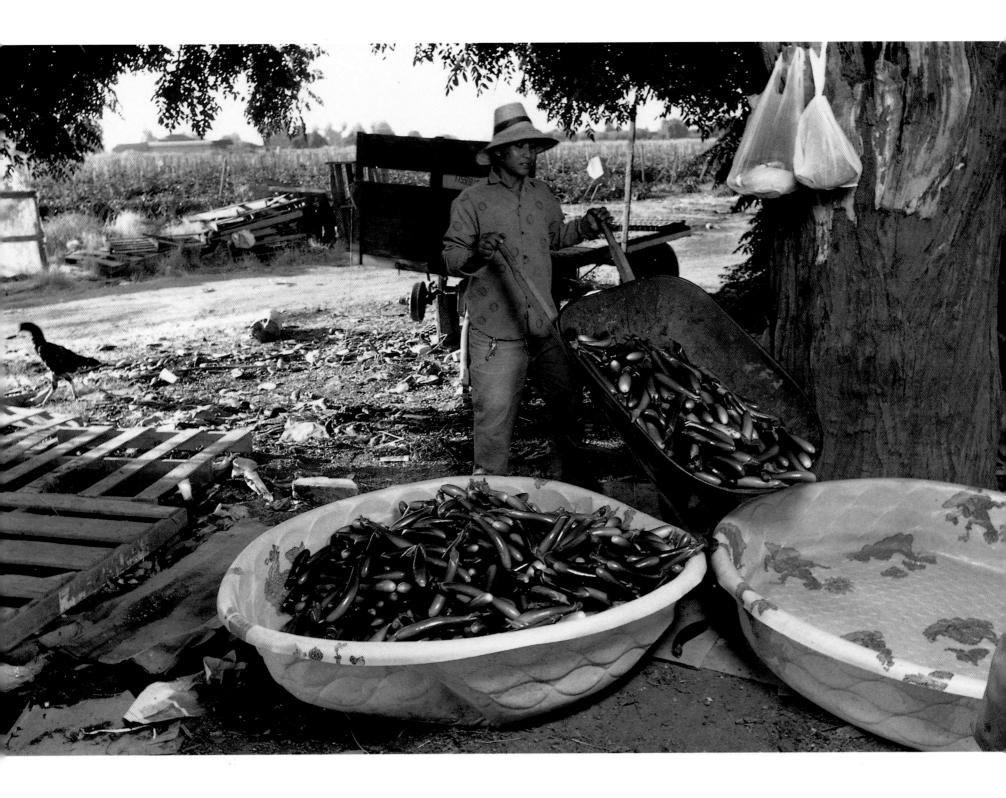

I farm ten acres. I do everything. I cultivate, harvest and spray. Yesterday morning I woke up at 5 A.M. I picked my crops, loaded them into my Toyota, and drove to Stockton. The supermarket said I didn't have enough for them to buy. So I drove back. I picked more. Then I drove back to Stockton. I sold it all. I got home at 1 A.M.

I don't throw anything away. I either sell to stores or eat it or trade it, one box, two boxes at a time. Sometimes I give people two dollars in produce. They give me coffee, sugar, a chicken. We barter. We trade. Very fresh. I walk right out in the fields and pick it for them while they wait.

Left: Harvesting Chinese eggplant at Asia Farms.

Right: Roueth Pen and a co-worker sorting chilis.

Hmong people become afraid when asked their name. They say, "What you want my name for? What you come here for? You crazy?"

They are afraid I'm a spy. They say, back in Laos, if you ask someone's name it's to put it on a death list and cut you at night and kill you. You never tell your name. You talk twenty or thirty minutes just to find out who you're talking to.

INTA PHAKHONEKHAM
University of California Extension, Fresno

Hoeing beans at Cherta Farms.

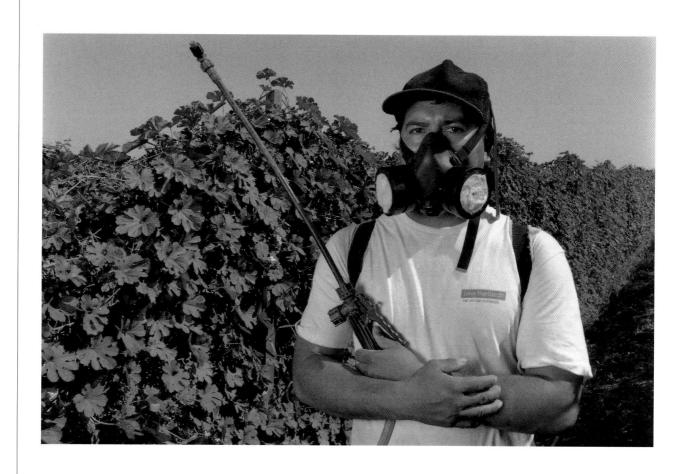

A worker spraying a bean field.

left Cambodia in 1981 because of the war and the fear for my life and my family life. In my family, I am the only seamstress. The style that I create is Cambodian style. The wedding costume has some influence from Thai style, but overall, I try to be original as possible, to be Cambodian style. I try to internationalize my work. I can make different designs but somehow preserve something Cambodian in that design. I am very proud to create something that still belongs to Cambodian heritage and that makes a kind of interfacing fashion to the rest of the world.

SAROEURP TES Seamstress, Modesto

Seamstress Saroeurp Tes working in her shop, located in Modesto.

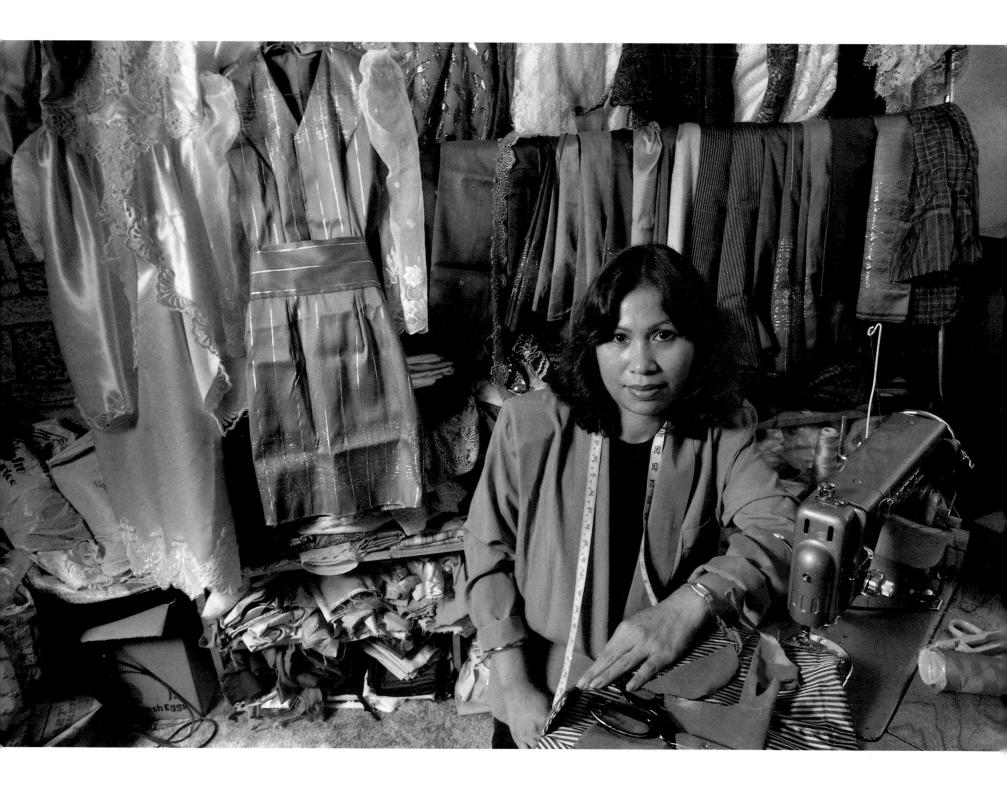

A GULTURE OF SURVIVAL

THE CANYON CAMPERS
SAN DIEGO COUNTY

0000000000000000

ORE THAN 15,000 MEXICANS, GUATEMALANS, AND SALVADORANS live in the canyons of north San Diego County. Claiming every patch of unfenced land, every wooded gully, every undeveloped lot, they have built hundreds of shanty encampments from North City up the coast to towns like Rainbow and east to Pauma Valley. Often located within shouting distance of million-dollar hilltop mansions, these provisional communities form the largest single concentration of immigrant squatters anywhere in California, and perhaps the entire country.

Newspaper reports paint these shadow cities as wild, dangerous eyesores. Conditions are certainly raw. Most camps lack electricity and running water. They don't have telephones, toilets, or garbage collection. Meals are prepared over smokey campfires and in mud-lined ovens. Mail arrives from the catering truck drivers who supply low-quality food at inflated prices. Everything is expensive: three dollars to translate documents; five dollars for a ride to town; a dollar for a soda.

There are few women or children in the camps. The men come from Mexico and Central America, leaving their families behind, hoping to earn the precious U.S. dollars that will be worth more than the currency back home. "That's why we risk our lives to come to the United States, to see if we can progress with our families," explains Pascual, a Kanjobal Indian from Guatemala who speaks little Spanish and no English.

Back home in the villages of Mexico and Central America, the families wait to receive help. Belen Rosas, a Oaxacan from San Sabinilla, Mexico who is organizing among the laborers in the camps, expresses the loneliness felt by many men there. "What good is it to have money, to have

Entering a canyon camp, *Rancho de los Diablos*, in San Diego County.

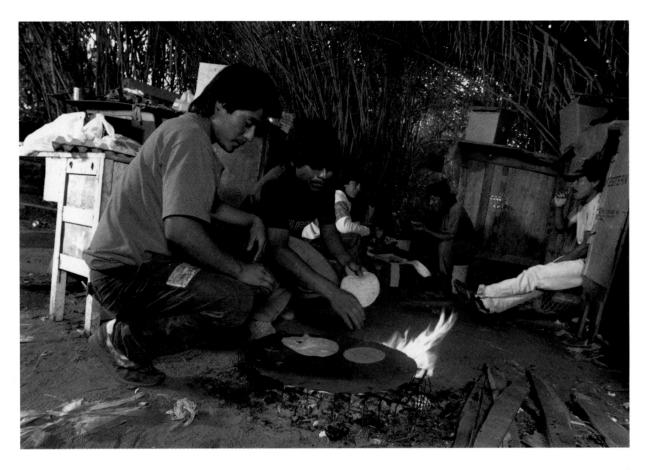

food, when the most important thing is missing—the family. And we go back with what little we made. We pay off debts or save for emergencies. Some buy land, others build homes, and still others come back the way they had left or in worse condition."

But despite the desperate conditions, the camps are also complex testaments to the tenacity of community spirit. San Diego's canyon camps serve as emotional and economic safety nets, welcome newcomers informally, and reproduce vital aspects of village life. Here, *paisanos*—relatives and friends from back home—feel safe, get established, are fed and housed and guided to jobs. For those who die in a canyon camp, friends pass the hat to collect the \$2,000 required to ship the body home.

Productive, essential labor dominates camp life. Days begin before dawn. Men emerge from

Canyon campers heating tortillas for the communal meal at *Rancho de Yasecoche* in Oceanside. If someone needs help transporting their dead, they go to the ranches. The problem is explained and people help with five dollars, others with three. If someone doesn't have work and wants to go back, we all pitch in some money and send him.

HIPOLITO
Rancho de Yasecoche,
Oceanside

Planting tomatoes with no gloves.

their shacks, feed twigs and empty egg cartons into rusty oil-can heaters, brew coffee, warm tacos, make burritos, wrap them in aluminum foil, toss them into backpacks, and begin walking out of the canyons. For hours, the hills stream with people heading for the town of Del Mar and a half-dozen other farming communities and towns in San Diego County.

The routine never changes. After ten hours of work digging ditches, mopping floors, and harvesting crops, the immigrants return to their camps and immediately begin hauling water to their campsites using a *palo* (pole) and bucket system. Wrapping their arms around the poles, they stoop down, hook ropes to the buckets, and walk as far as a mile, carrying eighty pounds of water in a posture reminiscent of the crucified Christ.

In the evenings, men gather for dinner. They fuel their campfires by burning plastic shopping bags on grills so that the superheated plastic drips onto pieces of kindling. For hours they stoke the fires, chop meat and onions for tacos, listen to small, battery-powered radios, exchange the news of the day and visit with neighbors. By 10 P.M. they're in bed, often twelve men in a room, stacked on three-tiered bunks inside windowless, flea-infested shanties.

Canyon dwellers rarely venture into the communities when they are not working. They don't frequent the coffee shops, hang out at the bowling alleys, attend movie theaters, or join other tour-

ists at the beach. Their only recreation comes on weekends. After getting paid, the canyon dwellers spend hours inspecting used clothes and merchandise trucked in by vendors for Friday night flea markets. Sunday is sports day. Every large camp has a soccer field or a basketball court with a homemade hoop nailed onto a plywood back and pole.

Canyon camps are full of things outsiders would never expect to find in such places. One of the largest camps, *Rancho de los Diablos* (Devil's Camp), shelters more than 400 men in a ramshackle settlement that meanders for a mile through the brush east of Del Mar. A visitor to the camps could easily get lost in a confused tangle of dusty alleyways; a

world of tinkers, bicycle repairmen, freelance mechanics, and vegetable patches. A couple of makeshift restaurants, built out of pallets, serve three-dollar meals of beans and rice. There is even a "driving school" where Oaxacans navigate Hondas along the surrounding trails.

San Diego's politicians have completely failed to assist the canyon campers. "Bulldoze the camps," they

say. "Pass no-loitering laws. Build walls. Call in the border patrol." What the local politicians don't say in public is that the vulnerable immigrant laborers who live in the canyons are essential to San Diego County's \$800 million-a-year agricultural industry. Enforcement of minimum wage laws is nonexistent. Hundreds of unpaid wage claims are filed by workers each year. The exploitation of the canyon campers is the only reason that growers are able to profit from harvesting tomatoes for the vine-ripe market when rivals can't. Immigrants also flip hamburgers, plant trees, wait tables, dig ditches, pour concrete, carry shingles. They do all of the stoop labor in the booming tourist and construction trades, multimillion-dollar industries that derive their profit, in part, because of cheap immigrant labor. "There are too many people," says Rosas. "If I'm working for five dollars an hour, they can find a hundred others who will work for four dollars and twenty-five cents."

The abundance of workers makes it difficult to bargain collectively. In addition, the canyon campers are hemmed in by a multitude of other obstacles. Seventy percent of San Diego's canyon campers are Oaxacan Indians and others from remote areas of southern Mexico. They are in desperate economic circumstances. The Oaxacans are mostly undocumented, and they are subjected to racism, not only from Anglos but from compatriots who call the Oaxacans "barbarians" because they speak an Indian language that others cannot understand.

Residents of a canyon camp located under an interstate highway use a map to locate their home town. The combination of isolation from family and culture, and oppressive living conditions appears to be reinforcing ethnic consciousness among the canyon campers, helping to create two grassroots organizations—the *Union de Trabajadores Agricolas Independientes* (UTAI) and *Comite Civico Popular Mixteco* (CCPM). Led by Rosas, UTAI's 110 members have concentrated on improving working conditions in surrounding nurseries. CCPM has taken a different approach and has used mass protests to force public and private agencies to develop housing programs for immigrants.

So far, UTAI has forced nursery owners to consider a seventy-five-cents-an-hour wage increase and medical coverage. CCPM has picketed merchants accused of abusing Oaxacans and persuaded the Mexican consul to tour the canyon camps. "The problem of those who live out in the camps, out in the open," explains Rosas, "is that they are unable to look for jobs in the city because they fear being picked up by the *migra* (immigration). They remain isolated; that's the worst thing that can happen. I want to help my people. I do it to obtain a system that is more just. To obtain well-being for all of us workers."

These organizing efforts may have the potential to become broad-based movements to fight the exploitation by employers and abysmal living conditions that the people in the canyons must now endure. "The best thing would be to bargain collectively with the companies so that we could resolve the housing problem. . . give the workers decent places to live," explains Rosas. "I think that our Mixtec community has historically had a natural organization. It emigrates into other communities and takes it along. The people who have been emigrating are young people. These are people who have been in school or have some type of preparation from home. Some could not continue studying, so they came to work in the United States with the desire to progress and organize. I think our young people will show the rest of us the light."

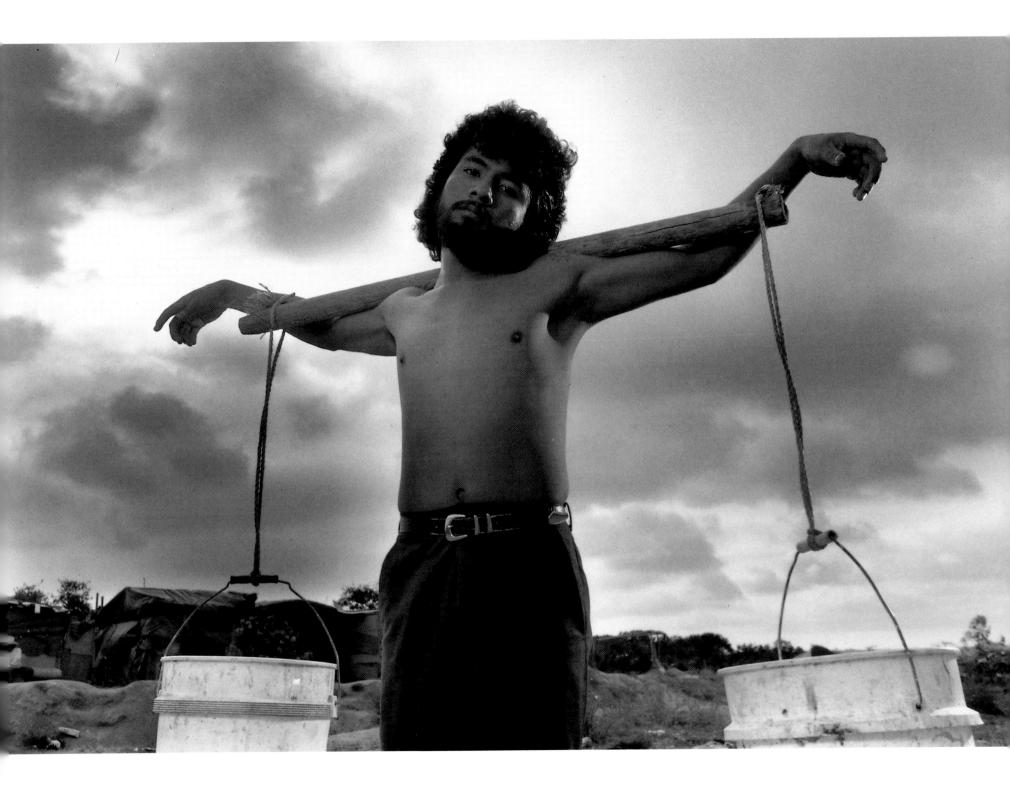

have three brothers and sisters. I'm the middle child. My father is a schoolteacher. Before I left for the United States, my father gave me a Spanish-English dictionary. I look up every word I don't know. I'm always using it.

When I arrived, I had no money. People fed me. I looked for work and collected tin cans and sold them to get money to buy beans and tortillas. Then I got a job in the tomato fields. I built my shack out of debris from the camp garbage pile.

I keep myself in good shape. I'm very religious. I read Scripture. I play soccer. We don't have water in the camp, so twice a day I fill up two buckets and carry them half a mile from a nursery to my home.

Back in Oaxaca I was a bantam-weight boxer. I had twelve professional fights. I'm undefeated. My goal is to go to New York and box. I want to be champion of the world.

LUIS MIGUEL RODRIGUEZ

Del Mar Heights Ridge Camp, Del Mar

Luis Miguel Rodriguez hauls water one-quarter mile from a nursery spigot to his camp.

30

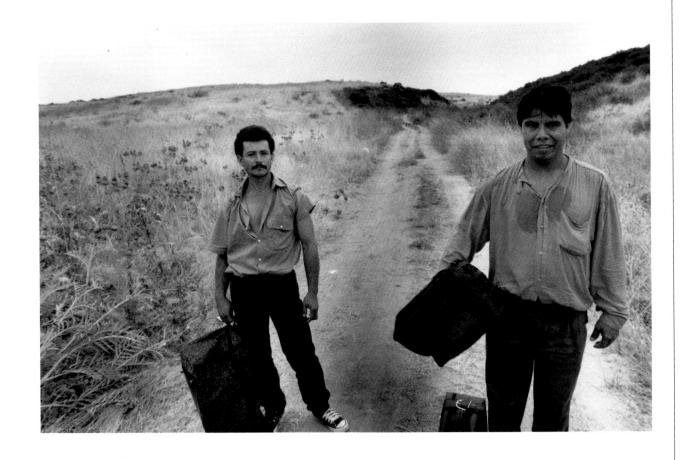

came because in Guatemala they are killing people. At about 15 or 16 they take you to be a soldier. They take you to the very center of Guatemala; you practice handling guns. They say there's a war right now. In a village named Colla there was a lot of war going on. They kill people there.

JUAN Rancho de los Diablos, San Diego County

New canyon campers arriving at Rancho de los Diablos after a three-day bus ride from Mexico City, a night crossing the border, and a two-hour hike through the hills.

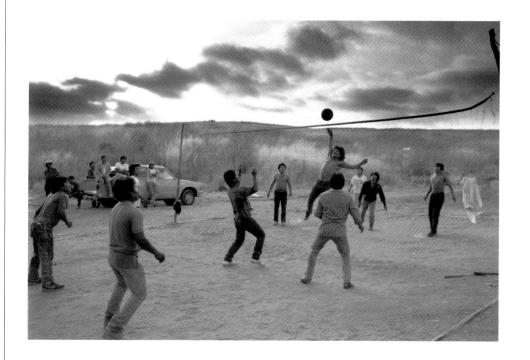

All of us who are here are from the same place. Some are cousins. We go to them. They invite us to have lunch or dinner. They help us. That is why it is convenient for us to be in the camps. If we go rent an apartment without a job or anything else, without being able to speak English, well, we can't.

ELIAS CHAVEZ

Rancho de Yasecoche, Oceanside

Canyon dwellers playing volleyball.

When we work around these big houses on the hills we see pets that live better than we do.

SIXTO GUTIERREZ

Rancho de los Diablos, San Diego County

Gloria Chrispin and Erika Salgado (nine months' pregnant), residents of *Rancho de los Diablos*.

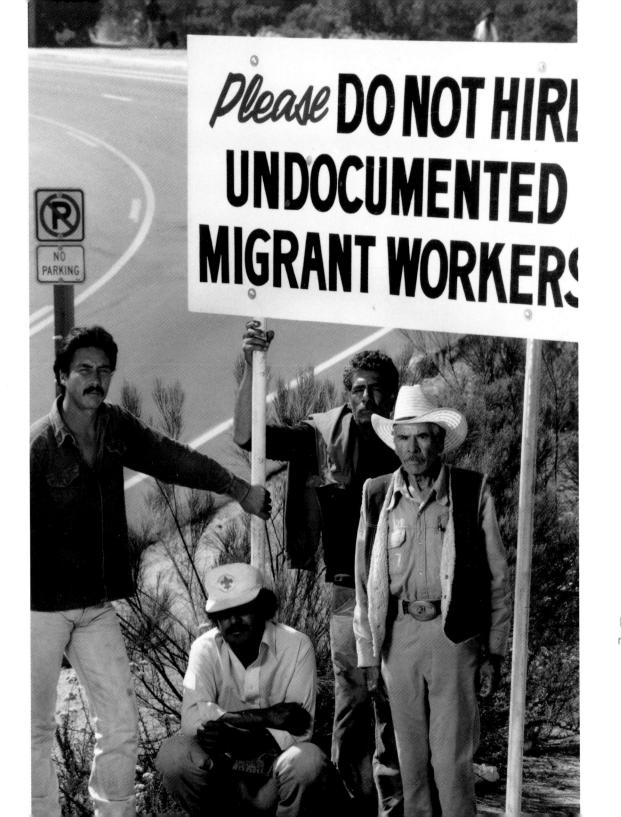

Canyon dwellers waiting for work beneath steel signs erected by city residents discouraging people from hiring canyon dwellers. Here in San Diego's north county there is an abundance of workers. If I am working for five dollars an hour, they can find a hundred others who will work for four dollars and twenty-five cents. There is little pressure that we can apply to force the company to bargain collectively.

Those who live in the camps, out in the open, are unable to look for jobs in the city because they fear being picked up by the *migra*. That's why they have to remain on these ranches. There is no communication between the people of the city and us who live in the fields.

I want to help my people. I do it to obtain a system that is more just. The changes have been minimal, but they have begun to take place.

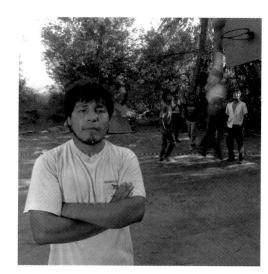

Belen Rosas, the founder of *Union de*Trabajadores Agricolas Independientes,
a union concentrating on improving
working conditions for canyon
dwellers in surrounding nurseries.

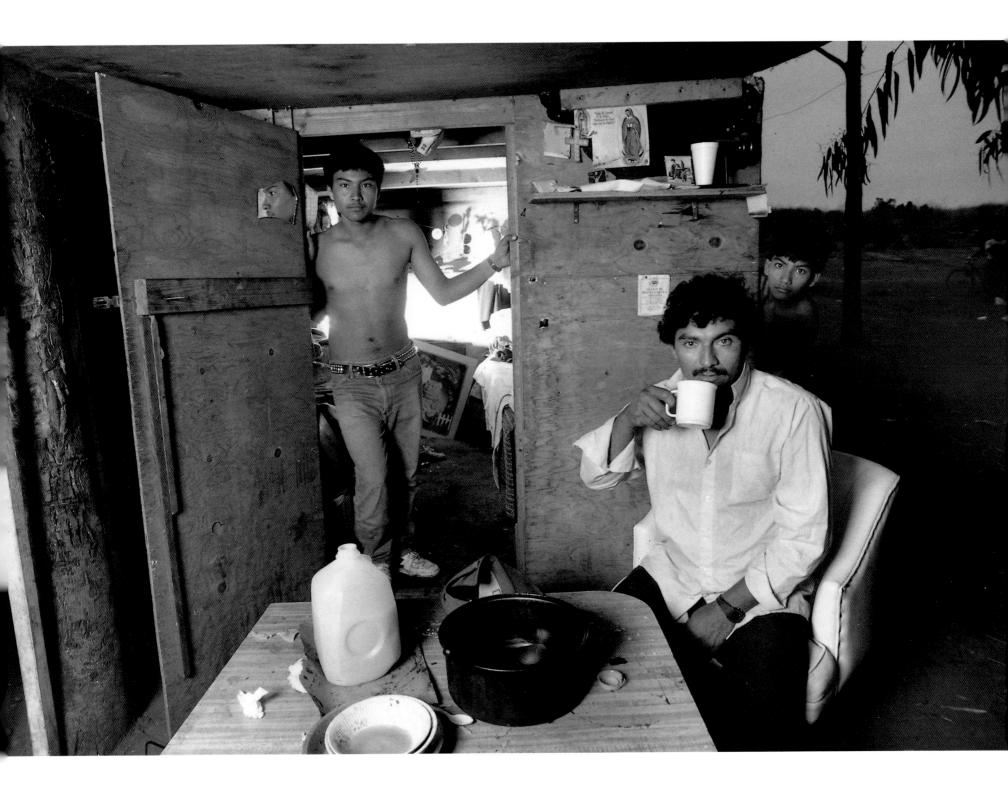

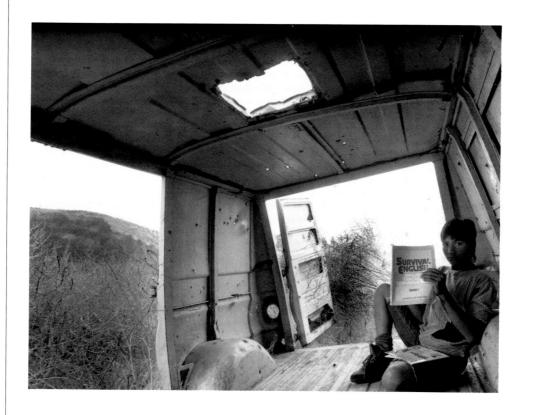

Left: A plywood, plastic and packingcrate home in a canyon camp built by the Gutierrez family.

Right: Canyon camper Jose Gutierrez studying English in an abandoned van.

There are schools to go study, but our work does not allow us. We come home, fix our dinner or our clothes, and the evening is gone. We don't get anything done. And that's how it is every day. So we never progress. In the city you work exactly eight hours and you can plan your time better. Here we work ten hours, we don't have time to study. We eat, sleep, and wake to another day of the same work.

TRANSFORMING COMMUNITY LIFE

LAS MUJERES MEXICANAS
COACHELLA VALLEY

T'S 6:30 ON A SEARING HOT SUMMER EVENING in the Coachella Valley, an artificial agricultural oasis in the desert 150 miles south of Los Angeles. Teresa Velez has just returned from ten hours of picking grapes in the 100-degree heat. She's been up since dawn. She's tired. But after preparing dinner for her family and washing the dishes, Velez tells her husband she must go out. Sensing his disapproval, she doesn't say where she is going.

Teresa Velez drives to City Park in the center of Coachella where a protest against the Persian Gulf War is underway. Holding up a picket sign and shouting, "Queremos paz, guerra no!" ("We want peace, not war.") Velez joins a group of outspoken, angry women, who belong to Mujeres Mexicanas, the first grassroots organization of campesinas (farm-worker women) in California. As a member of Mujeres Mexicanas, Velez and other Mexican women are learning how to participate in politics, make changes in their communities, and address campesinas' concerns. In just four years, the Mujeres has grown to more than 100 members by building strong community support for numerous causes. Mujeres Mexicanas has launched dozens of health and education projects and support groups for women. They have also organized political campaigns that have empowered campesinas and have shaken up the politics of Coachella Valley. "We're taking control of our lives," states Velez. "We're tired of being taken for granted."

Mujeres Mexicanas was formed in 1988 after a group of campesinas helped graduate student Maria Elena Lopez-Trevino gather information for a survey of farm-worker women. About a dozen campesinas, including Millie Trevino-Sauceda, Elizabeth Hernandez, Claudia Galvez and Virginia

Mujeres Mexicanas members

Maria "Cuca" Carmona, Claudia Calvez,
Teresa Velez, Petra Ruiz and

Maria Serrano atop a mural near
their homes in Coachella.

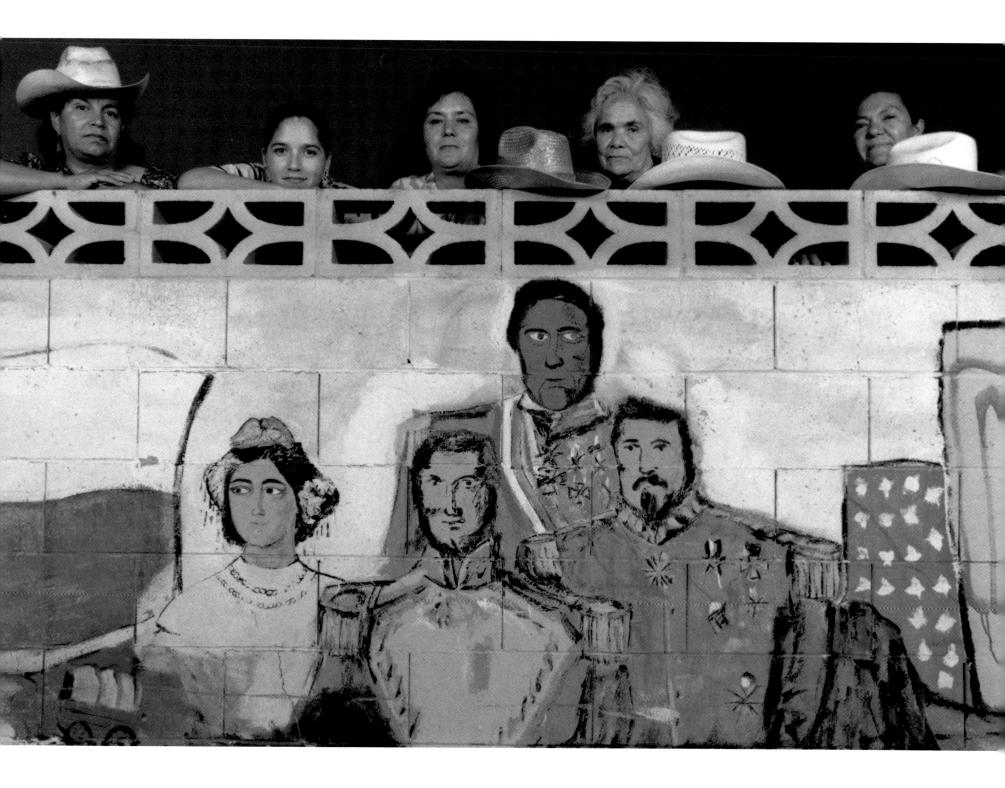

Ortega went door to door talking to women and hearing their stories. The survey uncovered a brutal labor system in which *campesinas* in the Coachella Valley picked grapes under the burning desert sun from May through August. Or they took any low-paying jobs they could find or went unemployed into the fall and then harvested citrus fruits and pruned vines in the freezing cold of winter. Earning \$4,000 to \$6,000 a year, the women labored under nonunion, piece-rate conditions. They couldn't afford day care and suffered from pesticide exposure. With private, on-farm housing disappearing and no new public farm-worker housing being constructed, entire families were forced to live in makeshift trailer parks, self-built shacks or in dozens of illegal labor camps stretching along Highways 86 and 111 from Indio clear to the Salton Sea.

This academic survey confirmed what these women already knew. "Even though we knew about their problems, we didn't have any statistics," explains Trevino-Sauceda. "We learned that most of the problems were domestic violence, poor education, very bad working conditions, and sexual harassment." After a lot of sharing and in-depth discussion of what *campesinas* face every day, the group felt strongly that it needed to organize. Trevino-Sauceda had learned to be an organizer while working as a farm worker and an activist with the United Farm Workers Union. She wanted to use the survey results to address the extreme isolation felt by so many women agricultural workers. "Women had participated in other groups but played a secondary role and were not included in

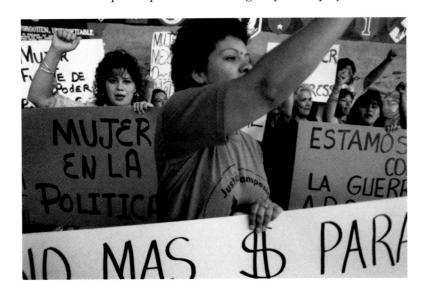

leadership," explains Trevino-Sauceda. "Since the beginning we all agreed that our role was to promote the socio-political and psychological empowerment of *campesinas*. We also agreed that professional women—the ones who had college educations—could only be advisors, not active members, because professionals tend to take over the leadership of the group. We wanted *campesinas* to be in control."

Mujeres Mexicanas protesting the Persian Gulf War. Mujeres Mexicanas immediately launched a series of what they termed "actions" throughout the Coachella Valley. They played a key role in getting the board of education in Coachella Valley to name a new school in honor of the first UFW union president, Cesar Chavez. After receiving training from the Southwest Voter Registration project, they began a votereducation campaign designed to

address the traditionally low turnout in the valley's Latino communities. The *Mujeres* canvassed the neighborhoods and passed out packets of information urging people, especially women, to vote. As they went from door to door they also asked women about the realities of their daily lives in order to determine how best to assist the *campesinas*. Quickly, *Mujeres Mexicanas* started to gain the attention of farm-worker women in the Coachella Valley.

In 1989, the *Mujeres* got involved in the Coachella city council election, supporting their own slate of three Chicano candidates for city council. These candidates won, largely because of the efforts of *Mujeres Mexicanas*. Coachella's Latino community set a record for voter turnout in California with 89 percent of the electorate showing up at the polls. "People thought one vote wouldn't make a difference," says Olivia de Lara, a member whose son became a council member due to the *Mujeres*' support. "We opened their eyes."

Members of the *Mujeres* worked with a migrant health clinic, assisting in immigration drives to avert a measles epidemic. A few months later, they branched out into public health issues. With the Tobacco Project, the *Mujeres* went door-to-door with educational pamphlets warning the Latino community of the dangers of tobacco, especially for pregnant women. The women also focussed on AIDS education, talking with prostitutes, drug addicts, and other people at high risk. They provided pamphlets, condoms, and bleach to disinfect needles. No local government or health agency in the

Mujercitas Mexicanas putting up local election posters in Coachella.

Coachella Valley was attempting anything like it. "We went to visit homes, laundromats or wherever we found a person," states Velez. "We explained to people how they could avoid getting AIDS. We asked them questions to see how much they knew about AIDS, and depending on how they would answer, we would give them personal explanations."

When the *Mujeres* heard of injustices in the school system's treatment of a Mexican mother and her child, they stood en masse at school board meetings until their questions were answered. When there was an election for the board of directors at the health clinic, *Progresso del Desierto*, *Mujeres Mexicanas* registered candidates—and elected five members to the board. "We try to help each other as farm-working women," explains member de Lara. "Better treatment in the fields, in politics, in health issues. The purpose of the group is to help each other."

In September 1990, more than 100 farm-working women attended the first Coachella Valley women's conference, organized and chaired by *Mujeres Mexicanas*. They shared problems, discussed tactics, networked, and formed *Mujercitas Mexicanas*, a group for the young daughters, nieces, and cousins of the *Mujeres*. Sylvia Berrones, a new member of the *Mujeres* at the time the conference took place, recalls, "To be honest, I was very afraid because there had never been a conference of Latino women. I thought no one would show up. I was very nervous. I felt sick. But now I remember it with much satisfaction. It was a victory." Berrones adds, "The majority were farm-working women from Coachella. You could see the need for them to get out, express themselves, listen. I don't know how they managed to get out and come to the conference, but I think it was beautiful for them."

The second annual conference drew nearly 200 women, primarily from the Coachella Valley. Because of the success of this second conference, the women decided to hold a statewide conference for *campesinas* in 1993. As a result of the impact of these conferences, politicians and educators continue to lobby the *Mujeres* for support and solicit their opinions on issues ranging from day care and housing to bilingual education and sexual harassment. "Mexican women in this region are becoming conscious of the fact that they're not alone, there are many of us," says Berrones. "They are made to feel that being a woman is not an obstacle, being a woman no longer means you can't do anything. To the contrary, we can do a lot."

For women with husbands, participating in *Mujeres Mexicanas* can present special problems. Velez's husband, for example, is uncomfortable with his wife's activism. "My husband says that this group has given me erroneous ideas, that I'm not OK, that none of my friends are OK," Velez

We have gone to the offices of the school administrators and the old men tremble because here come the gossipy old women. They know we aren't going to let anyone tell us what to do.

ENEDINA ARRAPAN

explains. "Every time I go home, he asks me, 'Were you with the gossipy women?'" She adds, "We would like *Mujeres Mexicanas* to focus on women—to help them feel like human beings. We have not been allowed to feel like human beings. We are used like servants. I would like to see women study and work and have the opportunity to feel that they are someone, with lots of rights."

The culture of machismo is deeply entrenched among farm workers. Berrones has seen many women struggle with the effects of sexism. "There are women who can't even go out to work because of the husband, or the children, or because they don't speak English," explains Berrones. "They go from their house to the supermarket, taking care of the children. They don't have any information. The situation exasperates me. It's very important to us to become involved doing voluntary work, taking information out into the community, so that all of these people can get ahead." Maria Carmona adds, "Our husbands have the idea that the woman should be cooking, taking care of the children, staying at home. When a group comes along and takes us out of the home and out of our ignorance—out of our shell—they do not like that. *Mujeres Mexicanas* feel better sharing experiences with one another. It makes me think, 'If she can resolve her problems, why can't I?' It makes me stronger."

After four years of organizing, the *Mujeres* have reached thousands of *campesinas*, helping them empower themselves and become more visible in their communities. "Wherever we go, we touch a lot of people's lives, especially women," notes Trevino-Sauceda. "Women are getting their self esteem, learning that they can do many things that most of their life they were told they couldn't do." *Mujeres Mexicanas* has started a college scholarship program to help *campesinas* who want to further their education, and plans a women's shelter in the future.

"I would like to see that the majority of the city council was made up of women," states Berrones, describing *Mujeres Mexicanas*' vision for the future. "I don't want to put men down, but it's been a long time since men have been in power. There are many women in the fields who have the ability to do other things, but they don't have the opportunity because they need training. My idea of the future: conscious city council members, preferably more women, more day care, more job opportunities and training centers for women."

This vision is shared by many of the *Mujeres*. "What we are doing is talking to women, asking them to join, explaining that we participate in many things, that helping the community is a beautiful thing," says Velez. "We would like for women to participate so that they can find their own voice, so they can be heard."

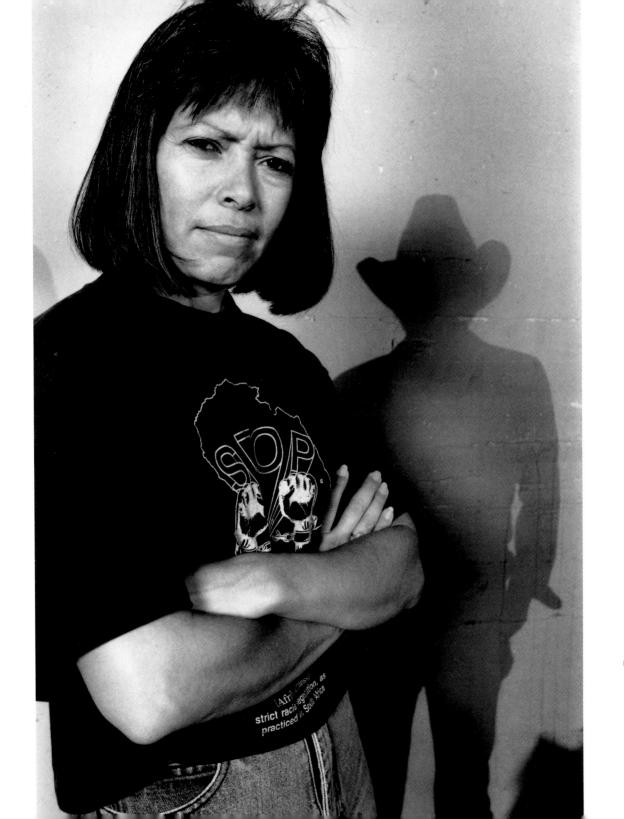

Millie Trevino-Sauceda, co-founder of *Mujeres Mexicanas*.

When I was eight years old I started working in the fields, moving irrigation pipes. We would get up at 4:30 in the morning to start work at 5:30. It was cold. After several months, I learned that my father and brothers were going to meetings to get organized. They were upset because they were working too much and the pay was very low. That summer, I found out what the union meant. I started learning that we had certain rights.

In 1980 I was pregnant. The family and my husband's relatives were working for this big company. We were organizing to renew a contract for the grape season. The ones that were organizing more were women. I was one of them. The workers were afraid to join a work stoppage or work slow. I would get up on top of those trucks where they loaded the boxes. I started yelling and screaming, trying to get everybody out. People would come out, not because I was yelling, but because I was pregnant. The growers could not intimidate me. They were afraid I would end up in the emergency room. We learned that a lot of employers, and a lot of men, don't expect women to get together.

In 1988, students from Cal State Long Beach asked me if some of us from this area could help do a survey for a thesis. I was interested because those of us who had been working with farm workers for several years could find out more about the needs of farm working women. Before, we didn't have any statistics. We learned that most of the problems were domestic violence, poor education, very bad working conditions, sexual harassment, things like that. Those of us who were working on the survey decided to form a group based on the education we got from the union. We wanted to help the Mexican-American community, especially *mujeres*.

MILLIE TREVINO-SAUCEDA

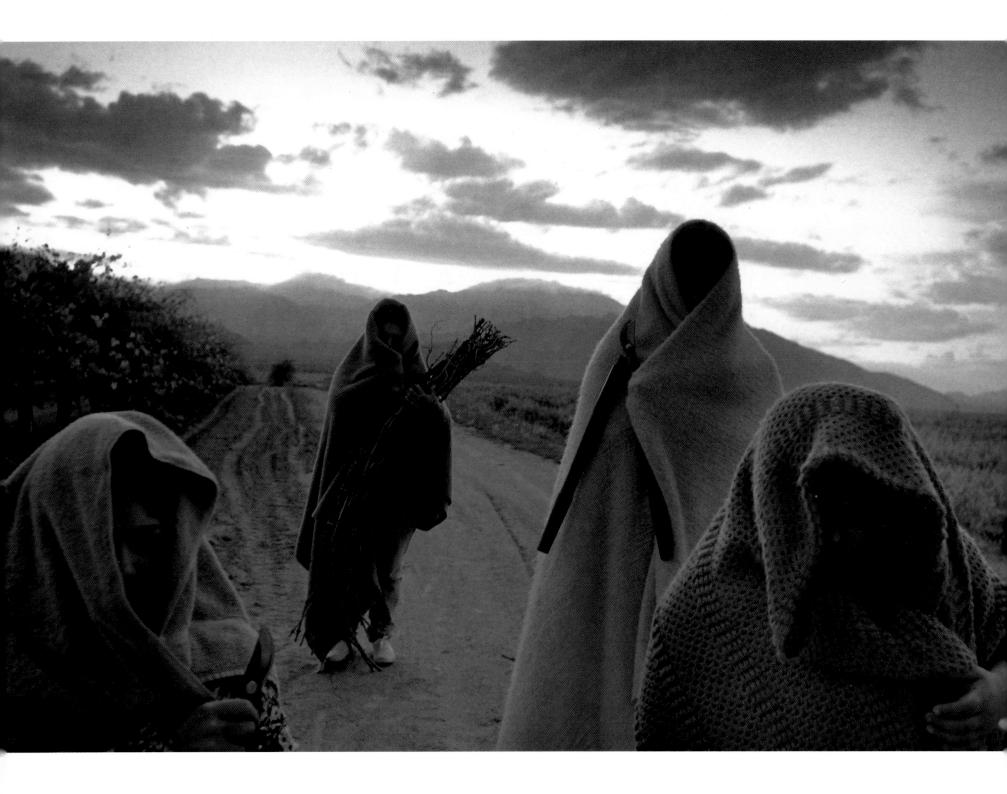

Now that my children have grown and I feel a little more independent, now I see that my old dreams might be a possibility or I can do something to make them happen for someone else or I can develop in a different way than I had imagined.

I am a farm worker. I am not embarrassed to be a farm worker. I know that my work is difficult. But many rich people eat from my labor. I work a lot and earn little. But my job is an honest job.

We have found our place within our community and even within our homes. We feel better sharing with other women and seeing the experiences of others. That makes us think, "If she can resolve her problems, why can't I?" It makes me stronger.

MARIA "CUCA" CARMONA

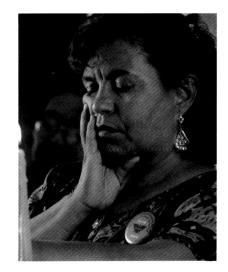

Right: Cuca Carmona at an anti-war vigil.

Left: Mujercitas Mexicanas, young members of Mujeres, waiting to begin thinning and leaf-pulling in the vineyards.

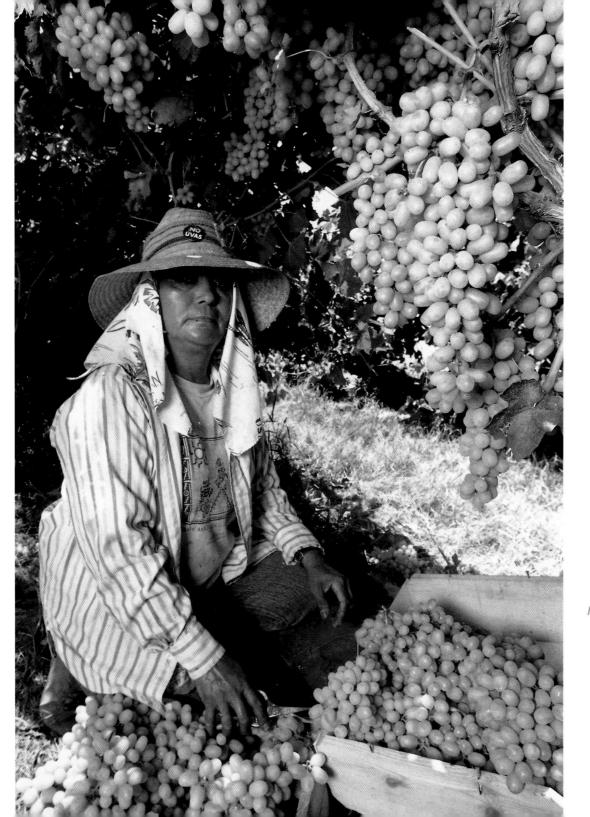

Teresa Velez, a member of *Mujeres Mexicanas* and the United Farm Workers
Union, supports the boycott of all nonunion grapes, even though she earns
her living as a grape picker.

Most of us who got married did so because our parents did not let us study, did not let us have girlfriends or boyfriends, or go anywhere. So we dreamt that when we got married, we would be free. We would be able to say, "This is my house and I'm in charge here." But we were wrong. To the contrary, marriage does not help a woman because man is against her development.

We have been used by our husbands. They get married, not because they want a person with whom they can share everything. They only share the sadness and the anger. They don't let us say what it is we want to do. We have not been allowed to feel like human beings.

My husband never supported me in telling me that I could study. When I would ask him for help with the English, when I didn't understand what people were saying he would tell me why hadn't I learned in so many years of being here? And I thought he was right. I never tried learning.

When I did try, he was angry. He said I was just wasting my time. He told me to stay home and take care of the children. I though he was right. I kept thinking how I hadn't made dinner for my husband before coming to school. So I couldn't concentrate. He has always been against my growth.

TERESA VELEZ

left my job in Mexico to come here with my husband. My children and I arrived on a Saturday morning in 1989. My sister-in-law came over and spoke to me about an elections campaign for the city council. That night there was a dinner for the three city council candidates. We were asked to distribute fliers before the dinner. There we were, just arrived in the morning, very involved in politics by evening. I can say I actually became involved with *Mujeres Mexicanas* from the first day.

When we first arrived, we made a huge scandal. My daughter didn't have a bilingual teacher. She was having substitutes who spoke no Spanish. My daughter failed [a test] because she didn't understand. What could I do?

The *Mujeres* started a big thing. We wrote letters to the Board of Trustees. I was angry. The principal did not like the way we handled it. He wanted to call off the meeting. I told him I was not asking for my daughter. It involved the entire class. They were being punished because they were speaking their language.

There was a new evaluation. They all passed. A new phase began. That's when I found that if you speak out, you can find solutions. But they will always try to keep you quiet.

Mexican women in this region are now becoming conscious of the fact that they're not alone. There are many of us. That lifts morale, pride. We are made to feel that being a woman is not an obstacle. Being a woman no longer means you can't do anything. To the contrary, we can do a lot.

Sylvia Berrones of Mujeres Mexicanas.

SYLVIA BERRONES

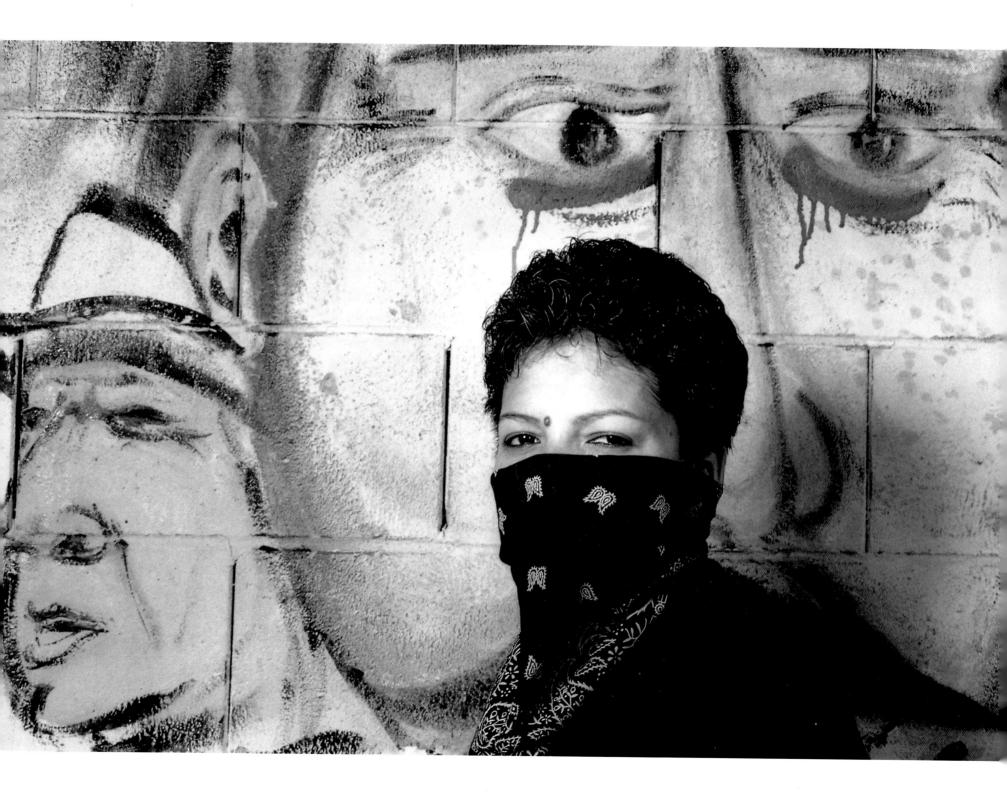

don't *feel* like a leader, I *am* a leader. We are leaders in the community. We do not have diplomas that say we're councilmen or presidents or mayors, but we are still leaders.

OLIVIA DE LARA

I have learned to feel trust in myself. I have earned much respect as a woman. I feel a lot of satisfaction to be part of a group that have made many changes, especially the changes that help women.

PETRA RUIZ

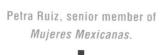

FIGHTING FOR THE CHILDREN

THE MIGRANT PARENTS ADVISORY COMMITTEE
YUBA CITY

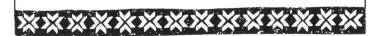

ARIA ROMERO AND NARANGAN BASSI are unlikely collaborators. Romero is a Catholic Mexican from the state of Jalisco in Mexico who speaks little English and spends up to twelve hours a day picking crops. Bassi is an East Indian Sikh from the Punjab region of India who speaks a native dialect and works nights in the canneries. However, these two women, along with dozens of other Latino and East Indian parents, are allied today because they felt that schools in Yuba City were not meeting the educational needs of their children.

Maria Romero has two children in grammar school. She believes farm-worker youth have special needs that must be considered when designing educational programs and policies. Bassi also believes farm-worker students suffer because educators don't understand the obstacles they must overcome. "Discrimination is one of the problems," says Bassi. "This discrimination problem is existing for such a long time. The administrators put children in the ESL [English as a Second Language] classes, they don't look at the ability of the child. They just put them. They feel the child is from a foreign country, a minority, they have to be in ESL without any testing to find out what is the ability of the child."

To defend farm worker-students, Romero and Bassi organized the Migrant Parents Advisory Committee (MPAC), and began protesting policies that they felt adversely affected their children. In the process, they have created a dynamic multicultural, trilingual advocacy group that is building self-esteem for both parents and children in this Northern California farming community, ending years of migrant parent acquiescence and isolation.

Karamjit Samara learns to write his name in the bilingual class at Terra Buena School in Yuba City School District.

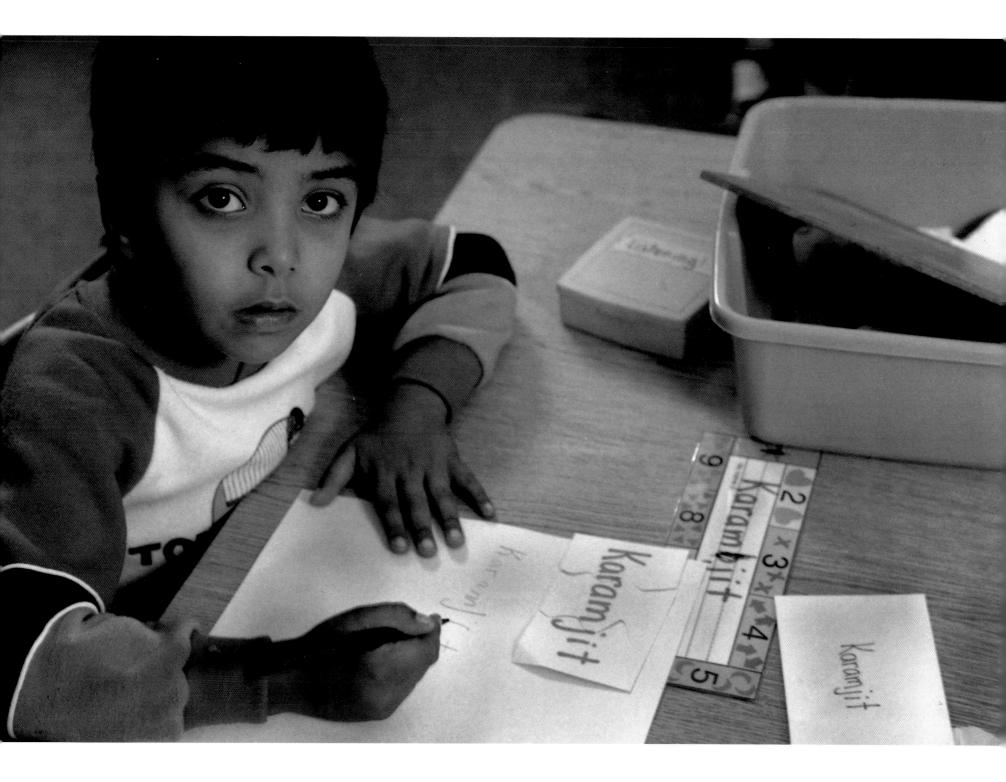

Latinos and Punjabis have never been very visible in Yuba City's political life. Most work seasonal agricultural jobs and few are able to maintain year-round employment. Food and rent define daily existence. "We work all the time," says Juanita Mendoza, a migrant parent. "During the summer the men get up at three or four in the morning. The women fix them lunch, say goodbye, and don't see them again until after dark." Romero adds, "To make ends meet, we women work in the canneries and the prune-drying sheds, or on the mechanical tomato harvesters. We go off to our jobs figuring our children will be taken care of in school. But in the afternoons, there's no one to watch them. We rely on the older children. We don't have day care. Before, we weren't involved in education. We felt we were not smart enough. We left those decisions to others."

All of that changed in 1985, when school administrators decided to cut costs on the migrant summer-school program by eliminating school breakfasts and transporting students in unairconditioned buses to unairconditioned classes located in adjacent Sutter County, where summer temperatures regularly soar over 110 degrees. Transportation is a special problem for migrant children who often live in remote areas and must walk three miles just to reach a bus stop. Improving transportation has been one of the parents' gravest concerns.

Angered and offended by the cutbacks, the Punjabi and Latino parents got together for the first time. Initially, school administrators were unresponsive to the new parent coalition. So, the parents

sought assistance from two CRLA attorneys. Parents learned they were legally entitled to meaningful participation in shaping migrant school programs and in determining how federal money would be spent. Realizing the power in numbers, the parents rapidly drew others into their coalition and within two or three days had pulled together more than fifty families.

Organizing a car pool, the par-

Children begin their school day at Terra Buena School.

East Indian children playing during recess.

ents drove to a Regional Migrant Education meeting in the nearby town of Woodland. It was a decisive moment. "We parents were very angry," recalls Mendoza. "We had been told that we were going to get an [airconditioned] facility, and then it turned out we didn't. We arranged a car pool, the whole community, regardless of ages of the children. We followed each other. We didn't even know where this meeting was. When we walked in, everyone turned around to look at us. We interrupted their meeting so we could be heard. We left with everything in writing. As a result, we had a meeting with the superintendent of Yuba City School District. They gave us the school, they provided adequate transportation and breakfast and lunch. Everything was resolved."

After this success, Latino and Punjabi parents began meeting in each others' homes, overcoming

years of cultural separation. Friendships developed and stereotypes dissolved. The group officially united to form the Migrant Parents Advisory Committee. They drafted bylaws, elected officers, and began evaluating every phase of their children's education.

After visiting classes and evaluating teachers, MPAC members compared notes. One of the first things they realized was that too many high-school and grammar-school students lost valuable school and study time because they had to take care of younger siblings while their parents worked in the fields. To rectify the situation, MPAC worked with the school district to open a preschool called *La Escuelita*. It was the first in a long list of accomplishments that has transformed migrant education in Yuba City.

First organized in 1985, MPAC is now an established and widely respected organization. Together, the parents have successfully lobbied for additional bilingual counselors and the district's first Latina principal. Parents have also helped resolve school conflicts, and inspired greater involvement from the migrant communities. MPAC members raise funds for school supplies, scholarships, and field trips through activities such as washing cars and selling cupcakes, tamales, and samozas (Punjabi meat pies). On its annual "Day of the Teacher," MPAC invites more than 400 educators to a dinner and awards ceremony in Yuba City. MPAC encourages greater cultural understanding by sending parents, supervised by Punjabi and Hispanic teachers, into classrooms on important holidays such as Cinco de Mayo, to teach children about Latino and Punjabi history and culture.

Nowhere else in California have migrant parents organized to establish such a comprehensive system of advocacy for their children and their neighbors' children. "Now we are recognized," states Mendoza proudly. "Many times a problem is not a typical school problem. Sometimes it is a fight among children, and the committee is called in. As parents, as members of this committee, not only do we look at the three-year plan, we see the needs—health needs, academic needs, art classes. That has been a great satisfaction for us."

In addition, the parents have dramatically influenced children's attitudes towards their elders. Noting the respect that MPAC members command, and the power they wield, students now regard these activist farm workers as role models. Surinder Chahal, Migrant Education resource specialist for the Yuba City School District explains, "Once the children see the parents in the classroom, whatever language they speak, they realize the ability of their own parents. Children say, 'My mom came to school today and made so many tortillas. My mom came to school today, and she taught the

Ever since I came to this country, I have not liked the way Mexicans are presented. The Mexican is presented sleeping underneath a cactus.

MARIA ROMERO Yuba City Mexican flag, the colors, and what they stand for.' The children feel proud of their mothers. That builds higher self-esteem."

But perhaps the greatest change has been in the parents themselves. Once too bashful and embarrassed to speak out, members of MPAC now have a vocal presence that is spreading to all areas of Yuba City life. They no longer worry that their English isn't perfect, or that they lack formal education. They understand how to organize the forces of community change and reach their goals. With a respected leadership, an effective organization, and a proven track record, MPAC is emerging not only as an important educational force but as a respected political power as well.

"We've extended ourselves in several things," explains Maria Romero, who is thinking about running for a seat on the school board. "We see there are other needs. We want to go farther. We see the community is growing, and with it the problems grow, too. If we can find a solution to them, we will. We're trying to make our community more solid."

Rafael and Ariana Salazar attend bilingual classes at Live Oak School in Yuba City. As farm workers we have always dreamed of seeing our children as far away from the fields as possible, with a respectable and stable economic position. It seems we are achieving that. The children are thinking ahead. They are taking their studies seriously. The dream of all of us parents is to see something better than we are.

We are waking up. The more we see, the more needs we find. We know that if we don't start something, no one will do it for us. No one will give it to us.

> JUANITA MENDOZA Yuba City

> > Juanita Mendoza and Robert Lagos (upside down) at Terra Buena School.

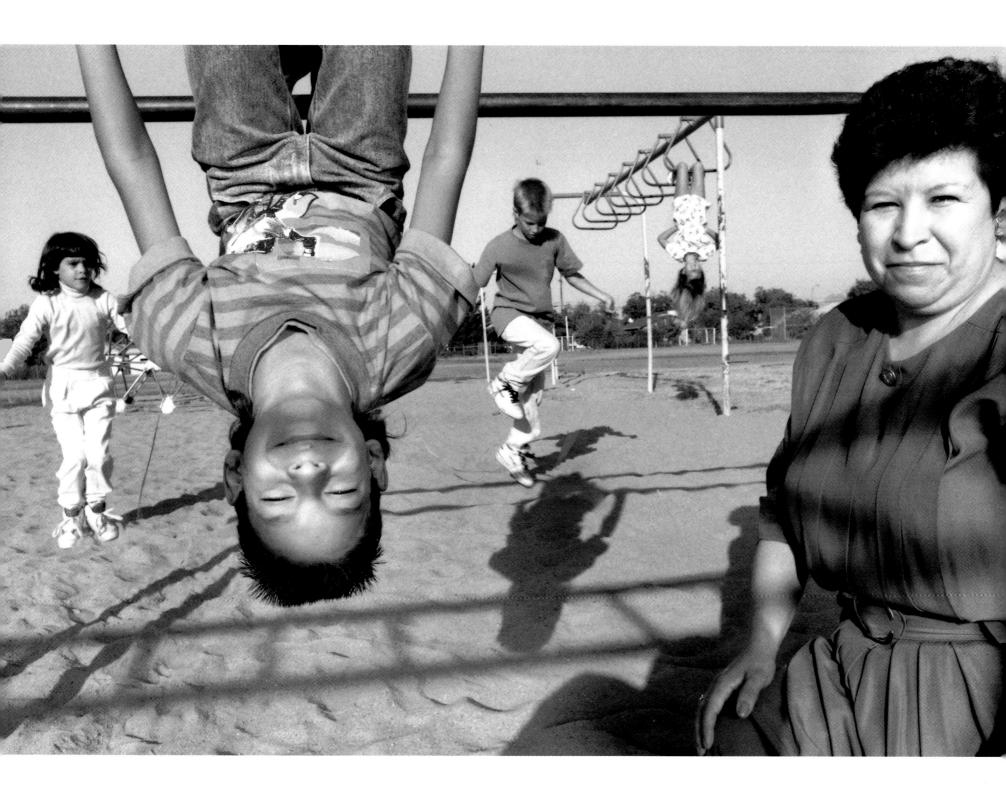

My father always told me that it was better to have a good education than money. But when we first get here, we need money. We go to the fields. Very few of us get an education. I see my husband. He works hard. I put his life as an example to the kids. My dreams are that they become professionals.

In the beginning, I thought I couldn't participate. I was in a different country. I never said anything. I was embarrassed. Now they can't keep me quiet. The beginning of summer school, I am always getting phone calls: 'Mrs. Romero, my daughter was not accepted.' 'Mrs. Romero, I have to go to work. Please look after my child in school.' The phone rings all evening. We have two lines. My oldest daughter tells me that I should just put up an office because the phone is always ringing.

I go to the schools. I go to the principal, even though my English is very poor. I can go to the superintendent. I can go to someone in the Migrant Program. The 'I'm in another country' doesn't hold me back. If I see a need, I go to the district offices, the regional offices, I don't care. If there's a problem, I go find a solution.

MARIA ROMERO Yuba City

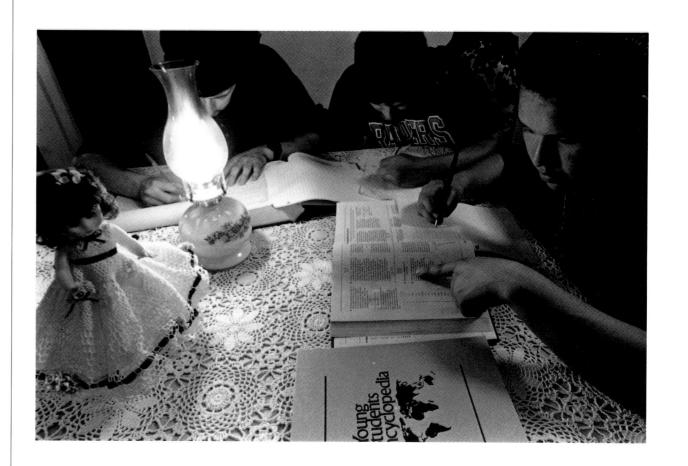

Omar Mendoza studies late at night with friends because he wants to attend college.

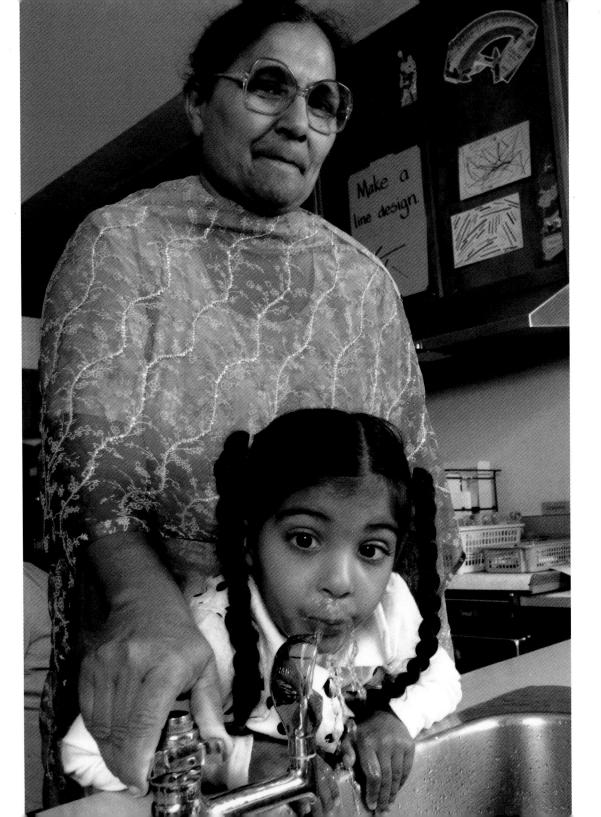

Narangan Bassi assists teachers in the Terra Buena kindergarten class.

-

A lot of parents come to me because I am an officer and I am very vocal at the meetings. I can raise my voice at somebody. If we had not raised our voice, the district would not even have known of all the problems we face. It is an achievement to make the district aware of our needs. The parents feel that they are taxpayers and their children should be equally benefited by the school district.

NARANGAN BASSI Yuba City

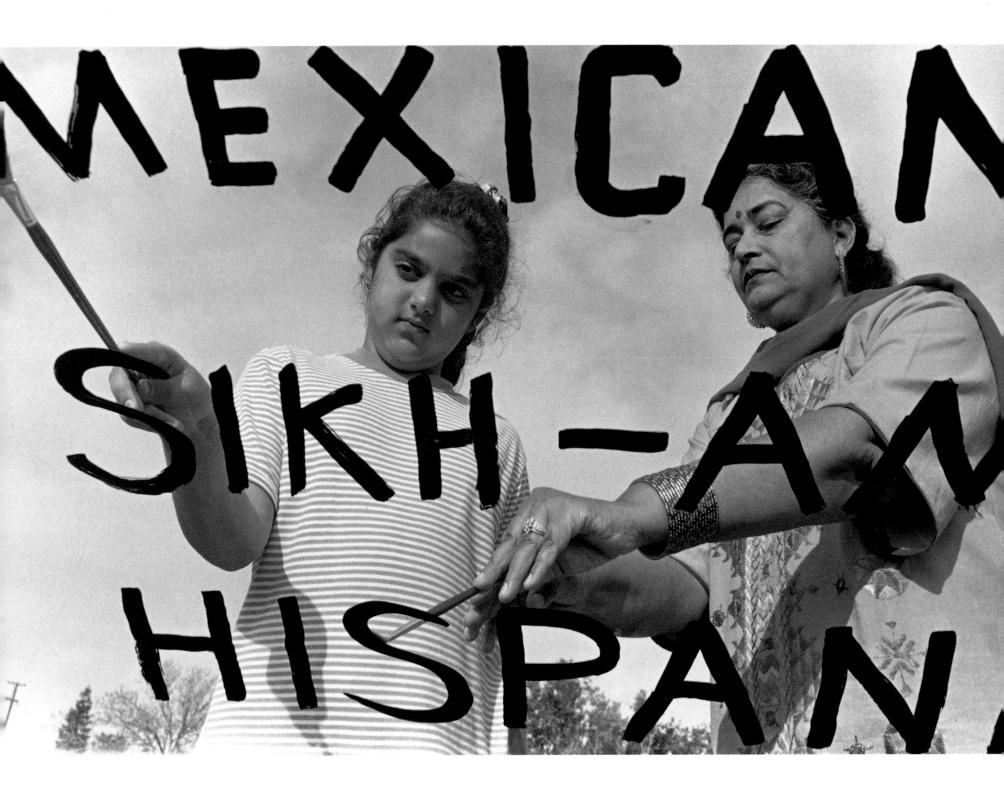

The two migrant communities, Mexican and East Indian, work very closely together. They have one goal, and they need to achieve that goal as a collective unit. They are worried about every migrant child.

SURINDER CHAHAL

Resource Specialist, Yuba City School District

Migrant education specialist Surinder Chahal teaches a multicultural lesson to Puneet Takhar. hope our story helps other parents. I hope other parents become motivated, that they won't say, "I don't know how to speak. I don't know the language." People say, "Oh, they're Mexican." But we can make a difference. Every day there are more of us.

MARIA ROMERO Yuba City

> Reyna Chavez (right), co-founder of the Migrant Parents Advisory Committee, supervises the education of her children.

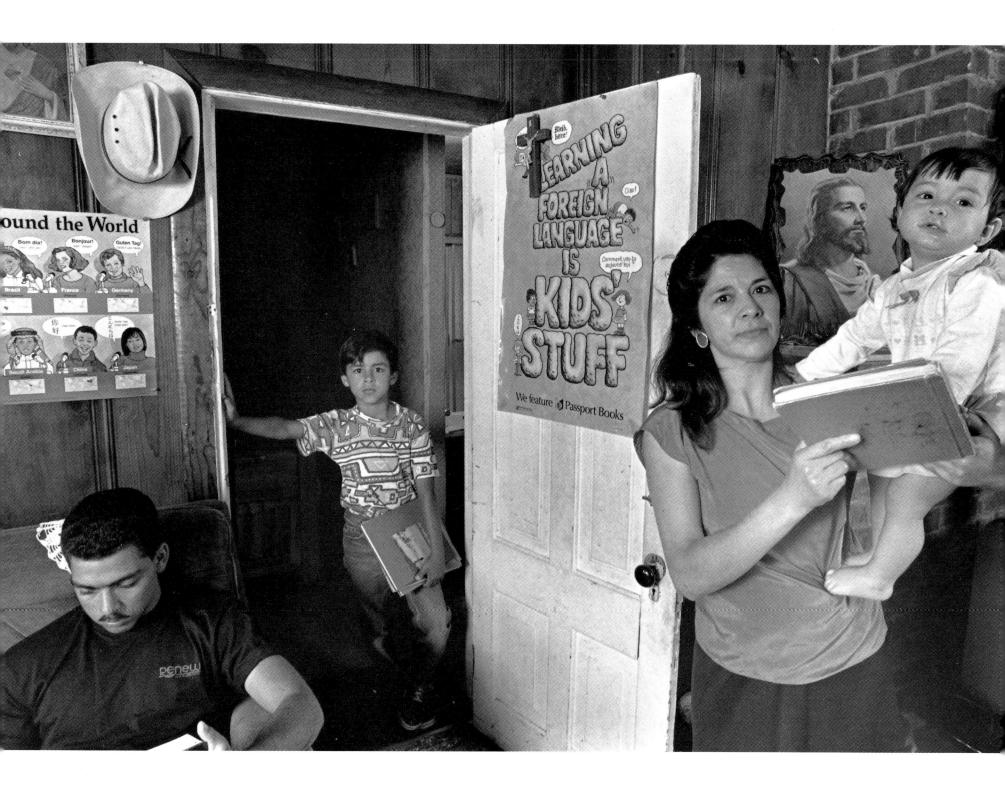

COOPERATING FOR THE COMMON GOOD

THE SANTA ELENA HOUSING COOPERATIVE SOLEDAD

VAVAVAVAVAVAVAVAV

HICK SUMMER FOG ENSHROUDS SANTA ELENA, a tidy trailer park wedged into a parcel of land between Highway 101 and the Southern Pacific railroad tracks in Soledad, California. For more than a decade, Santa Elena's pristine lawns, pastel-colored mobile homes, and clean brick community rooms have been home to the hundred Latino farm workers here who run the most successful housing cooperative in California.

The healthy, stable lifestyle of the residents of Santa Elena stands in marked contrast to the living conditions endured by most farm workers in California. Santa Elena is quiet and safe. Residents tend gardens, grow flowers, paint their trailers, walk their kids to the playgrounds, and display confidence and pride in their community.

Most privately owned farm-worker housing consists of squalid labor camps where serious health and safety violations are the norm. When officials do attempt to enforce housing codes, growers simply shut down the housing. For fear of being evicted, many farm workers are reluctant to report the horrendous conditions in which they live. Seventy-five percent of farm-worker housing in California has disappeared in the last decade, forcing workers to spend the growing seasons living in cars, caves or outside in the fields, where they lack even basic sanitation.

Santa Elena has not always been a great place to live. It was originally known as The Pinnacles Mobile Home Park for retirees, boasting reasonable rents, playgrounds, and "Deluxe 5-Star Quality." However, the mobile home park was not able to attract enough retirees to fill all the spaces. Beginning in 1974, farm workers attracted by the hope of better housing began to move in; they

Santos Zavala, co-founder of Santa Elena, and neighborhood children celebrating Day of the Dead.

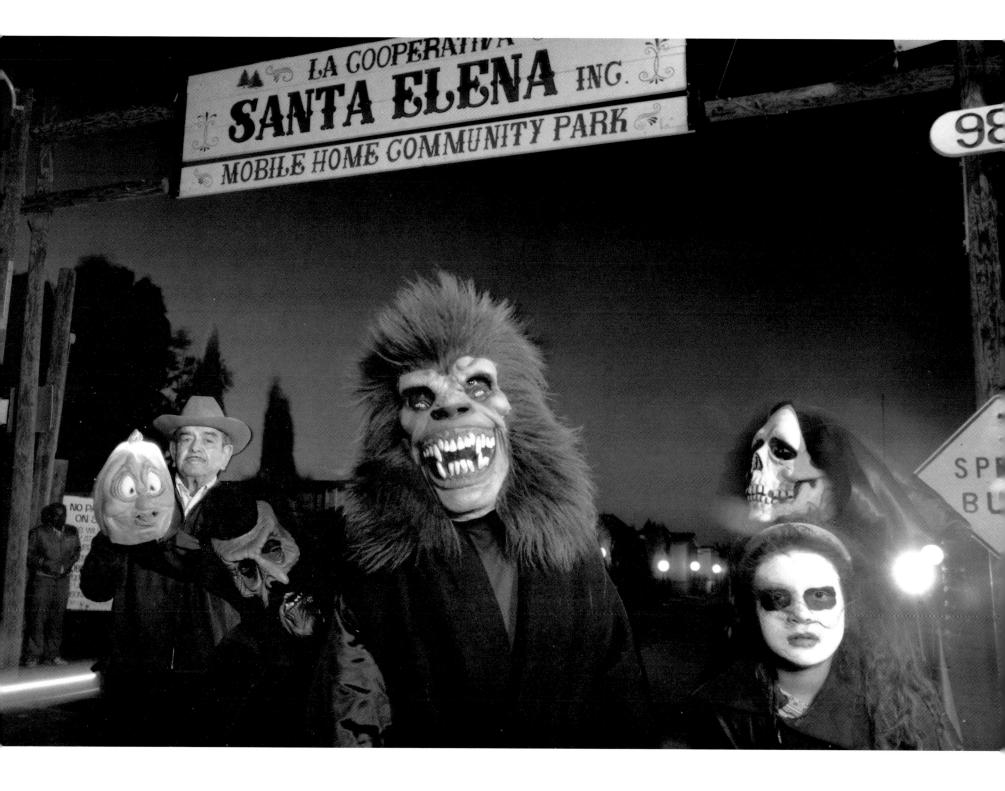

soon discovered health and safety violations similar to those in the neighboring labor camps where growers had ignored the maintenance of the camps for years.

"The rents kept going up," explains Santos Zavala, a retired irrigator who moved into the park in 1974. "There was garbage all over the place. Dogs roaming through it. I spent part of every day picking up trash. At night you had to carry a club. There was no lighting. We did not have storm drains, and lakes of water formed. You had to row a boat to get around." Residents had few options. Most families earned less than \$9,000 annually, wages that barely paid for food and housing. They didn't want to stay, but they couldn't afford to leave.

In 1978, with help from California Rural Legal Assistance (CRLA), the tenants filed a \$1.5 million class action suit against the park's owner, alleging, among other things, health and safety violations. The suit temporarily froze rent increases. However, the tenants feared that once the suit was settled, nothing could prevent the landlord from raising rents to pay for improvements. They decided that the only way to guarantee decent and affordable housing was to remove the landlord from power and purchase the mobile home park themselves. In desperation, Zavala and a handful of other tenants organized the Pinnacles Committee.

Community worker Hector de la Rosa suggested forming a cooperative. This was an unusual but exciting solution. Ruben Garcia, one of the founders of Santa Elena, did not find that the cooperative idea came naturally. "For me especially, the cooperative idea was something strange. I was more aware of the capitalistic system—owner, renter, boss, worker. We had mainly been indoctrinated in the capitalistic method." Tenants met two or three times a week for several years, conducting an extensive organizing campaign. Not everyone was enthusiastic. Skeptics said the trailer park would become a little Tijuana, a dump full of beer cans and dirty diapers. Several tenants gave away their trailers and left. One Soledad council member said uneducated farm workers could never run such an operation.

The Pinnacles tenants, with the technical assistance of CRLA and Rural Community Assistance Corporation (RCAC), were able to obtain funding from the National Consumer Cooperative Bank (NCCB), the State of California and the City of Soledad and received training in cooperative management. "The first training sessions that took place were hard to understand," recalls Garcia. "What convinced me was that the people would have control and govern ourselves. The philosophy of cooperatives moved me. It is similar to Christianity — the Apostles put all their goods in one fund

We don't have much schooling. We barely know how to read. And we work in the fields. But we try to do things well. I am proud that this is a quiet place. We try to keep it looking nice always. I hope that the educated people who do come will see that we are doing a good thing.

SANTIAGO GARCIA

and then distributed goods according to need. There are no rich or poor. That motivated me."

In July 1981, the cooperative obtained \$1.5 million in grants and loans to purchase the mobile home park. The tenants renamed the park Santa Elena in honor of Ellen Reed, the housing specialist from RCAC who was instrumental in prying funds out of the NCCB despite President Reagan's freeze on the disbursement of such funds.

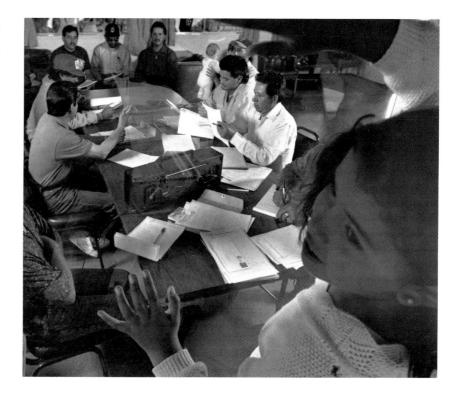

Today, most of the early

obstacles have been overcome and the cooperative enjoys a stability that people living in many privately or publicly run housing projects might envy. Inside the park manager's office, Saul Barron and leaders of Santa Elena Housing Cooperative relax on folding metal chairs and old sofas surrounding a scuffed wooden desk. The Board of Directors' meeting is about to convene to make the day-to-day decisions that keep this community together. Everyone focuses on Barron, 34, Santa Elena's current president. This serene man in jeans and T-shirt recalls the early days when the residents were just learning to run their cooperative. He talks about a day a few years ago when cooperative director Ruben Garcia was nearly killed. "We set up a rule that any member who did not come to meetings would be fined \$40," says Barron. "One of our members refused. He ended up shooting Ruben." Jorge Lopez, a founder of the cooperative, adds, "All of us who have served on this board have bitter moments. I had a brother who did not speak to me for six years because I gave him a letter about having too many people in one trailer."

A meeting of the board of directors for Santa Elena convenes while children watch through the windows. Once the meeting convenes the board hears pleas, plans, reports, stories, explanations, and even tears. A visiting representative from a local bank gets a lesson from the board in the principles of cooperative management. In the future, the bank will not be so quick to deny loans to Santa Elena cooperative members. Once the meeting is over, the positive benefits of all the rules become clear. Walking outside into the foggy Salinas Valley evening, board members are greeted by a community that is clean, peaceful, and secure.

Santa Elena's current residents are families from Mexico who used to come to Soledad only to work. "They just wanted to know who was the labor contractor and where was the next job," explains community worker Hector de la Rosa. "They came here, they did their work, they got paid, and then they went back to where they came from." Santa Elena changed that, replacing the rootless, marginal existence of camp life with a sense of belonging that comes from owning a home in an established community.

Santa Elena is successful because of the commitment and hard work of its residents. Newcomers must provide numerous references and receive extensive training in the operations and principles of cooperativism. To remain, they must participate in the cooperative by attending meetings and volunteering for committees such as the Maintenance or the Scholarship Committee. Residents

must also maintain their trailers in excellent condition.

Families, and especially children, thrive in Santa Elena's healthy environment. Along with their parents, children learn to problem-solve with patience and persistence in a community environment. Santa Elena has two playgrounds, a swimming pool, a basketball court, and a volleyball court. Children attend school knowing that if they want to continue past high school, Santa

Pouring driveway, early morning, Santa Elena. Elena maintains a scholarship fund for them. The children are free to enjoy their childhoods and dream about their futures. They have hope.

Santa Elena also provides a healthy environment for political involvement. Positions for the governing board and various committees are hotly contested. Community members go trailer-to-trailer discussing issues and soliciting support. Everyone votes. But participation doesn't stop at Santa Elena's property line. Hector de la Rosa calls this the "ripple effect." "Once people learn the way the cooperative works, it's very easy to go to city hall and say, 'I know this is the way you work also. If I run for city council, I can get elected,'" he explains. Today cooperative members serve on church committees, school boards, and citizens' groups. They run for local office and attend city council meetings.

Santa Elena's greatest clout, however, comes from the large block of votes it commands. Soledad politicians can no longer ignore Santa Elena's voting power. "They come here and sit at the table with us," explains resident Jesus Salazar. "That's a big thing. A bunch of farm workers mixing with city councilmen! For me, that's a big thing." Today, Santa Elena is one of the leading organizers of statewide cooperative conferences. Members lobby aggressively to increase funding for other cooperative projects and travel throughout California to educate farm workers.

Santa Elena's success depends on every new member being trained in the history and significance of cooperativism through an ongoing educational plan. The co-op members conduct courses in citizenship, reading, writing, and voter registration. Leaders have brought in mobile health clinics where adults and children receive regular checkups and immunizations. The county library, at Santa Elena's request, parks the bookmobile twice a week at the school bus stop where children pass rows of books before returning home.

Santa Elena residents no longer live under the tyranny of threatened evictions. They have rights and they speak out. Residents thrive in a safe, sanitary, wholesome world of their own creation. They are a part of the community, no longer the outsiders. "People used to be afraid to admit that they lived here," says resident Gilbert Cisernos. "Now, it's great when they say this place is beautiful. And my children now proudly say, 'I live in Santa Elena cooperative.'"

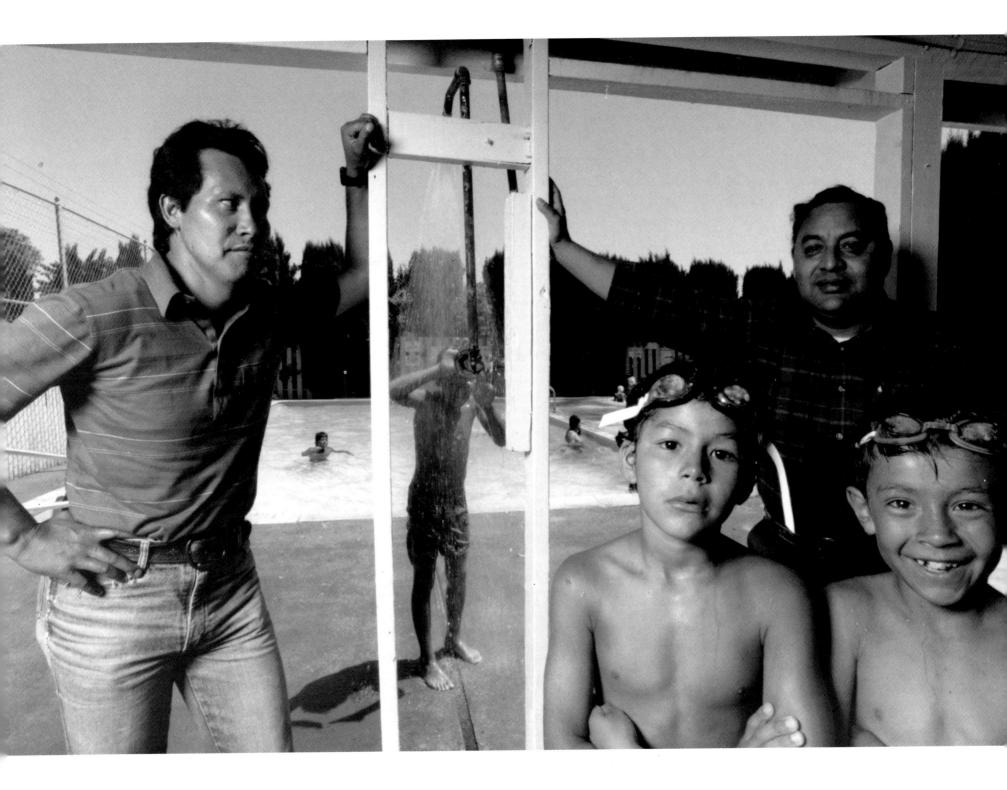

had no previous education. I did not participate in the Agrarian Reform in Mexico, but my relatives did. My great-grandfather was a leader who managed to impose the agrarian system in the town where I was born. My grandfather and my father were *ejidatarios* [cooperative farmers]. From there I learned that without preparation, without technical assistance, one can't get anywhere.

My father and grandfather lost their lands, that's why I'm here. I learned from that experience. If there is no preparation, even if they give us the land, if they give us the money, we're still going to lose the land. We need the preparation, perhaps not formal education, but technical assistance.

And that's what happened at the co-op. We were fortunate in getting good advice. A good educational system was planned that enabled us to develop in several aspects and be able to run the co-op. That's where I came in. I was trained as an administrator and I was able to learn the most basic things. That's how the co-op has been able to maintain itself. If not, the co-op, like all the rest in the region, would be weakened. With appropriate technical assistance, the Santa Elena co-op has been successful.

Ruben Garcia, the first manager of Santa Elena, and Hector de la Rosa (right), one of the co-op's founders, with twins Kickos and Kito Tinagero at Santa Elena's pool.

RUBEN GARCIA

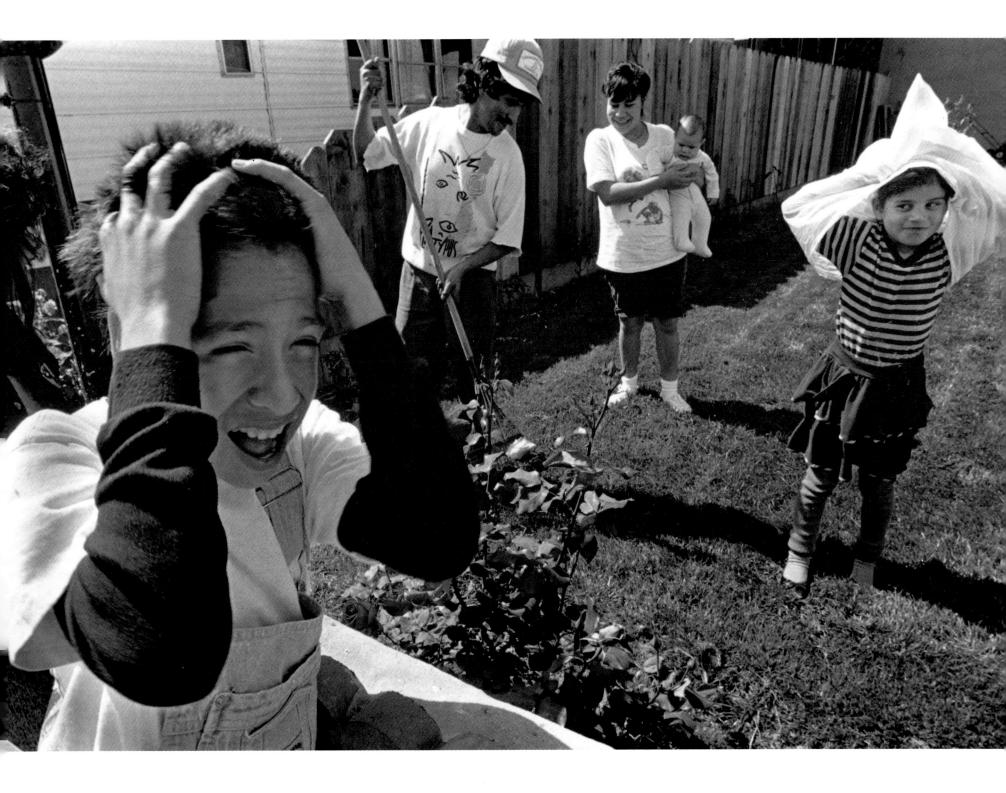

Before they were owners of the co-op, they were renters. They did not keep up the place. Who would want to build a fence around their trailer? Who would want to do improvements? They just let the place run down. After all, they were paying rent and the owner was responsible.

Now that they're owners, you can see the flowers, they're putting up brick fences. People are painting their trailers. Santa Elena has given them a sense of identity. It has given them pride. They have more dignity now. They feel that they're part of something. If you rent, you do not learn those things.

Left: Two generations of the Chavez family tend their garden on a Sunday afternoon.

Right: Noe and Ellia Caballero are new residents at Santa Elena.

HECTOR DE LA ROSA

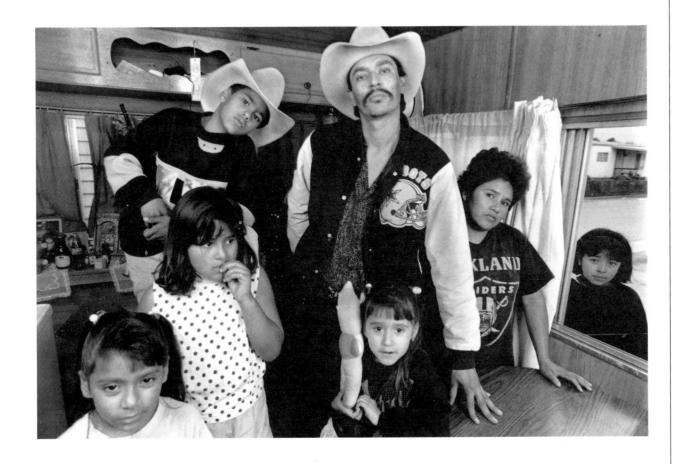

The Rodriguez family.

Many people thought it was crazy. I was one of the crazy people who went door to door asking for a donation to start raising the first monies. People rejected us. They said it was impossible to beat the landlord. And there were others who would immediately pitch in with five or ten dollars or even fifty. Convincing people was the hardest thing.

MANUEL ALCANTAR

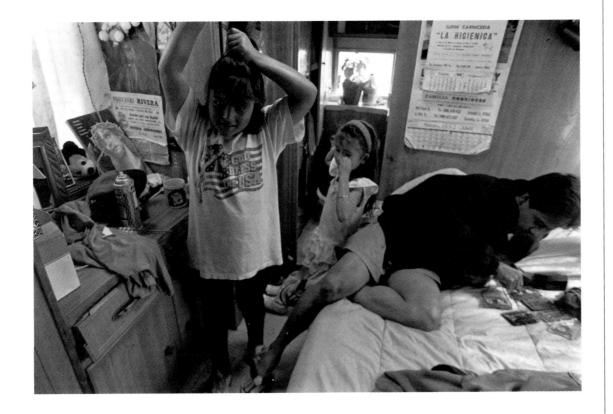

Being responsible is a big thing in the life of a human being. That's why we farm workers are down at the bottom. The lack of responsibility on the job, as a father, as a citizen, is what makes a person lose self-respect. I used to be that way. I used to be anti-social. I didn't like to share with people. I didn't think it was for me. I thought it was only for the educated. I have learned immensely. I have become a better person. I socialize more. I have learned much. At a personal level, it has helped me a lot.

JESUS LOPEZ

Every summer Maria Rodriguez's brother Luis stays with the family while working in the lettuce fields.

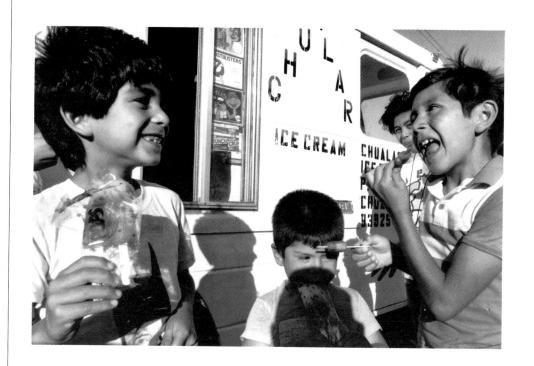

The ice cream truck arrives at Santa Elena.

None of us had any experience. It is important that people know that the need of the people was the driving force behind the formation of the co-op. The need of the people made the unity.

MARIO SALAZAR

Gladys Hernandez, 5, at Santa Elena's swimming pool.

•		

BIOGRAPHIES OF CONTRIBUTORS

RICHARD STEVEN STREET is a photographer and writer who specializes in California agriculture. His essays have appeared in publications as the *Nation* and *West Magazine*, and his photographs have appeared in numerous publications nationally such as *Life*, *U.S. News and World Report*, and *Forbes*. Street is the recipient of the World Affairs Council Award for International Journalism, the Lincoln Steffens Investigative Journalism Award, the Best Agricultural Writing in California Award and the James D. Phelan Award for Literature.

SAMUEL OROZCO is the news director for Radio Bilingue in Fresno, California. Orozco has worked on several oral history projects including *To the Promised Land*, a book describing the lives of migrant farm workers in California. For the past seven years, he has been the executive producer of *Noticiero Latino*, an internationally distributed public radio news service.

ANN WEINSTONE is a community activist and writer. Her plays have been produced in New York and Philadelphia. Previous publications include *Self Help: In Our Own Words*, an oral history of eight low-income New York City tenant associations, of which she was the editor.

SARAH LEVIN is a graphic designer based in Berkeley, California. She specializes in book design, and was the art director for the journal *News from Native California* for several years.

GRACIELA OROZCO is a bilingual educator with a masters degree in school counseling. Born in Texas of farm-working parents, Orozco grew up on a farm in the San Joaquin Valley in California. For more than ten years she has been involved in community radio, primarily as a programmer for Radio Bilingue.

SUPPORTERS

Marco Antonio Abarca

Ralph Abascal

Margarita Altamirano

Maria de Anda

Adrian S. Andrade

Ramon Arias

Pauline Armstrong

George R. August

Victor Barajas Gloria Barrios

U D C

Yvonne E. Campos

Luke Cole

Comite de Madera

Clare M. Conk

Breda Courtney

Edgar Diaz

Deborah Escobedo

Pablo Espinoza

Charles Farnsworth

David Fielding

Judith Anne Fiskin

Robert Fries

Pauline Gee

Martin Glick - Howard, Rice,

Nemerovski, Canady,

Robertson & Falk

Max Gutierrez, Jr.

Antonia Hernandez

David Hernandez

Hernandez & Ramirez

Stephen Herzberg

Douglas Keegan

Pauline Kim

Richard S. Kohn

A. Diane Leka

Benjamin M. Lopez

Nancy Martinez

James Mattesich -

Livingston & Mattesich

Susana Medina

Mark Miller

Margaret & Osmond Molarsky

John Patrick Moore

Bea Moulton

Baldwin Moy

Holly Myers

Bernadette Nunez

John O'Toole

Iose Padilla

Frank T. Ramirez

Julio Ramirez

Hermenegildo Regalado

Honorable Cruz Reynoso

Marco Antonio Rodriguez

Ramon Romero

Isidoro Romero

Roberto de la Rosa

Stephen Rosenbaum

Samuel Salgado

Teresa Sandoval

Dee Schilling

Chris Schneider

Brad Seligman

Elisa Snedden

Marion B. Standish

Michael Stern

Casimiro Tolentino

Juan Torres

Tom Unterman

Jose Angel Velasquez

Marta Vides

Jose P. Villarreal

Peter Weiner -

Heller, Ehrman, White

& McAuliffe

	." *			

OTHER TITLES AVAILABLE FROM NEWSAGE PRESS

The New Americans: Immigrant Life in Southern California by Ulli Steltzer

Family Portraits in Changing Times by Helen Nestor

Stories of Adoption: Loss and Reunion by Eric Blau

Exposures: Women & Their Art by Betty Ann Brown and Arlene Raven Photographs by Kenna Love

A Portrait of American Mothers & Daughters by Raisa Fastman

Women & Work, Photographs and Personal Writings by Maureen R. Michelson Photographs edited by Michael Dressler & Maureen R. Michelson

Common Heroes: Facing a Life Threatening Illness by Eric Blau

FORTHCOMING BOOKS

When the Bough Breaks: Pregnancy and the Legacy of Addiction by Kira Corser and Frances Payne Adler (April 1993)

The "C" Word: Teenagers and Their Families Living with Cancer by Elena Dorfman (August 1993)

SPEAKING RULES!

Classroom games, exercises, and activities for creating masterful speakers, presenters, and storytellers

Cathy Miyata

Pembroke Publishers Limited

Dedication

This work is dedicated to Susan Jessica Rogers, in loving memory, for laying my foundation in creative and exploratory work, and to Bob Barton, for guiding me along the way.

Acknowledgments

The story "Ellie Mitchell Meets Death" is from the Canadian Children's Annual, courtesy of Potlatch Publishing, 30 Berry Hill, Waterdown, Ontario LOR 2H4

The story "The Wife Who Ate Nothing" is courtesy of Masako Sueyoshi, storyteller, Sakura City, Japan.

The poem "Dark Moment" is courtesy of Jim Bennett, poet, Toronto, Ontario.

I would like to acknowledge my editor, Kate Revington, for her skill and insight and the continued support of my writing group, Lynda, Sylvia, Gisela, Rachel, Estelle, Jim, Steve, Ann, Nan, and Sue. Bless you all.

© 2001 Cathy Miyata Pembroke Publishers

538 Hood Road Markham, Ontario, Canada L3R 3K9 www.pembrokepublishers.com

Distributed in the U.S. by Stenhouse Publishers 477 Congress Street Portland, ME 04101 www.stenhouse.com

All rights reserved.

No part of this publication may be reproduced in any form or by any means electronic or mechanical, including photocopy, recording, or any information, storage or retrieval system, without permission in writing from the publisher.

We acknowledge the financial support of the Government of Canada through the Book Publishing Industry Development Program (BPIDP) for our publishing activities.

National Library of Canada Cataloguing in Publication Data

Miyata, Cathy, 1956-

Speaking rules! : classroom games, exercises, and activities for creating masterful speakers, presenters, and storytellers

C2001-901391-4

Includes bibliographical references and index. ISBN 1-55138-132-X

1. Public speaking. I. Title.

Editor:

Kate Revington

Cover Design:

PN4086.M59 2001

John Zehethofer

Cover Photo:

PhotoDisc

Typesetting:

Jay Tee Graphics Ltd.

372.62'2

Printed and bound in Canada 9 8 7 6 5 4 3 2 1

Contents

Introduction: Public Speaking — or Death? 7	
Facing the Fears 7	
How to Use This Book 8	
Preparing to Meet the Demands of an Audien	ice 10
Approaching Oral Communication Strategica	illy 10
Understanding the Art in Technique and Skill	11
Watching for Related Benefits 11	
Never Too Much Practice or Praise 12	

Part A FOCUS AREAS IN ORAL COMMUNICATION 13

1 Imagining 14

The Foundation of Creativity 14
Understanding the Imagination 15
In Touch with the Imagination 16
Pre-test: Recalling Dreams 17
Preliminary Exercise: Tuning In 17
Imagining Exercises 19
Using a Story for Imagining 26
Curriculum Extensions: Writing 31

2 Listening Actively 33

Responsibilities of the Listener 33
Pre-test: Checking Perceptions 34
Technique: Positive Body Listening 34
Technique: Giving and Receiving an Image 35
Technique: Questioning 37
Curriculum Extensions: Responding to a Speaker 38

3 Remembering 41

Remembering Versus Reciting 41
Begin with Storytelling 42
Pre-test: Retelling a Story 43
Strategies for Remembering 44
What to Do About Forgetting 45
Overcoming the Terror of Forgetting 47
A Time for Recitation 48
Curriculum Extensions: Mapping 49

4 Developing Rapport with an Audience 52

Recognizing the Audience 52 Pre-test: Making Eye Contact 53 Technique: Eye Contact 53

Technique: Audience Participation 57

Curriculum Extensions: Call/Response Patterns 59

5 Using Body Language 62

Sending the Right Message 62 Pre-test: Telling It Straight 63

Technique: Stance 63

Technique: Facial Expression 66

Technique: Gesturing 67

Curriculum Extensions: Miming 69

6 Exploring Voice 71

Discovering What the Voice Can Do 71

Pre-test: Talking Off the Top of Their Heads 72

Vocal Warm-ups 72
Technique: Volume 73
Technique: Pitch 75
Technique: Pace 75

Technique: Use of Silence 77

Curriculum Extensions: Making Sound 79

7 Showing Composure 83

Managing Nervous Energy 83

Pre-test: Body Language — Deliberate or Uncontrolled? 84

Technique: Controlling Fidgets and Fright 84

Technique: Effective Openings 87 Technique: Polished Endings 88

Technique: Relaxation 89

Curriculum Extensions: Moving in Response to Cues 90

8 Improvising 94

A Safety Net for the Public Speaker 94 Pre-test: Getting Down to Business 95

Technique: Spontaneity 96 Technique: Focus 97

Technique: Decision Making 100

Curriculum Extensions: Acting on Short Notice 102

9 Interpreting 105

The Meaning Behind the Words 105

Pre-test: Making Meaning 105

Technique: Tone 106 Technique: Attitude 108

Curriculum Extensions: Setting the Mood 108

10 Critiquing *112*

Critiquing Versus Criticizing 112

Pre-test: Checking for Subjectivity 113

Preliminary Exercise: Building a Criteria Base 113

Technique: Nonjudgmental Critiquing 114 Curriculum Extensions: Rapping 115

Part B PERFORMANCE MATTERS 119

11 Evaluating Oral Language Performance 120

Working with a Rubric 120 Peer Evaluation 121 Self-Evaluation 126 Reflective Evaluation 129

12 Developing Content for Performance 130

Purpose Backed by Passion 130
Selecting a Speech Topic 131
Selecting a Story 131
Managing the Length of the Material 134
How to Write a Speech 135
How to Use Cue Cards 135
Developing a Relationship with the Material 135
Knowing Your Audience 135
Matching Passion with Receptivity 136

13 An End ... and a Beginning 140

Raising the Stakes 141
Arranging for a Practice Audience 141
Choosing the Best Time for Performance 142
Making the Performance Something Special 142
Coaching Performers 143
Performing Outside the Classroom 143
Public Speaking for Life 144

Appendix: Stories for Students to Tell 145

Professional Resources 150

Index 151

Introduction: Public Speaking — or Death?

"I'll work with you for eight weeks," I announced as the Grade 6 class eyed me warily, "and at the end of the project, each one of you will make a five-minute presentation to the class. Alone."

As my words sank in, the boy in the front row let his head droop forward. The small, nose-studded girl at the back gasped and moaned. The tall dreadlocked boy to my right stared out the window. A tension crept over the students, thick and heavy like an unseen fog. Fear was etched on their faces. Their unvoiced thoughts screamed at me across the room. "She wants us to get up in front of the class and talk!"

I cleared my throat and tried a new approach. "Did you know that the number one fear of most people in North America is death?" They all stared at me blankly. "Do you know what number two is?"

Some of the students shook their heads. One boy nodded.

"What?" I asked him.

"Public speaking," he answered, his voice as hard as the fist he had clenched.

I smiled. "That's right. Which puts our project right up there with the Grim Reaper, doesn't it?"

"I'll take number one," the boy directly in front of me muttered and laid his head on the desk.

Facing the Fears

And that just about sums up how most students regard public presentations. Standing up in front of an audience to speak makes them feel intimidated and threatened. They fear embarrassment and humiliation, they risk having their self-esteem marred, their desire to take risks may be strangled, and headaches, stomach aches, nervous twitches, and anxiety attacks may afflict them.

Public speaking is perhaps the hardest thing teachers expect students to do. As educators, we never expect a student to climb up on a balance beam and execute a front flip without serious preparation. So why would we expect the same student to stand, exposed and vulnerable, in front of an equally unprepared audience of peers to entertain them?

"Courage is resistance to fear, mastery of fear — not absence of fear."

Mark Twain

Speaking Rules! is about enabling students to feel confident and in control, giving them the tools, techniques, and guidance they need to become successful public speakers and effective communicators. It will allow both you and your students to face the fears associated with public speaking and to reap the benefits of empowerment. Witnessing the changes in students after only a few games and exercises is exciting. Their eyes shine, they smile, and they lift their heads higher. They laugh together and begin to take risks.

In public speaking, risk is everything. The dangers of embarrassment, ridicule, and judgment by peers make students uncomfortably vulnerable. But they have to risk trying if they are going to grow in self-confidence, build self-esteem, and command respect.

It's funny, but most people who fear public speaking can't even define what makes them afraid. They just are. It's not as if their lives are being threatened. Nothing terrible will happen if they stand up and speak. Yet the terror is real.

Facing the fear is the challenge. As Franklin Roosevelt so aptly put it, "The only thing we have to fear is fear itself." But how does one face the fear?

You can help your students handle risk. When my sister decided to attempt whitewater rafting, my entire family howled with laughter. She was the biggest chicken, and none of us could imagine her trying such a thing. The instructors, however, dealt with fear and risk all the time. They knew how to progress the rafters as they were ready. Participants were given choices of risk levels represented by numbers: one was a slow-moving creek and six was Niagara Falls. For some, number one was all they could handle at first, but others would start at five. Everyone had to start somewhere to overcome the fears and move up the number scale. Public speaking is no different.

Students will enjoy the heady triumph of communicating well and commanding an audience's attention, moving up the risk scale one step at a time. They will face the fear of feeling vulnerable and discover it is only a slow-moving creek. Eventually, they will take the risk of a not so smooth ride and learn to work harder at the skills that keep them in control. They will plunge into deeper and frothier waters, trying new techniques and skills with greater and greater confidence in what they can handle. Who knows . . . perhaps one of them will go for the falls.

This book also addresses the issue of developing respectful, aware, and knowledgeable audience members. Speaking and listening are partners in communication. Both require skills and training, not just good manners. Next to reading, no other set of skills will serve students better than being able to speak and communicate well. These life skills will always be in demand.

How to Use This Book

Speaking Rules! presents ten focus areas that develop the techniques necessary to speak and listen effectively:

- imagining
- · listening actively
- remembering
- · developing rapport with an audience
- using body language
- · exploring voice
- showing composure

- · interpreting
- improvising
- · critiquing

These appear as Chapters 1 to 10 in Part A of the book.

The developmental strategies in each area are designed to work with students from Grades 4 to 12. It is not necessary for your students to explore every game in every area to obtain successful results. You may find your class is very strong in one area, such as interpretation, yet weak in another, perhaps body language. Even within one area, students might have varying skills and strengths. For example, in the chapter on exploring voice, your group might not need instruction in pace and pitch, but could benefit from training in the use of silence.

If you are unsure whether the class requires development in a certain area, use the appropriate pre-test to help you determine the group's strengths and weaknesses. Feel free to choose exercises according to their needs and your objectives. Sometimes, you might let the group decide what they want to work on. Often when I ask classes what they feel they need, they say "overcoming stage fright." As a result, we spend more time on learning techniques in composure.

Each of the ten focus area chapters is composed of five parts:

- an introduction, which provides background information, anecdotes, and suggestions, as well as an overview of techniques and skills related to that area;
- a pre-test, which permits an observational or check mark assessment of a class's strengths or weaknesses in that area;
- developmental strategies, which include games intended for a variety of partners and teams, class activities, and partner and small-group exercises to strengthen and develop specific skills and techniques;
- curriculum extensions of the games, activities, and exercises; and
- assessment prompts for both teacher and student.

Where these focus areas fit into the curriculum

Exploration, development, and evaluation of oral communication skills are part of a basic language arts curriculum. For some school boards, one-third of a student's term mark is assigned to oral communication. A commitment of only fifteen to twenty minutes a week, throughout the school year, would make a difference in a student's development.

These skills can also be introduced through a special five, eight, or ten week oral language term project. The finale could be a special presentation. If a number of classroom teachers, perhaps the Grade 4 team or the whole intermediate division of the school, is willing to commit to the project, many more avenues for sharing, practising, and developing open up for students.

But these strategies do not have to be limited to classroom time. They can also be incorporated into an ongoing drama program, highlighted in a careers unit, implemented in a guidance or personal improvement course, or added to an extracurricular leadership training program. There are many ways to approach and enjoy effective communication.

"I needed more time learning my story."

Molly, Grade 5

"We needed more time working on the middle of the performance, not just the beginning and the end."

Bryan, Grade 9

Some Avenues for Performance

- A traditional public speaking contest
- · A storytelling festival
- · A poetry show
- · A liars' contest
- · A riddling duel
- · A joke telling session

Preparing to Meet the Demands of an Audience

Like any complex art or trade, the learning and development of the art of pre-

sentation should be approached in stages. You cannot play a flute concerto until

you understand which end of the instrument to put to your lips, where to place

your fingers, and what notes to play, and then you have to practise a *lot*. Oral presentation is no different. Simply telling a student to stand in front of an audience, remember what to say, sound interesting, and look at the audience while he is up there doesn't work. The instrument the student is playing is his own body, tuned with his emotions, and when an audience is present, that instrument

"I needed your encouragement. Now, I can make a presentation."

Hana, Grade 9

I have come to define an audience as eight people or more, or the number of people it takes to make you raise your voice enough to keep their attention around a dinner table. If only four are at the table, you can carry on a conversation with unduly straining the voice, adding gestures, or standing. Add two more people and you have to adjust slightly. Add four more people and you feel pressure to "enlarge" yourself. Suddenly, you may feel uncomfortable, centred out, and obliged to force your voice and consciously look around the table to include all possible listeners. If you cannot enlarge yourself enough to "entertain" the group, the group will break into smaller pockets of conversation and the members will entertain each other.

An eight-person audience may seem small, but it produces stress and every eight added to that audience demands that much more of the speaker. Therefore, placing a student in front of a whole class of maybe thirty to forty peers right away demands far too much of the individual. Many of the games and activities in Part A call for partner or small-group work. Working in these groups will allow the students to experiment and practise specific techniques used in presentation before they have to face a full audience. The groups are then systematically expanded to allow the students to adjust. Bear in mind that some games and techniques can be practised only in a group larger than five because the technique needs a larger audience to be fully realized and mastered. Simple strategies such as rehearsing in front of a younger audience and presenting as part of a team are explored in Part B.

"I liked the way you did not put people on the spot and let us work in small groups."

Amar, Grade 10

Approaching Oral Communication Strategically

Effective communication does not just happen. It is the result of a complex set of skills that are developed, refined, practised, encouraged, and adapted to suit the circumstances. Some students refine their skills quite naturally. Consider your current class clown. This student knows how to get attention and keep it, entertain a group, and even make them laugh. But can these "skills" be redirected to a more appropriate set of circumstances? Absolutely. Ah yes, I hear you saying, but that student has a gift (as inappropriate as it may be). What about my painfully shy student, my ESL students or even my non-reading Special Ed. students? How can they cope with being the centre of attention? It is the last thing in the world they want.

Well, they can learn to enjoy the experience if the subject is approached strategically. Students need to be assured that they will not be thrown in front of their peers without serious preparation, guidance, and support. As you work with the program that I present in this book, I recommend that you post charts and lists around the classroom as reminders of skills and techniques being

"I learned how to tell [stories] using expressions and Axshons. I can use it [the skills] by telling a story and making ser that my audience is lisnin. That has relley helped me. When I tell something to my brother he says shut up. But now he listens to me."

Gillian, Grade 5, Student with Special Needs developed. Also, having students keep a response journal to record their reactions and progress through the different strategies will promote personal reflection and further assessment.

Understanding the Art in Technique and Skill

Throughout the book I refer to the development and implementation of certain techniques and skills. The words are used synonymously in the dictionary and thesaurus, yet there is one distinct difference worth pointing out.

"Skill" is an Icelandic word that represents a learned practice. Tradespeople and professionals who are competent in their fields are considered skilled. They do their work well and probably make executing the moves needed look easy. That is why we, as adults, ask for experience when we look for a roofer, a bricklayer, or a surgeon.

The roots of "technique," however, come from *technic*, a Greek word which represents the branches of learning in the arts. The genius technique of a painter, musician, or actor sets them apart from others in their field as masters or stars. Therefore the word "technique" refers to the artist.

I will use the words technique and skill synonymously despite their differences in origin and meaning: I feel any trade, profession, or business has brilliant stars, not just the arts. However, be aware that the ability to speak and present, as Aristotle pointed out to us, *is* an art. You will have students who will shine and emerge as gifted and talented. Time after time, I have witnessed non-readers and students with special needs, dyslexia, and even identified AD/HD thrive in the oral traditions. They couldn't read or calculate, but oh, could they perform. All students will benefit from the experiences provided, all will gain confidence and improve the skills necessary to cope with the demands of public address, but some will be stars. Let them be. They will serve as models for the other students and you will enable them to blossom in the talents they came with, but which are often ignored or left buried in the educational system.

Watching for Related Benefits

Many of the games and exercises provided are closely linked to literature and literary practices. Teachers I have worked with found their students' ability to interpret stories, write creatively, and understand literature improved after using the games and exercises. Even an interest in reading folklore developed. Watch for these direct spinoffs as you move the students through the different focus areas (Chapters 1 to 10), as well as many other positive changes.

"Focus on oral language directly impacted the students' written language skills."

Mr. Peters, Grade 5 Teacher

"There has been a real change in the kinds of literature that is used in the library."

Mrs. Howlette, Teacher-Librarian

"[My students] became more open and in tune with their own and others' feelings."

Mrs. Farrow, Grade 8 Teacher

"There is no doubt that they have all improved their communication skills, but, more important, I think they respect one another's abilities a lot more now."

Mrs. Pantry, Grade 9 Teacher

"Students were asking to do another story — enthusiasm was extreme even among the most hesitant. Confidence skyrocketed and reading interest did as well."

Mr. Simmons, Grade 6 Teacher

Never Too Much Practice or Praise

Even though a student may appear to have mastered a technique (like eye contact) but his classmates have not, it will not slow his progress to take part in games or exercises practising that technique with his classmates. In oral communication, every time group members are shuffled, the dynamics of the interaction change so profoundly that the student will remain challenged. Furthermore, many of the games provided foster several skills simultaneously: even though the focus may be eye contact, other skills will develop at the same time.

Often a student is unaware she has developed a particular communication skill. Unlike the reading or mathematics skills practised daily, her oral skills were never pointed out. It may never have occurred to a student that looking someone in the eye is a technique used in building a relationship with an audience or that pausing before the punch line of a joke is a skill called *comic timing*. Pointing out this ability and praising a student's natural talents will validate her unique strengths and encourage further use and development of them.

An indication that the student has achieved some success in a certain skill is her comfort in using it. When asked about practising the skill in a game or exercise, the student might simply observe she did not find it uncomfortable or hard to do.

Acknowledging the ease with which a student demonstrates a skill as she progresses through the activities will allow her to climb the ladder of small successes. One small achievement after another, rung after rung, builds the confidence needed to get to the highest rung — self-fulfillment.

"It was hard, you know, looking right at someone to talk."

Jason, Grade 4

"I thought it was easy!"

Beth, Jason's partner

PART A Focus Areas in Oral Communication

Preparing students for public speaking calls for students to explore the *relation-ships* that language facilitates rather than language itself. Indeed, the dual thrust of public speaking is relationship building and communication.

Public speaking is more demanding and stressful on an individual than exploring expressive language. When students explore expressive language, they play with language through choral speaking, chanting, story drama, participation stories, soundscapes, skits, and more. The structure, or model, often used to develop expressive language begins by engaging students in non-threatening whole-group activities. Then the students graduate to smaller groups where more demands are placed on individual members to contribute independently.

Expressive language activities can help prepare students for public speaking on a different level than the program offered here, but are not essential. They can also serve as warm-ups to start off an effective oral communication session.

The model for public speaking, however, is the reverse of that for expressive language. The ten focus area chapters introduce activities, games, and exercises in partners or trios, *not* for the whole group. Students can thereby experiment with and develop techniques without emotional stress or strain on the voice or body. Instead of maybe forty eyes staring at one student, there are only one or two pairs. (See a graphic representation of the model on page 119.)

Once the students have practised several games and activities from various focus areas, they can move on to slightly larger groups. They can do the same games and activities with the new groups, while adjusting to a larger listening audience. Then, new games and activities designed to develop skills realized in front of a larger audience can be added. Executing the "sweep," an advanced eye contact technique, is an example.

Performance is, of course, the final stage of this model for public speaking. Here, in Part A, the book focuses on stages 1 and 2 of the model; Part B focuses on stage 3. CHAPTER 1 Imagining

In my mind's eye, I could see that golden ring. It didn't exist, at least not in our world; it was only a word in a story, a figment of my imagination. Yet, when I reached out my hand, as if to touch it, every eye in the audience looked at that ring in wonder. I was flabbergasted at the suspended reality created in that moment. For those few seconds, we all existed together in an imaginary state, as one creative mind, seeing the unseen.

The Foundation of Creativity

What, you may be wondering, has imagination got to do with effective communication? . . . Everything. Imagination is the foundation for all creative thought and creative work, in giver and receiver. Dynamic speakers know this and use the power of their imaginations during the preparation process, delivery, and later in analysis of the presentation. They also cleverly engage the imaginations of their listeners in every way they can. In *Speak and Grow Rich*, Dottie Walter relates this story about using one's imagination effectively:

As I stood terrified on the stage that night, I began to visualize my home. I saw myself tucking my children into their beds with a soft pink blanket our family called our comforter . . . In a flash, I filled the whole auditorium with the comforter in my mind. Then I smiled and began. I received four standing ovations and five additional bookings that day.

Walter used her imagination to gain composure, but it can also affect improvisational skills, memory, body language, vocal expression, and the ability to interpret and select material. And that is not all. Imagination also serves as the cornerstone of active listening. After Walter accepted her standing ovations and additional bookings, her story continued:

After [the presentation] a woman came back stage and said, "How did you arrange to get that pink light into the auditorium? It was so pretty!" There was no pink light. She saw the loving comforter I had visualized. There is power in thought. As Anatole France, a Nobel Prize winning writer, declared, "To imagine is everything."

"When I hear stories, I can dream awake."

Mohamed, Grade 4

In short, imagination influences almost every aspect of effective communication. Exactly how the imagination can assist your students in areas such as composure, memory, voice, and more will be dealt with in Chapters 2–10. But before those areas are tackled, you should understand what the imagination is, how to get in touch with it, and how you can use it in different ways. For each exercise provided in this chapter, there is a link to a specific focus area. The follow-up for each imagination exercise emphasizes that students express aloud what they saw and felt. This type of vocalizing is completely safe as no student can be wrong — the imagination is perfect. The key to building confidence is self-expression.

Understanding the Imagination

The imagination never shuts off. It is running when you are asleep and it is still running when you are awake. People tend not to pay much attention to it when they are awake. Unless they are prone to daydreaming or fantasizing, they are too distracted by the sights, sounds, and sensations of the world around them as they move through their day. If they are attuned, they look inwards and watch the small screen in their mind that displays pictures no one else can see. At night most people pay more attention to their imagination, because it entertains them in the form of dreams while they sleep. Often the dreams reflect those same sights, sounds, and sensations experienced during their day, especially if what they faced was profound or disturbing. The mind plays it back again, reliving the incident over and over, but often in strange or disjointed circumstances (after all, the imagination is rather imaginative).

The imagination exists within every individual whether recognized or not. Many times when I have asked students if they see pictures in their heads while I am telling them a story, they have answered no. They don't seem to understand where the picture is supposed to be. They expect it to be projected on a wall somewhere like a big screen TV. But when I ask the same students if they have ever had a scary dream, they can describe the dream in great detail and with much emotional intensity. These students had to be taught where to see the pictures while they were awake. They needed to understand that the pictures were inside them, within their minds and could be called upon at any time for a great number of reasons. In the beginning some students need to close their eyes to screen out the world around them to "find the pictures." This will pass.

The imagination is perceived differently by different people. Consider your own imagination. Do you see full images in color as you see on a movie screen or do you see pictures in black and white? Or, do you see only fragments of pictures or no pictures at all, just swirling movement or a sense of something? People see with their imaginations differently and can adjust what they see at will. If they have never seen a full picture, they can be trained to do so.

Also, individual students will respond differently to different exercises. Some students may find it difficult to see images or pictures during an imagining exercise, yet see pictures very clearly when listening to a story. Some students may find it difficult to see pictures during a story, yet react very strongly to sensory exercises. These reactions are worth noting, discussing, and celebrating.

The imagination can be guided or you can guide it. Have you ever lost your keys, only to have a sudden mental picture of them lying on the floor of the car? Your imagination was at work. Ever had a dream of an upcoming event or been warned in your sleep of an accident? Again, your imagination was guiding you. Once when I was rehearsing a story, I suddenly saw myself presenting in a completely new way. But that's inspiration, you might say. Of course it is! Where do you think inspiration resides? Inspiration is delivered through the imagination. If you have a problem to solve, a book to write, or a dress to design, your imagination can show you how. But your imagination doesn't always have to lead you: you can direct it. You can consciously formulate pictures that will assist you with memory, composure, interpretation, and improvisation.

The imagination does not know the difference between fantasy and reality. This fact is what gives the imagination its incredible power. One of my favorite exercises in discovering and developing the imagination is "The Lemon," page 20). Once, when I was leading a group of Grade 8 students in this exercise, one of the girls became quite angry. She accused me of hypnotizing her. I was stunned and asked her why she would say such a thing. "I could taste it — the lemon. The taste was in my mouth!" she insisted. I started to laugh. The girl was totally unaware of the power of her own imagination. When she pictured herself biting into the lemon, her imagination responded as though she were actually doing it and released the appropriate sensory responses. It happens. If you dream of falling off a cliff, your heart will race, your palms will sweat, and you may even lose control of your bladder, because the terror was real to your body.

What you picture in your mind, your body will hold as true and respond. This is why Olympic athletes are trained to use their imaginations as a tool. If you can see yourself making the jump, lifting the weight, executing the dive, the body will deliver accordingly. It works and it is exciting. Corporate executives are also trained in visualizing to relieve stress and many American clinics now teach the power of creating images to heal cancer.

In Touch with the Imagination

The first step in utilizing and developing the imagination is recognizing its presence. But as I mentioned earlier, I have worked with students who insisted they do not see images in their head. So, I begin with their dreams.

"I shut my eyes in order to see."

Paul Gauguin

Teacher: Have you ever had a scary dream? (Many hands shoot up.)

Teacher: No, no, not a scary dream, I mean an . . . Oh Wow! wake up, heart

pounding, pee-the-bed, kind of scary dream!

Students: YEAH! (Much laughter and head nodding)

Teacher: And did it happen?

Students: What?

Teacher: The dream, did it really happen?

Students: NOOOOO!

Teacher: Oh, then where was it . . . the dream I mean . . . where did it take

place?

Students: Here! (Students point to their heads.) In our imaginations!

Teacher: Ahhhhhhhhh, the imagination.

I admit that it is not always easy to determine if a student is using her imagination. For imagination results, you can rely only on the student's responses to the exercises through her verbal descriptions and physical reactions.

I once led a group of Grade 9 students in an exercise titled "The Trap" (page 22) and was dumbfounded by the response of three of the girls. During the activity all three of them started to squirm around uncomfortably. One of them even slapped her arms and frantically brushed her legs as though trying to rid herself of something. During the follow-up discussion I discovered they had just seen the movie *Silence of the Lambs*. Apparently, in the movie there is a horrible pit in which the psychopath puts his victims. All three students imagined that they were in that pit and the experience overwhelmed them. We moved on to another more pleasurable activity to allow the girls to let go of the image. It was easy to tell that these girls were responding to their imaginations.

Sometimes, however, the responses were totally inappropriate, either unrelated to the theme or outrageously silly. Students were making up answers to please me or impress the class. I consider such kids out of touch. These students do not even trust their own minds enough to look, listen, and learn from them. But, by your reaction to them and the modelling of the other students, the out of touch students will eventually learn to trust the prompting of their own inner seeing, feeling, and intuition.

Words to the Wise

As you move through the developmental exercises, encourage any student who cannot yet "see" to describe how he "feels" during an exercise. As long as he is staying in touch with himself, he will progress, and at some point the pictures will come.

Pre-test: Recalling Dreams

Open up a discussion similar to the one presented earlier. After a couple of students have shared their dreams with the class, instruct all of the students to sit facing a partner. Instruct one partner to recall, in detail, a frightening dream and describe it as carefully as possible to their partner. Afterwards, have the second partner do the same. Students can also recount recurring dreams, silly or strange dreams, and dreams that were significant, symbolic, or a warning about something.

Ask the students if, in their dreams, they are ever someone else, a member of the "opposite sex," or an animal. Are they able to fly or do something unusual? Are they seeing through the eyes of the person in the dream, or are they watching the person they are in the dream? Perspective is significant because it can shift. Pointing this out to students will enable them to watch for perspective changes during their imagination development work.

Watch and listen to their responses. Using a class list, check off which students can relate a dream easily, which students are hesitant, and which students do not participate. A student may not see inwardly as the rest of the class does, even by the end of these exercises. This ability may not come until later, so encourage the student to trust the process.

Preliminary Exercise: Tuning In

If your students have never experienced a quiet, meditative type of exercise intended to focus them inwardly, they probably need to learn how to tune out the world around them, so they can tune into themselves. The following exercise develops concentration, focus, self-awareness, and active listening.

Instruct students to spread out around the room and lie or sit on the floor. They should be able to hear your voice easily. Talk students through the following exercise.

Look around you, so that you know exactly who is near you and make sure you feel completely comfortable and safe where you are . . . then relax in your spot. (Wait for students to settle.)

Now, close your eyes and listen. (Pause while students listen.)

Stretch your hearing outside the room and try to identify as many sounds as you can coming from beyond these walls. What do you hear? (*Pause*. *Allow students to make suggestions from where they are in the room*.)

Good. Now contain your hearing to inside the room. What sounds do you hear? They are quiet sounds. Listen hard. (At this time you can expect at least one student to add a sound to the room. Let the students laugh and move on.)

Try to identify as many different sounds in the room as you can. What do you hear? (*Pause. Allow students to make suggestions.*)

Good. Now you are going to listen to even quieter sounds. (Pause)

Listen to the sound of your own breathing. Don't try to change it, just listen. Can you hear the sound of your breath? (*Pause*)

Where do you hear the sound? You don't have to answer this out loud, just tuck it away to tell me later. Exactly where do you hear the sound of your breathing? (*Pause*)

Good. Now go even deeper. Listen to the sound of your heart beating. Listen and feel the sound of your heart. Focus. (*Pause*)

Where do you feel the pulse? In your temples? In your chest? Where? (*Pause*)

Can you hear it? (Pause and look at their faces. They will either look relaxed or as if they are trying very hard.)

If the sound of your heart beat is not clear, put your hand on your heart and listen and feel the movement inside you. (*Pause and watch to see how many students put their hands on their chests.*)

Count the rhythm of your heart beating. (Pause)

Excellent work. Now take a deep breath and let it out slowly. Gently shake your shoulders and your head. Open your eyes and return your focus to the classroom.

Gather the students together to discuss the exercise. Ask them the following questions:

- Did you hear anything outside the room that surprised you?
- Did you hear anything inside the room that surprised you?
- Did you hear the sound of your own breathing? Where did the sound come from?
- Could you hear your heart beating, or feel your heart beating, or both?
- Did you notice anything unexpected while you were listening for your heart beat, for example, were you more aware of being hungry or do you have an ache or pain that seemed worse?
- How do you feel now that the exercise is over?
- What do you think this exercise does?

Imagining Exercises

Color Imagining: BALLOONS

Benefits: Develops ability to consciously guide the imagination, explores imaginative color formation, develops concentration, and develops active listening

Format: Instruct students to spread out around the room and lie or sit on the floor. They should be able to hear your voice easily. Talk students through the following exercise.

Make yourself comfortable and close your eyes. (*Pause and wait for movement and rustling to stop.*)

Relax your shoulders. Take a deep breath and let it out slowly. (*Pause*)
In your imagination let the following colors flash before you . . . Red . . .
Green . . . Blue . . . Black. (*Pause*)

Now imagine the following objects . . . A glossy red apple (*Pause*) Tall, green grass waving in the wind (*Pause*) A big blue sky with fluffy clouds (*Pause*) A black hearse driving by (*Pause*)

Let all the pictures dissolve away.

Now see a big bunch of helium balloons attached to strings.

The balloons are different colors. What colors do you see? (Pause)

Count the balloons. (Pause, and don't be surprised if some students lift their hand and point to the nonexistent balloons as they count.)

Now one by one let the balloons go. (Pause)

When your balloons are gone, sit up, slowly open your eyes, and bring your focus back into the room.

Gather students together to discuss what happened. Ask the following questions:

- Did you see any colors? Which ones? (Black and red are usually the easiest to see.)
- Was it easier to see the colors by themselves or the objects that were that color?
- Which object did you see the clearest? The apple, grass, sky, or hearse? (Often it is the hearse because there is an emotional reaction. If the class responds to this one the strongest, ask them how it made them feel.)
- Did you see the balloons?
- · What colors were they?
- How many were there?
- Were you in the picture?
- Did you see all of yourself in the picture holding the strings or did you just see the balloons and your hand holding the strings?
- Did you see someone else there?
- Where did the balloons go?

Answers will vary. Some students will notice many things such as where the balloons went and others won't. Some students will see the colors easily and others may not. Reassure students frequently that all reactions, pictures, and feelings are correct. They cannot be wrong in their imaginations. They are in an adventure to find out what is there and how to work with it.

This kind of exercise works well after a recess break or gym class as a settling or calming activity. In the beginning, keep these exercises short to maintain interest and prevent restlessness. You can always use the beginning of the previous exercise, "Tuning In," to get the students to focus if they need it.

Words to the Wise

It is normal for a student to suddenly act out what he is doing in his imagination such as the counting, but if he starts to mime letting the balloons go as well as the counting, he might be doing this for your benefit. Privately mention this to him later, to encourage him to let future exercises happen only in his head and not to use his hands.

In the same session or the next day, try the exercise again using another vivid image. You could lead the exercise or the students could work in partners, with one partner leading the exercise and the other imagining. The point of this exercise is to distinguish colors, so the guide needs to select familiar objects with vivid colors.

Words to the Wise

Guides should not tell the listener how many objects to see. Some students will be able to picture many objects and some students may be able to picture only two. Telling the listener to picture seventeen balloons may only frustrate him. The listener's imagination will provide what the student can handle. It is like a natural censor.

Some Objects for Imagining

A bouquet of flowers A school of fish

Markers Marbles
Birthday candles on a cake Fruit
A rainbow Smarties

Exploding firecrackers Crayons

Sensory Imagining: THE LEMON

Benefits: Develops ability to consciously guide the imagination, promotes sensory imaging, strengthens concentration, and fosters active listening

Format: Instruct students to spread out around the room and lie or sit on the floor. They should be able to hear your voice easily. Talk students through the following exercise.

Make yourself comfortable and close your eyes. (*Pause and wait for movement and rustling to stop.*)

Relax your shoulders. Take a deep breath . . . and let it out slowly. (*Pause*)

In your imagination I want you to see your kitchen at home. You are standing in the middle of your kitchen, just as it was when you left this morning. (*Pause*)

You are alone. No one is around to interrupt or disturb you. The house is quiet. (*Pause*)

Face the sink. (If a student suddenly turns around, don't be surprised, just say: "Remember to keep the exercise in your head. Don't move around, see it only in your imagination." Then continue on.)

Look at the counter next to the sink. Is there anything on the counter? Do you see any cups or plates? Is there any food left out?

Don't worry, I don't want you to put it away. Just notice that it is there. Is the counter top clean or does it need to be wiped off? (*Pause*)

Look above the sink. What is there? Do you have a window, a wall, or a picture over your sink? Look at it carefully.

Now, look down at your feet. What kind of floor do you see? Is it tile, carpet, or wood? What color is it? Does it need to be swept or cleaned? Do you notice any marks on the floor? Look carefully at the pattern.

Good. Excellent concentration. Now, I want you to look directly in front of you again and then turn, very slowly, in a circle so you can look around the kitchen. Notice the chairs. Notice the walls. (*Pause*)

Are there any plants?

Can you see the refrigerator or stove? Do you notice anything different about them? Good. Now I want you to walk towards the place where you usually eat. Do you eat at a counter or sit at a table? Walk towards that place.

About surprises: Once when I was doing this exercise, a young woman said her father suddenly appeared beside her in the kitchen and they got into an argument. She explained that her father was a dentist and had always told her never to bite a lemon because it would strip the enamel from her teeth. She tried to explain to him that it was just an imagination game, but he was very annoyed with her. She was quite frustrated by his interference. Everyone in the class was speechless, but such is the power of the imagination. It is full of surprises.

You will find a lemon, sitting on a plate, on the table or counter. It wasn't there when you left for school, but it is there now. Walk directly towards it. (*Pause*)

Look at it carefully. It is a large, bright yellow lemon.

Reach out and pick it up. Hold it in both hands. How does it feel? Notice the weight of it. Is it cold or warm? (*Pause*)

Run your fingers over the peel. Is it rough or smooth?

Now put the lemon on the table and get a knife. (Pause)

Carefully, so as not to cut yourself, slice the lemon open and look at the two halves rocking on the plate. (*Pause*)

Put the knife down and pick up one of the lemon halves. (Pause)

Run your fingers over the inside. How does it feel? (Pause)

Look carefully at the inside. Do you see any seeds?

Depending on how you cut it, do you see any sections? (Pause)

Bring the lemon close to your nose and smell it. (Pause)

Now, open your mouth wide and take a big bite. (Pause and watch for facial reactions. Some students will grimace, some might shake their heads, and some might even wipe their mouths.)

Good work. Now, go and rinse out your mouth. (Pause)

Take a deep breath, gently shake your shoulders and head. When you are ready, open your eyes and return your focus to the classroom.

Gather students together to discuss what happened. Ask the following questions:

- Did you see your kitchen?
- Was the floor messy?
- Did you notice anything in your kitchen that you hadn't noticed before?
- Could you see the lemon? Describe it. (If necessary, arrange the students in partners.)
- Did you smell the lemon? Describe what you smelled.
- Did you taste the lemon? Describe what you tasted.
- Did you have any physical reactions? mouth watering, gritting your teeth, lips stinging?
- Did anyone refuse to bite it? (If someone did refuse to do it, ask why. Point out that they would only have done so in their imagination. This often leads into a class discussion about how real the experience felt.)
- Did anything happen during the exercise that surprised you?

Follow-up: In the same session or the next day, try the exercise again using another vivid sensory image. You could lead the exercise or the students could work in partners, with one partner leading the exercise and the other imagining. The point of this exercise is to stimulate sensory recall through the imagination. The guiding partner needs to choose a familiar object with a strong taste or smell.

Words to the Wise

During the exercise it is important for the guiding partner to lead up to the sensory moment by focusing on the surroundings first. Doing so heightens the sensory experience.

Some Taste Examples

In the kitchen - blue cheese or garlic
In the bathroom - cough syrup
At a picnic - sour milk
In the backyard - watermelon
In the bathroom - mouthwash
In a restaurant - hot, hot chicken wings
In the school lunchroom - rotten apple
At a campfire - melted marshmallow

Some Smell Examples

In the woods - skunk
In the kitchen - curry or apple pie
In the backyard - dog excrement
In a funeral parlor - lilies
At the cinema - buttered popcorn
By a pool - chlorine
In a department store - perfume
At a school locker - smelly gym clothes
In the bathroom - nail polish remover or hair spray

Problem-Solving Imagining: THE TRAP

Benefits: Develops ability to consciously guide the imagination, develops ability to problem-solve through imagining, develops concentration, and develops active listening

Format: Instruct students to spread out around the room and lie or sit on the floor. They should be able to hear your voice easily. Talk students through the following exercise.

Make yourself comfortable and close your eyes. (*Pause and wait for move-ment and rustling to stop.*)

Relax your shoulders. Take a deep breath . . . and let it out slowly. (*Pause*)

In your imagination see yourself standing on a white sand beach. There is no one else on the beach but you. You are all alone. (*Pause*)

It is a warm, sunny day. You have no shoes on and you can feel the warm sand under your feet. Wiggle your toes to feel the sand. Look out over the water. Shade your eyes if you feel like it. Is the water smooth or rough? Listen to the sound of the waves. Way off in the distance you can see a boat. What kind of a boat is it? (*Pause*)

The sand is starting to feel hot under your feet.

You turn around, away from the water. Along the edge of the beach is a dense forest. The trees give shade. Head towards the trees that line the beach. You move quickly over the sand because it is hot. (*Pause*)

When you step into the shade of the first trees there is a sudden drop in temperature. It is much cooler here and the ground feels different under your feet. How does it feel? (*Pause*)

Between the trees you see a worn path. Follow it through the forest. As you follow the path the trees are closer together. There is less and less light. The path is overgrown, and now you have to push aside small bushes and plants to keep going. Be careful where you step.

There are noises too — different noises. What do you hear?

You walk more carefully. Just ahead of you, piled on the path, is a big clump of old leaves. You wonder how they got there.

You step up to the pile and wade into the leaves. They are cold and damp in the middle of the pile . . . and unsteady.

Suddenly you feel wobbly. All at once there is a loud crack and you drop. You drop so fast that you lose your breath. You fall right through the leaves, down, down, down until Wham! You hit something hard and crumple into a heap. (*Pause*)

It takes you a while to focus. You move your head. Where are you? It's dark. You look up and realize what's happened. You have fallen into a trap, a crude pit, probably built to trap an animal. Above your head, quite a ways up, you see the opening you fell through. There are still some sticks covering part of the hole, and you can see a few leaves hanging over the sticks.

You struggle to your feet. You are stiff and sore, your back aches, but nothing is broken. The ground beneath your feet feels moist and cold, very cold.

There are odd smells, unfamiliar smells, but one is stronger than the others. What is that smell? (*Pause*)

Look around you. What's there? (Pause)

You have to get out.

You run your hands along the walls of the pit. How does it feel? (*Pause*) You could stand there and scream your head off, but no one would hear you. You are alone. You must find a way out.

Solve the problem. Find a way out of the pit and watch yourself get out. (*Long pause*)

When you are safely out of the pit, gently shake your shoulders and head. Open your eyes and return your focus to the classroom.

Gather students together to discuss what happened. Ask the following questions:

- On the beach, did you feel the sand under your feet? Was it comfortable or uncomfortable?
- What did the boat look like?
- What did you feel when you stepped into the shade? (Did you shiver or get goose bumps?)
- How did you feel while you were walking through the woods?
- What did you hear?
- How did your feet feel when you walked into the pile of leaves?
- Were you nervous or anxious? (If the answer is yes, press for more detailed descriptions of body sensations.)
- How do you know you were nervous or anxious? What did you feel? Did your stomach tighten or flutter? Did your palms sweat? Was your mouth dry?
- How did you feel when you dropped?

"The Trap" is a wonderfully exciting and tantalizingly imaginative adventure. The exercise is carefully constructed to go from a safe, warm place to an uncomfortable, threatening place, yet the ending is *always successful*. The transition from safe to threatening elicits a range of emotions and body sensations. Students love this exercise.

- Describe the pit. (You may have to pair students because they will all want to describe what they saw and felt, and every student should have a chance to vocalize.)
- What did you find in the pit?
- What was the smell?
- How did you get out?

Follow-up: In the same session or the next day, do the exercise again using another problem-solving adventure. You could lead the exercise or the students could work in partners, with one partner leading and the other imagining. This exercise sets the listeners in a safe situation, leads them to a problem situation, and then lets them escape using their imaginations. The guide never gets them out. Listeners use their imaginations to solve the problem.

Some Adventure Examples

Come home from school — rushing because you are late for practice (or rehearsal) — get locked in the bathroom.

Babysitting — reach into big toy chest and fall in — lid closes and locks you inside.

Got the day off school to golf — starts to rain — a funnel cloud heads right for you.

Walking through the woods — find an abandoned tree house — ladder breaks just as you reach the tree house — you are stranded.

On a water ride at an amusement park — small craft flips over — you are trapped underneath.

Sleeping at a new friend's house — wake up and smell smoke — trapped in the guest room.

Drifting on a river in a small boat — water moves faster — heading for a waterfall.

Riding new bicycle — start down a steep hill — brakes give out.

Alone in house — watching favorite TV program — you hear a window break and footsteps in the house.

Enjoying a campfire in the woods — fall asleep in sleeping bag beside the fire — you wake up to sniffing and growling beside you.

Driving the family's new car for the first time alone — on a lonely stretch of road — suddenly lights start flashing on the dashboard and the car engine quits.

Inspiration Imagining: THE WISE ONE

Benefits: Develops ability to consciously guide the imagination, to listen intuitively to the imagination, to concentrate, and to listen actively

Format: Instruct students to spread out around the room and lie or sit on the floor. They should be able to hear your voice easily. Talk students through the following exercise.

Make yourself comfortable and close your eyes. (Pause and wait for movement and rustling to stop.)

Relax your shoulders. Take a deep breath . . . and let it out slowly. (*Pause*)

In your imagination, see yourself walking through the woods.

It is a warm summer night, the moon is full, and you can see easily. The trees are still. You hear the occasional hoot of an owl, but mostly the woods are still and calm. You have been waiting for this night for a long, long time.

As you move along the path, you feel excited because you are sure tonight she will be there. You walk a little faster. She has something for you. Something precious. You have waited for this all of your life.

Suddenly, a large black bird flaps out of the tree ahead of you and lands on the path, blocking your way. It just stands there and stares right at you. You see its yellow eyes. Its head cocks to one side. It seems to look into you and right through you. You can't move. You hold your breath and wait.

Suddenly, it squawks, flaps its wings and takes off. It's gone. Where did it go? Was it real? You listen and hear nothing. Was it a sign? Was it a test?

Hesitantly you step forward. Nothing happens. You start to walk again, following the path, but now you are wary. You listen for other things, unseen things. What do you hear? You stop. You hear something new.

A flute? It sounds like someone is playing the flute, but the sound is different. The sound is not coming from the woods. It's coming from inside you.

You move on. Up ahead, through the trees, you see a light, a soft glowing yellow light. You walk slowly towards the light. You come into a clearing. In the middle of the clearing is a fire, a large bonfire. Beside it are many baskets.

On the other side of the fire, something is huddled. You move closer, around the fire. You stop. A person is huddled over, resting on the stump of a tree. A person with long flowing white hair. What is she wearing?

She lifts her face and you are amazed. You have never seen anyone so old. She looks at you, but she seems to look into you and through you. What color are her eyes?

She lifts up one bony finger and beckons to you. The music, the flute music is stronger, louder. You have found her.

You move close to her and kneel down. She lays her hand on your forehead. Her hand is cool and soft. There is an unusual smell to her clothes and hair. What does she smell like? Suddenly, she brings her hands together two times. She claps and the sound of the clapping seems to echo through the forest like thunder.

She stands and hobbles towards the fire. She beckons for you to follow. The heat from the fire is intense. The light plays on her face and clothes.

She points at one of the baskets, the one with the lid.

You pick it up for her and hold it out to her.

She slowly lifts the lid and takes out a box. A small carved box. She holds it in both hands and closes her eyes. Then she stretches out her arms so that the box is before you.

You set down the basket and take the box.

She still has her eyes closed, but you know what to do. The box is for you. You have waited for it all of your life. It is for you alone. You slowly open the box. (*Pause*) What is inside? (*Long pause*)

You nod and smile and close the box. You look up. She is gone. You tuck the box safely under your arm and go home. (*Pause*)

Words to the Wise

Before allowing students to volunteer descriptions of what they saw and felt, explain that this exercise is very different from the others. Students may not wish to share what they found in the box. After all, you did say it was for them alone. In so doing, you gave them permission to see something very personal.

When you are ready, gently shake out your shoulders and your head. Open your eyes and return your focus to the room.

This exercise is not as easy to duplicate when students act as the guides. I recommend that you remain the guide for further inspirational adventures. Gather students together to discuss what happened, but begin the reflection by telling them that they do not have to share their precious object. Ask the following questions:

- How did you feel when the black bird stopped you?
- · What do you think it meant?
- How would you describe the old woman?
- What was in the box? (Remind them they do not have to share this.)
- What do the box's contents mean to you? Tell us if you'd like to.

Follow-up: Students often want to express themselves after this type of exercise, but due to the personal nature, prefer a more intimate form. Allow students to write in a journal, draft a story, create a poem, or draw a picture of the experience.

Using a Story for Imagining

Using story to stimulate imagery is as old as the human race. Storytelling is by far the oldest profession and a good story has never failed to engage an audience. I highly recommend the 398 section of your library, the folklore collection, to find great material. Pick anthologies by such well-known collectors as the Brothers Grimm or Andrew Lang. A Scandinavian collection or Native collection will be full of rich and varied images, tantalizing adventures and surprises. There will be a multitude of books to choose from, at least as many as the multicultural range in your classroom. Try a story from every culture represented in your room. Comparing the stories makes great social studies investigations and every choice you make validates the student of that culture. Narrative poems such as "Wynken, Blynken and Nod" by Eugene Field or "The Highwayman" by Alfred Noyes also make great reading/listening experiences.

However, make sure you select books *without* pictures. I made the mistake of using a picture book once and then let the students see the pictures after the experience. When the student sitting directly at my feet saw the artist's version of the character in the story, he said, "Oh, I was wrong." I was crushed. I wanted to take back the image, but I couldn't. I had let the student down. The version in his head would have remained perfect, if I had not shown him the pictures from the book. Furthermore, once a student sees the artist's versions, it is difficult for him to hold onto his own image — his image has been replaced. He has been stripped of the sense of ownership or the personal creativity he may have been nurturing towards his imaginative work.

I am not saying, "Never read picture books to students." It would be a shame to deprive students of the beautiful illustrations in picture books available now. Many have even won artistic recognition. I am saying a *balance* is necessary. Students need to be shown images, especially in the form of art, but they also need opportunities to create their *own* images. The imagination is like a muscle or organ in our bodies — use it or lose it. Unfortunately, since television became pervasive in our society, we have been losing our ability to create images. We allow television and cinema screens and computer graphic designers to create them for us. So, why not use story reading as an opportunity to develop what is your students' most creative gift?

Some Other Inspirational Themes

- Walk up a mountain path and find an old man with a message.
- Row to an island and find a chest buried in the sand with something in it.
- Enter a cave and meet a tiny person with a significant piece of jewellery.
- Trek across the desert and find an oasis with a magic spring.
- Go up in a hot air balloon and meet a creature with a musical instrument sitting on a cloud.

The following is one of my favorite stories to share with students. I have broken the story up into sections, with pertinent questions to ask the students after each part. When you break up a story like this, be careful to do so during a tense moment. It drives the students mad with suspense and leaves them begging for more.

Section #1

Ellie Mitchell lived in one of those old log cabins, tucked up the side of one of those great big Rocky Mountains. Maybe you've seen a picture of them. She used to live with old Jack. But he had long since died and now she lived all alone.

Well, that's not fair, she wasn't completely alone. She had a moo cow she called Dolly and some chickens in the chicken coop. Ellie's favorite thing to do was sit out on her porch and watch the sun go down and the moon come up. She could hear the trickling of the mountain stream nearby and the birds calling in the night. Nice comforting sounds.

Tonight there was a real nip in the air. It was late October and winter was closing in. She decided she better get into her cabin and light up the stove or come morning she was going to be blue with the cold.

Ellie was just stirring up the fire, when she stopped, because she heard a different sound. A horse. Yeah, that's what it was. Now, this was a strange thing because Ellie very rarely had visitors. Especially after the sun went down because she lived too far off the main road. Ellie moved towards the window to pull open the shutter and take a look. But before she got across the room, she heard a step up onto her porch and then there was a sharp rap on the door.

Should she open it? Would you?

Well, Ellie wasn't afraid of much, but she was a cautious woman, so she decided to open the door, just a crack, to see who was there. Standing on her porch was a man. All dressed in black. He had on the shiniest black boots Ellie had ever seen. A long dark cloak billowed about his knees. His collar was turned up real high and his skin was as white as chalk. But it was his eyes that made Ellie back away from the door. She knew who he was. She'd never met him before, but she knew. Ellie backed all the way across the room until she was right up against the wall. That door swung open all by itself and Death walked right into the cabin.

To develop oral language skills, ask these questions of the students orally.

- Did you see Ellie Mitchell?
- What does she look like? What was she wearing?
- How old is Ellie Mitchell? Prove your answer. (An argument may erupt here. Some may say twenty, some fifty, some eighty and inevitably one will say twelve. All answers are correct. The information "she used to live with Old Jack" will lead some to believe she was once married and her husband died. But the story doesn't say Old Jack was her husband. Old Jack could have been the family dog. Ellie is whatever age students made her. Every one of them has their own version of the story going on inside their head and every one of them is right.)
- Describe the inside of the cabin.
- Did you start to feel nervous or uncomfortable? When and in what way?
- Describe Death, specifically his eyes.

- Who or what is Death?
- What do you think is going to happen now?

Follow-up: In partners, have students take turns retelling this section of the story, using the "pictures in their head" to help them remember what happened. Encourage them to add any exciting details they "saw" in their version.

Section #2 If this section is being read a day or more after the first section, have students orally recall the first section before you go on.

Death strolled around inside the cabin, picking up Ellie's things, then putting them back down. Then he sat down in Ellie's old kitchen chair. He looked right at Ellie, he smiled, then he said, "I can tell by the look on your face, Ellie Mitchell, you know just who I am. Come on, girl, let's go."

Ellie pressed herself against the wall and shook her head. "I'm . . . not going anywhere," she said.

Death sighed. "Oh, Ellie. It's been a long day. I don't want to take you out of here kicking and screaming." He leaned forward. "Tell you what. I'll give you some time to think about it." You see, sometimes Death wants to play with you. "On the waning of the old moon, I'll come back for you. Then you're mine."

Death got up and walked right out the door. The door closed all by itself. Then Ellie heard the sound of the horse's hooves trample out of the yard.

Ellie started pacing across the floorboards. She talked to herself. "I'm not ready to die. My bones don't even ache unless I chop too much wood. Who will take care of Dolly? And the chickens, they'll freeze in the winter. I'm not ready to die."

Ellie didn't sleep so good that night. Would you?

Come morning she had a dark cloud of despair hanging over her head. But that didn't stop Ellie Mitchell. She yanked herself out of bed and pulled on her work clothes and her old rubber boots. "I'm gonna feed my chickens. I'm still alive and that's what I do every morning." She marched herself across that yard. She dug the scoop into the barrel of grain and was just about to sprinkle it over the ground, when she stopped because there in the dirt was a little pile of feathers and some blood.

Ask these questions of the students:

- What did the yard look like?
- · What did Ellie find?
- Why do you think it was there for her to find?
- What do you think will happen now?

Follow-up: In small groups, recount the first two sections of the story, by orally passing the story from one person to the next. You can clap when it is time to pass the story on, or let the students decide.

Section #3 Recall the story orally if this section is being read one day or more after Section #2.

"I know what did this," said Ellie Mitchell. "A coyote, that's what. Well, we'll see about that!" She stomped over the yard and banged around inside the cabin, looking for her rifle. It took most of the day for her to find it though. She hadn't used it in a while. But her pa had taught her how to oil

it real well, so it was in fine shape. She set it right up on the kitchen table so she could see it and then she looked for the little white box of shells. She found it in her bedside table. Then she loaded up the rifle. "Dang coyote," she muttered to herself.

She waited for the sun to go down. Then she pulled on her warmest green sweater and a matching hat. She dragged her old kitchen chair across the yard and set it right beside the chicken coop. Then she settled in and she waited. It was close to two o'clock in the morning when she saw a shadow coming around the edge of the chicken coop. She lifted up her rifle and got it in her sights. Oh, it was a coyote all right. A big one.

She just started squeezing back on the trigger when the coyote stopped, looked her right in the eye and said, "Don't shoot."

Ellie just about dropped the rifle. She didn't know coyotes could talk. Did you?

"But . . . but, you're stealing my chickens!" said Ellie.

"That's right," said the coyote. "But you've got to understand my position. I've got five young pups back in my lair and if I don't get them some food, they'll starve. It's hard catching a gopher or a squirrel, you know."

Well, Ellie could hardly believe what she was hearing. She did have a soft spot for animals . . . but coyotes?

"Tell you what," said the coyote, easing down on her haunches. "If you don't shoot me, I'll make you a bargain."

"What kind of a bargain am I going to make with a coyote?" sniffed Ellie Mitchell.

"I know you had a visitor last night," said the coyote real cool like. "And I know how to cheat Death."

Well, Ellie couldn't resist. She leaned a little bit forward.

"If you take your clothes off," whispered the coyote, "turn them inside out and then put them back on . . . Death can't see you."

Ellie let the nose of the rifle drop down. "Really?"

That coyote jumped and took off out of the yard so fast that Ellie wouldn't have been fast enough to shoot her anyway.

Every night after that, Ellie marked a big red X on the calendar. Then she'd sit out on her porch and watch the sun go down and the moon come up. Every night that moon got a little smaller and a little smaller, until tonight, it was just a little silver sliver in the sky. And Ellie knew tonight was the night.

Ask the students these questions:

- How did you feel while Ellie was sitting outside by the chicken coop?
- Did you hear anything?
- How did the yard look from where she was sitting?
- How would you describe the coyote?
- Do you trust the coyote? Why or why not?
- What do you think will happen now?

Follow-up: In groups of three, retell the story this far from the coyote's point of view, Death's point of view, or Ellie's point of view.

Section #4 Conclusion Recall the story orally if this section is being read one day or more after Section #3.

Ellie went inside the cabin and took off all her clothes. Then she turned them inside out. She even turned her socks inside out. She stared down at her worn leather shoes. Can you turn your shoes inside out?

She kicked them under the bed. She didn't light any of the lamps. Somehow she felt safer in the dark. She pushed her kitchen chair into the corner beside the stove. And she sat. She didn't sit for long. Death doesn't always come at midnight, you know. Death comes when Death wants to.

She heard the horse's hooves clumping across her yard. Then she heard the footsteps. She squeezed her eyes shut and held onto herself so tight she was making bruises, but she didn't care. As long as she could feel something, at least she knew she was still alive.

There was a step up onto the porch. She just had to peek. The door swung open and in walked Death. Even in the dark she could see the white of his skin and his smile. He paused in the centre of the cabin and listened.

Her heart was pounding so loud she thought, "He can hear me!"

"Ellie Mitchell," said Death, "I know you're here. I can feel it. You can't hide from me." He swept over to the bed and got down on his knees. That's the first place Death's targets hide. All he saw was an old pair of shoes. He headed for the closet. That's the second place they hide. But it was empty.

He stood in the middle of the room and looked around very slowly, until he was looking right at Ellie Mitchell.

His eyes narrowed. All he saw was an empty chair. Death let a scream out of him that would make your blood run cold. He knocked over her kitchen table and roared out of the cabin. The door slammed behind him and she heard that horse take off out of the yard.

Ellie was still sitting there long after the sound of the horse's hooves had died away. Then she heard a different sound. It was the sound of a coyote howling up at the moon. And that made Ellie smile. She got up and lit all the lamps. She righted the table. Then she took off all her clothes, changed them back the right way, and put them back on. She said to herself, "Well Ellie, I guess it's time for a cup of tea."

And she's still up there in her cabin drinking it.

Ask the students these questions:

- · What did Ellie's shoes look like?
- How did Death look? The same or different from before?
- Did you notice anything in the closet? What?
- Did you hear the coyote? What did it sound like?
- Should Ellie have changed her clothes back the right way? Why or why
- Do you think Death will come back? What will happen?

Follow-up: Have the students create a storyboard or cartoon picture version of the entire story and then instruct them to tell the story to someone outside of the class. They can use the storyboard to assist them in remembering the story but remind them not to let their listeners see the storyboard because it might interfere with their audiences' own imaginative pictures!

Language Arts

Language Arts

Language Arts

Language Arts

Curriculum Extensions: Writing

Dream Journal: Ask students to keep a journal recording their dreams for one month. In their journals, they can make note of what dreams were reflections of daily events. From what perspective was the dream viewed? Was there anything unusual or magical in the dream? Was the dream somehow significant? To be able to answer such questions effectively, students should keep a journal and pen beside their bed and record the dreams upon awakening.

Response Journal: Beyond asking students to reflect on questions raised under Student Reflections, which appear at the end of all focus area chapters, encourage students to keep a journal recording their emotional, mental, and physical reactions to games and exercises. A response journal is an effective way to subjectively measure personal growth or changes over a period of time. The following questions will give students food for thought:

- How did the exercises make me feel? (physically, mentally, and emotionally)
- What did I realize about myself today?
- Will I do anything differently after today?
- What are my goals for tomorrow?

After two weeks, tell them to reread entries and consider the following questions.

- What things do I see and do differently now than I did two weeks ago?
- What is my biggest surprise?

Creative Writing: In pairs, students select one of their dreams, brainstorm it into an adventure, then write it up as a blockbusting movie script — *The Wizard of Oz* was originally a dream. Students can also cast the roles and choose a filming location. (The same can be done for any of the students' reactions to imagining exercises or stories you read to them.)

Descriptive Writing: In pairs or threes, students select the setting from one of the imagining exercises or stories and describe it in detail including flooring, walls, furniture, and decorations. They then write up a sales pitch for the newspaper. Looking at some Realtor ads in the paper will give students ideas and insights into descriptive selling.

Student Reflections

Invite your students to consider and respond to some of the following questions in their response journals.

- 1. Which imagination exercise was the most powerful for you? Why?
- 2. What is your favorite way to see pictures in your head? (For example: imagination exercises, dreaming, as a listener hearing stories.) Why?
- 3. As a result of doing some imagination exercises, what have you discovered about yourself?

Teacher Assessment

Focus: Imagining

Date:			
Frequently	Sometimes	Rarely	
s in			
		Frequently Sometimes	

CHAPTER

Listening Actively

My son came home angry from baseball practice. "The coach," he sputtered, "intends to put *his* son at second! Why did I even bother to get ready?" I shook my head and sighed in sympathy. As little as I knew about the game, this I could understand. The coach's son couldn't field a ball. My son, the catcher, had trained all winter to throw a ball from home plate to second base in under two seconds. But what was the point now, if the second base man couldn't receive it? The catcher was nothing without an effective second base man to complete the play.

Responsibilities of the Listener

In oral communication exists the very same dilemma. The speaker may be hysterically funny, moving, poignant, witty, clever, in short, brilliant, but if no one is there to receive the presentation, it's just an incomplete play and no one will ever win at the game. Communication needs at least two effective players to be successful.

The listener carries as much weight of responsibility as the presenter in making a presentation work. But how can you get students to listen more? You can't. Students already listen 80 percent more than they read, write, or even speak and if you tell your students one more time to "pay attention," they might tune you out completely. Students need to listen *actively*, not more, to engage in the listening process by understanding how they can listen better. Three mcthods of active listening — using body language, imagination, and inquiry skills — will create more effective listeners.

An added benefit to developing effective listeners is that the speakers who are entertaining the listeners improve at the same time. So, although this chapter concentrates on listening, skills will also evolve in the speaker: to use descriptive language, effectively tell a personal story, and discern fact from fiction.

"It was so . . . wonderful, having someone really listen just to me." Rob, Grade 11 School for the Arts

Pre-test: Checking Perceptions

Ask the students the following questions: Who has more responsibilities during a presentation — the speaker or the listener? You can have a class discussion or invite students to respond in notebooks. Instruct students to list responsibilities under the following headings:

Responsibilities of Presenter

Responsibilities of Listener

You will probably discover that the majority of students, regardless of their age or grade, think that listeners are responsible for one thing only: being polite. In fact, the weight of responsibility is equal between presenter and listener. Presenters are responsible for making sure everyone can hear them, checking that everyone is seated comfortably so they will not get restless, ensuring that they can make eye contact, preparing something worth listening to, and keeping to a time limit. Listeners, on the other hand, are responsible for giving the speaker their full attention without whispering, shuffling, eating, playing with something, or grooming themselves; imaginatively seeing the presentation; not leaving before the presentation is finished; mentally questioning the presenter during the presentation; and then posing those questions, if invited to, when the presentation is done. These ideas will be explored in this chapter.

Technique: Positive Body Listening

All students are aware of the language of the body. They read it all the time in their friends, their teachers, and their parents. They are not always aware, however, of their own body language or of the power it has over both speaker and listener.

Only the body language of the listener is explored in this chapter. (See Chapter 5 for more information about body language and the speaker.)

Activity: LOOK! I'M LISTENING!

Benefits: Develops sensitivity towards a speaker and understanding of the power of body language

Format: Demonstrate (or have students demonstrate) the following body language positions of a listener. Ask how it would make the speaker feel if she saw a listener behaving in these ways:

- covering her face with her hands
- reading a book
- sprawling out on the floor
- staring at the speaker without any facial expression
- leaning forward
- · watching the speaker intently
- nodding
- laughing at what the speaker said (This can be good or bad.)

Students will probably determine that the four behaviors listed at the right above reflect positive or encouraging body listening postures. When a speaker sees an audience member lean forward, watch intently, nod, or laugh appropriately, she tends to react in one or some of the following ways: relaxes, gets

louder, gets excited about what she is saying, and wants to complete her presentation and not give up or run off stage.

If any of the first four behaviors (bottom left, page 34) are displayed by audience members, the speaker tends to do the opposite: gets tense, softens the voice, loses enthusiasm for what he is saying, and maybe stops speaking altogether.

This next game promotes the adoption of positive body language postures.

Game: TRUE CONFESSIONS

Benefits: Allows students to practise body language postures that indicate positive listening

Format: Arrange students in groups of four or five. One student is designated as the starter. Starter student uses the opening line "When I was really young, I am told I used . . ." and completes it. The listening students are responsible for doing the following:

- 1. leaning forward
- 2. looking at the speaker and watching him carefully
- 3. nodding, smiling, or reacting in some way to what the speaker is saying
- 4. laughing out loud if the speaker is really funny, moaning if he is gross, clapping if he is clever in some way reacting audibly to the speaker so that the speaker knows they are listening

The person to the starter's right confesses next and the confessions continue around the circle until everyone has had a turn. When the circle is complete, gather the students together to discuss how it felt to be the speaker with a "reacting audience." Encourage students to share a confession with the whole class. Ask all listeners to use positive listening body language before the confession begins.

No one wants to be bored. Everybody wants to listen to something interesting, something entertaining. Listeners are not just supposed to be quiet and polite; they are supposed to support and encourage speakers to do well, to be the best they can be. Both speakers and listeners should be prepared to give their energy and concentration to a good performance.

Technique: Giving and Receiving an Image

An active listener uses the imagination to form pictures and impressions, to react intuitively and to problem-solve, especially while listening to a presentation. The imagination can clarify, add insight, provide extra information through memory and enhance a presentation's entertainment value. The imagination is a listener's friend and guide. But forming images sometimes takes practice, especially when students are listening to each other. Students need to consciously use their imaginations both as givers and receivers. When students recognize their imagination as a tool, they can then rely on it for stimulation, creative direction, and as a silent method of focus and concentration. (See Chapter 1, Imagining, for further exercises on the development and uses of the imagination.)

If the speaker is presenting for over five minutes, the listening audience should not be expected to lean forward throughout the presentation. The listeners' body positions can change without discouraging the speaker, if the rest of the body signals remain positive.

Pre-game activity: Stimulating the Senses

How often have you heard someone say, "You had to be there." Actually, the person was really saying, "I cannot find the words to recreate the event or object so that you could see it and get the same reaction." Finding the words takes some thought and some skill, but if your students learn two simple descriptive tricks, they will always "find the words." The first is using the senses; the second is using a comparison.

1. Put a chart up in the classroom listing the five senses and descriptive words under each sense. Students can refer to the chart while they are searching for the right words. Here is an example:

SMELL	TASTE	TOUCH	SOUND	SIGHT
sour	sweet	smooth	soft	color — pale blue
sickly	salty	bumpy	grating	shape — rounded
sugary	bitter	prickly	loud	size — huge

2. Tell students to create comparisons and put those up for easy reference. For example:

He looked *like* a gentle lamb. She spouted the water *like* a whale. It felt as soft *as* toilet paper.

Game: I SEE WHAT YOU MEAN

Benefits: Develops descriptive vocabulary, imagining skills, ability to communicate an idea, and positive listening posture

Format: Half of the class sits in a circle, facing outwards. In the middle of their circle is a table with some items, covered with towels. The rest of the class forms an outer circle and sits facing the inner circle. Students facing one another are partners. The students in the outer circle, who can see the table, are the speakers. The students facing outwards are the listeners.

When the students are ready, remove one of the towels. Only the speaker students can see what is underneath. The listening students may not turn around and look. Speaker students describe the item on the table to their partners, but may not at any time name the item. Speakers must use three out of the five senses and at least one comparison in the description. The word picture needs to be so vivid that the listeners get a crystal clear picture of the item in their imaginations.

The listeners practise positive body language (see previous activity) while listening to the description. When speakers are finished, the listeners tell the speakers what the item is and may turn around to look at the real thing. Listeners and speakers switch positions and a new item is uncovered. When both students have had turns at listening, the outside circle moves over one place and new partners are formed.

Variation: To explore taste, you will need a cup for every student because they will all want a taste. To highlight smell, use containers of spices, herbs, and familiar items such as tomato sauce, and something medicinal, but strong smelling like Ozonal or Vicks VapoRub. This exercise is a little trouble to prepare, but it is worth doing, at least once. No one can create out of a vacuum

Possible items for the table include a live pet, a stuffed toy, and a pair of silly underwear.

The stronger the emotional reaction to the item, the more effective the description. I once brought in a live baby chick. The reaction on the faces of the speakers when they saw it drove the listeners wild, the excitement mounted, and the speakers really struggled to find the right words. The same thing happens when the item is particularly funny (as with underwear) or gross — I once brought in a rotting compost pile, flies and all.

and stimulating the senses produces fantastic results. The payoff is always worth the trouble.

Technique: Questioning

It is not enough for a listener to just hear the sounds a speaker is making and look like he is listening. The listener must comprehend what the speaker is saying for the presentation to have any value. One of the simplest methods of checking, rechecking, and analyzing information being presented is to ask questions about it.

Asking questions of a speaker allows the listener to clarify points, better understand the sequence of events, or just relieve a healthy curiosity. Unfortunately, most question periods occur after a presentation; however, that does not stop the listener from asking questions internally. Maintaining internal dialogue about the presenter and the material being presented keeps the listener focused on the presentation. Silent questioning prevents mind wandering, daydreaming and even fretting about some unrelated incident. If the questions can be remembered, some of them may even be put to the speaker after the presentation is over. If not, they are excellent points for discussion with classmates later on. But even if the questions are never voiced, a questioning and probing mind is an alert and growing one. According to *The Art of Speaking* by Elson and Peck, "The habit of courteous, intelligent and courageous inquiry is one of the greatest assets of an expert listener. Cultivate it."

The games "Do You See My Story?" and "Liar" (next) can be played again and again using new partners or new material. Students might tell the story of being lost, suffering a car accident, enduring an embarrassing moment, facing the death of a pet, receiving the worst present, or enjoying their best present.

Game: DO YOU SEE MY STORY?

Benefits: Develops use of imagery, descriptive vocabulary, sequencing, memory, confidence through validating oneself as worth talking about, ability to question a speaker, and ability to concentrate on a speaker's words

Format: *Part A* Demonstrate to your students the following two-minute personal storytelling lesson, using an incident from your own life. Since all students will be sharing a "scar" story, tell a "scar" story of your own, explaining how you got the scar. For dynamic results, follow this procedure:

- 1. Start the story with the *who* (who was there) and the *where* (where it happened). An amazing thing happens if you begin the story with the who and the where: the listeners get pictures in their imaginations which grab their interest.
- 2. If your story happened some time ago, add the *when* so the picture of you will adjust in their heads.
- 3. Explain what you were doing and why. Were you playing a game? Were you riding your bike, driving a car, or running down the street?
- 4. Build up to the moment of the injury as though it was the story climax.
- 5. When you get to the part explaining the injury, use vivid detailed descriptive words. Was there blood? How big was the cut? Was there a bone sticking out?
- 6. Describe how you reacted to the injury and how the people around you reacted. (This portion is often very funny without meaning to be because quite often people scream or faint.)
- 7. Describe how you were treated for the injury. Did your mother or father fix it or did you go the hospital for stitches?

During informative, motivational, or explanatory speeches, note taking is a valuable skill. Point-form notes, written discreetly so as not to distract the speaker, keep the listener focused and make excellent material for questioning after the presentation.

To help students focus on note taking, demonstrate (or have a student demonstrate) an unfamiliar activity. For example: Changing a bike tire or doing a card trick. Students may only observe during the demonstration, keeping notes on unclear points or new vocabulary and using one-word notes to jog their memories about questions they have for the discussion afterward.

Copy this *personal story model* onto a chart for student reference. Ask students whether they have a scar or some sort of injury story to share — perhaps a fall down the stairs, a burn, or a wallop with a ball or bat. Discussing injuries as a class will trigger the memories.

Part B Arrange students in partners. One student is A and the other is B. Student A, the storyteller, will tell B her scar story. Partner B, the listener, should encourage the storyteller with his body language, leaning forward, watching the teller, and reacting with facial expressions, or more depending on the events described. Storytellers must follow the guide demonstrated by the teacher, to ensure their partners get imaginative pictures. The goal of the storytellers is to make the incident so real and vivid that the partners get perfectly clear pictures.

During the story, B is to ask *three questions* to clarify either the pictures or the sequence of events. When the story is over, B asks *three more questions* to clarify the pictures, the sequence of events or any details that were missing. If more questions are necessary at the end of the story, then the listeners may ask more, but no more than three questions can be asked during the telling.

Game: LIAR

Benefits: Develops memory and the need to ask more questions

Format: After students have played the previous game, they will have heard two stories: their own and their partner's. Ask them to find a new partner. Students will take turns telling scar stories again, only this time students will try to trick their new partners. Students may tell their own stories again or their previous partners' stories, which should sound as convincing as their own. New partners must guess whether the story is the speaker's or someone else's.

As in the original game, listeners are allowed to ask three questions during the telling and three questions afterwards.

Curriculum Extensions: Responding to a Speaker

Building Descriptive Vocabulary: You will need five pillowcases with an object inside each one. Label the pillowcases 1, 2, 3, 4, and 5. Arrange students in groups of four to six. Give each group a pillowcase with an unknown object inside. Starter students reach into their bags, touch the objects, and describe what they feel. When the description is complete, the students in each group guess what their object is. A recorder notes student responses and the number of the pillowcase.

When all members of the group have guessed, the pillowcase is passed on to the next group, a new pillowcase is obtained, and a different student reaches in, touches, and describes the object.

When all pillowcases have been investigated, bring the class together and reveal the contents of each bag.

Directional Drawing: You will need five simple geometric designs on paper. Make sure the paper has a backing so students cannot see the design through the paper. Each student will need paper (recycled is fine) and a pencil. No erasers are allowed.

Language Arts

Visual Art

Arrange students in groups of four to six. One student, the starter student, is given the drawing. She cannot show the drawing to her group. On your signal, the student with the drawing must explain how to draw the design. Group members draw as she explains.

When time is up, students can compare their drawings with the original. Geometric designs are then passed to the next group, and a different student gets a turn to give the directions.

Student Reflections

Invite your students to consider and respond to some of the following questions in their response journals.

- 1. How did learning to sit as an audience member help you as a speaker?
- 2. Do you make up more questions in your head now? If so, how does that help you?
- 3. How did you feel about someone listening to you so intently? Why?

Teacher Assessment

Focus: Listening Actively

Name:	Date:		
	Frequently	Sometimes	Rarely
Technique: Positive Body Listening			
The student demonstrates positive body language with peers with teachers with guests with friends			
Technique: Giving and Receiving an Image			
The student demonstrates focus and concentration during descriptive sharing receptivity towards partner's input			
Technique: Questioning			
The student demonstrates a spirit of inquiry through pertinent questioning during presentations through pertinent questioning after presentations during discussions after a presentation by note taking during a presentation			
Comments:			
			В

CHAPTER

Remembering

Sam (short for Samantha) had good energy in front of a crowd and a nice smile. But what, I wondered as I watched her in front of her Grade 10 class, was she doing with her hands and eyes? She would say a few lines, stop, look up towards the ceiling, then suddenly shake her right hand and go on. Over and over again she did this — pause, stare, and shake. Then it hit me. She was reading. Somewhere in her mind were lines of text that she was reading, and when the words seemed wrong, she erased them with her right hand. It fascinated me how her imagination worked for her, but unfortunately, her reliance on the words blocked out any possibility of developing a rapport with us, her audience, essentially the purpose of her giving the presentation in the first place. The lines of Sam's speech were not yet part of her. She had not learned them well enough to allow them to flow out of her as natural dialogue. Our reaction to her words, even our existence didn't matter; she was too busy reciting the words in her head.

Remembering Versus Reciting

Dale Carnegie was one of the most effective and renowned public speaking instructors in North America. When asked whether or not someone should memorize a speech or presentation, his answer was a thunderous "No." Carnegie considered memorization a trap, and so do I. Winston Churchill was famous for his carefully planned and rehearsed speeches in Parliament. Then one day he got up and drew a total blank. He couldn't remember one word of his entire presentation. He sat down humiliated and vowed never to memorize a speech again. He didn't, and neither should your students.

Do not assume that working or improving your memory means memorization. It does not. I am frequently asked, "How do you recall all of the stories you tell?" My answer is always the same: "I remember them, as I remember what I had for breakfast." For me, remembering is a visceral act, actively using all of my senses and every aspect of my being. But I had to train myself to *see* and *feel* the information I needed to remember so it was part of me. This mental, emotional, and physical involvement is one hundred times more effective in communication than memorization, and if you have ever listened to someone recount a memorized speech, you know exactly what I mean.

"Thank you for helping me to remember. That's what I needed. Now I'm not so nervous."

Sylvia, Grade 8

"My mom and me worked out our own strategy. She paid me a penny every time I practised my story out loud. I practised lots."

Amy, Grade 6

I can always tell when a student has memorized a presentation. His focus is not on creating a rapport with the audience or with expressing the words with intensity; it is on *reciting* words. He will stare at the back wall or the ceiling as though reading invisible prompt sheets or look past the members of the audience, not even registering their presence. He is preoccupied with words and not his own natural words either, not the words he uses in everyday conversation to express his thoughts, feelings, and passions, but *contrived* words that leave out the heart of what he really wants to say. Students have personal thoughts and opinions and express them every day of their lives. A public presentation is the last place where a student should give up or replace his natural sense of expression.

If your students are ready to *present* a speech, teach them the memory strategies provided in this chapter. However, keep in mind that the practice time for learning and presenting a speech is completely separate from speech writing. Creating a speech requires a different set of skills: research, structuring, writing to make a point, timing, and knowledge of the listening audience, as well as an ability to create small stories to exemplify points in the speech.

Do not try to compress the writing and presenting skills all together. If you want your students to present well, after you've taught them the writing process and given them ample time to create speeches that people want to hear, give them class time to learn, practise, and develop the other focus areas using their speeches. If you devoted two weeks of class time to writing the speech, then allow the same amount of time for preparation of delivery. (For more information on speech writing, see "How to Create a Speech," pages 137–38.)

Begin with Storytelling

The memory strategies used to learn a story are the same as those used to remember a speech. But, I have to admit, a speech is more difficult to remember and present than a story. Human beings are natural storytellers, but not natural speechmakers. According to research by educator Jerome Bruner, we even think in narrative. Stories tend to be easier for us to remember and are definitely easier to listen to than facts, figures, or just plain talk. For these reasons, it makes sense to let students *begin with stories* when developing their memories.

Beginning with speeches has several drawbacks. When a student presents a speech, she usually has written it herself. It has taken so long to put the material together that she feels every word she put on the page is precious and therefore must be presented. It is harder to paraphrase a speech, especially one self-written, and students will inevitably resort to memorization. I am not saying that students should forget what they write and say whatever comes into their heads or that they should not prepare and present speeches. I am saying that students will perform better, learn techniques more effectively, and develop their own memory strategies more easily through storytelling than through speechmaking.

So start with stories.

A collection of stories for your students is provided in the Appendix, Stories for Students to Tell. Your students can also use these stories when developing any of the other techniques in the focus areas and move onto speechmaking once they are ready.

Stories entertain. Your student audience will listen actively and develop better audience skills if allowed to practise these skills through stories.

In my own experience, both ESL students and Special Education students have remembered stories more effectively than speeches. I have often witnessed teachers surprised and delighted with the results.

Pre-test: Retelling a Story

The biggest hurdle for students to overcome is believing they can remember what they need to say. What happens if I forget? What happens if I go blank? These are all natural panic attack reactions, but are also based on the memorization trap. So, prove to them they can remember.

Read or tell the story below to your students. Ham up the gestures, facial expression, and vocal expression, because whatever you do, they will feel they can do too.

There was once a crow in crowdom who thought he was the most beautiful of birds. He would sit in the tree with all of the other crows, day after day, and shake his wings so that the feathers would gleam in the sunlight. "I am such a lovely color," he would say to anyone who listened. Then he would throw back his head and smile.

One morning he looked out through the branches and saw another bird, a very different kind of bird strutting across the grass. This bird had a long, long tail that dragged behind him. The colors of its tail twinkled in the early light. Then, all at once the new bird lifted his tail and spread it out wide, like a gigantic fan.

The crow gasped. Never had he seen such glorious feathers. The rich blues and greens seemed to glow and on the tip of each feather was a magnificent colored eye. The crow stared after the bird as it strolled away and then just sat there in silence.

Finally the crow looked down at his own wings. "What a dull and ugly bird I am," he crowed. "Why can't I be like that bird?" As soon as he had said this, he knew he would be something else. He bent his head, snatched one of his feathers in his beak and pulled. Again and again he plucked and tugged, until at last he had removed every one of his own feathers and sat there — a completely naked bird. With one great swoop, he flew from his nest and searched for the new bird. For days the crow followed the beautiful bird. Every time an old feather dropped from him, the crow snatched it up and stuck it into his own skin. Soon he had bright green-blue feathers sticking out of him in every direction.

"Now," he said to himself, "I am beautiful, too beautiful to live with plain crows." So the crow moved in with the flock of new birds. When the peacocks found this strange and ugly bird amongst them they shrieked and pecked at him. They chased him away. The crow could not live with the peacocks. The crow flew back to crowdom. When the crows saw the strange and ugly bird, they also shrieked and pecked at him. They chased him away too.

So now the crow sits in his nest all alone with no one. And no one admires him, not even himself.

At the conclusion of the story, arrange students in pairs. One student is A; the other is B. Instruct A to start telling B the story. Since some students have trouble getting started, I recommend giving A the opening sentence to get the story moving along. After about twenty seconds, clap your hands. This is A's signal to stop telling and let B continue the story where

A left off. Wait another twenty seconds, and then clap again. Continue this back and forth until the story is completed.

Remind students that they must tell the story they just heard. It will not be exactly the same because they cannot possibly remember every word you said, but they do know what happens. The story cannot be about a blue jay that marries a submarine. Another day they can create their own stories; their task today is to remember this story in the correct sequence.

If one set of partners is finished much sooner than the others, tell them to retell the story, adding more details.

After this exercise, gather the students together and ask the following questions:

- Did you have difficulty remembering any parts of the story? (Most students have no difficulty remembering the story. If a few did have difficulty, ask them what they did to finally remember or what they would do next time to help them remember.)
- What did you do to help yourself remember? Did you see pictures in your head? Did you remember certain words?
- What part was your favorite?
- Did you add any gestures or facial expression when you told the story? What were they? Did that help to tell it?
- As a listener, did you hear anything different in your partner's version of the story? What?
- Could you tell the whole story on your own? (You could assign the telling as a reading buddy alternative if the students are involved in sharing stories with younger children.)

On a class list make note of the students who struggled with the telling. These students may need special tactics to help them remember. These tactics are investigated later in the chapter.

Words to the Wise

A few students may want to prompt, disagree with, or take over the telling from their partner. So make a rule: No interrupting the teller. If the teller wants help, he must ask for it.

The younger the students, the more active, or kinesthetic, the learning modes tend to be.

Strategies for Remembering

Learning something new is a challenge at any age. Consider your own ability to take in new information and learn something you must use. How do you best remember it? Do you write it down? My mother has sung everything she ever had to remember, including her multiplication tables. Perhaps *you* need to hear it over and over again.

On the basis of his research in the field of learning strategies, educator and theorist Howard Gardner confirms that we all learn best in different ways. According to Gardner, there are eight learning modes, or "multiple intelligences," through which human beings learn. He says that the range is enormously different: some people learn best through movement, while others use mathematical or logical thinking. After twenty years of working with children (and adults), I agree. We all use different strategies to learn and combinations of strategies to learn well. I add one more "intelligence" to Gardner's list — imagination.

When I want to remember a new story or rehearse a speech, I use several strategies to help me internalize the information I need. I usually start by reading the text out loud to hear and get used to the words. I often play with the words by

"My secret is simple: preparation. I address audiences naked, that is, without a lectern in front of me . . . The cost of speaking without notes is hard work — it means writing out a talk and committing it to memory beforehand — but it pays off in face-to-face audience contact."

James C. Humes

To give a great presentation, remembering the words is only the beginning.

Words to the Wise

"Seven Strategies for Remembering" can be sent home as a homework assignment. Before doing that, though, be sure to model the strategies. I have requested parental involvement, encouraging parents to work on a strategy with their child and to listen to the child practise. I also send home a list of praise words for parents to encourage their child.

Words to the Wise

It is *never* enough to say a story in one's head. Everything changes — tone, pace, character dynamics — when the story is spoken aloud. In order to internalize the story and let the process develop, each student needs an opportunity to learn and practise out loud without fear of embarrassment, ridicule, or criticism.

singing them, exaggerating them into melodrama or racing them — focusing on speed and automaticity. Sometimes, if I want to learn something extra quickly, I tape the material and listen to myself tell. I play the tape many times — this is a perfect strategy when in the car. When the material is comfortably in my head, I tell it to myself out loud, over and over and over. In all cases, my imagination is actively involved. I need to *see* what I am remembering, or I won't remember.

I learned my most effective and efficient ways to remember over years of trial and error.

But students don't have years. They need to discover quickly what their memory strengths are or how they learn best. Out of the seven activities outlined in "Seven Strategies for Remembering," at least three strategies should work for each of your students.

Activities: HOW I REMEMBER BEST . . .

Benefits: Explores a variety of learning strategies and develops memory through reading, auditory stimuli, drawing, movement, singing, sequencing, and imagination

Format: Review and discuss "Seven Strategies for Remembering" (see page 46). Or, if you prefer, share only three or four strategies at a time. Ask students to choose at least three strategies to experiment with. They can either select their own stories to learn, be assigned stories from the Appendix, Stories for Students to Tell, or apply the memory strategies to a speech they have prepared.

It takes a minimum of one week for a student using the memory strategies every day, to be free of the text. When students are comfortable with the words and do not have to keep looking at the print, then the other focus areas can be tackled. As the story or speech is worked on through different techniques, the memory of it becomes stronger and stronger. It is not unusual for the learner to refer back to the text, even after a few weeks of working on the selection, to clarify a word or a phrase that seemed important.

After each session of learning their material, ask the students the following questions:

- Did this strategy help you to learn your first story faster? How?
- Would it help if you combined this strategy with another one?
- Do you need a partner to learn better, or do you learn faster alone? Why do you think that is?
- Are you ready to tell your story out loud to someone else? If not, how many more practice sessions do you think you might need?

Invite them to respond in their journals.

After reviewing the seven strategies, instruct students to suggest other ways to learn a speech or story and add them to your list. Every memory strategy suggested uses a different learning mode to promote remembering, but every one leads to practising out loud. The student suggestions must do the same.

What to Do About Forgetting

Every once in a while, everyone forgets something. I have witnessed a variety of "oops, I forgot" displays from the front of a classroom. One young woman simply stood there, as if frozen, holding her breath. A boy in Grade 5 repeatedly smacked himself on the side of the head. Neither tactic worked to bring back the

Seven Strategies for Remembering

1. Reading Aloud

Choose a story or draft a speech that appeals to you, and get a piece of string, yarn, or a shoe lace about 20 cm (8 inches) long. Read your story or speech out loud with lots of expression. You might read to yourself, your pet, or a parent. Picture the story in your imagination. Put a knot in your string to record your reading. After you have read the story out loud five times (and put five knots in your string), try telling the story out loud to yourself without looking at the story. If you get stuck, check that part of the story, then put the story down and make yourself keep telling. Now read the story five *more* times out loud with lots of expression. Remember to use imaginative pictures (and put five more knots in your string). You should be able to tell yourself the story now without reading it at all.

2. Drawing

Think about your story as a cartoon. How would you draw the main character? How would you draw the setting? Draw out your story as ten to fourteen cartoon pictures, but do not add the word balloons. Check to be sure your cartoon shows the beginning, middle, and end of the story. Color your pictures. Show your cartoon to a friend and tell them the story using your cartoon as your illustrations.

3. Listening

Read your story into a tape recorder with as much expression as you can. Listen to the story four times. See the story in your imagination. During the fifth time listening, tell the story along with the tape. Now shut the tape recorder off and tell the story to yourself out loud. Could you get all the way through? Listen to the part where you got stuck and try saying just that part. Now, go back to the beginning and try telling the whole story again.

4. Singing

Sing your story as a song to a familiar tune. (It can be a simple tune like "Three Blind Mice" or "Teensy Weensy Spider," a rock song such as "Rock Around the Clock," or a ballad-style song such as "The Wreck of the Edmund Fitzgerald.") You can write out the song first if you like. You can also rap it if you wish, but remember a rap must rhyme!

5. Improvising

Act out your story as though you were in a play. Try the different characters with different voices and different walks. Then try telling the story as though you were the narrator, adding in the different characters as the story unfolds.

6. Mapping

Create a map of the story (or path of events) and tell the story to yourself or a partner using the map as your guide.

7. Sequencing

Condense the whole story down into sixteen essential lines. Then, shrink the sixteen down to eight. Put the eight lines on index cards, one line on each card. Shuffle the cards, then put them in order of the story from beginning, middle, and end. Shuffle the cards again and try to put them in reverse order. Shuffle the cards and see how fast you can order them. Have a contest with a partner to see who can order them the fastest. Now try telling the condensed version out loud to yourself. Next, do the longer version. If you are missing some words that you really wanted to use, go back to the text and practise that part out loud.

"The human brain starts working the moment you are born and never stops until you stand up to speak in public."

George Jessel

lost thought or words, but it did serve well to point out the blunder and make a bad situation worse. I forgot a major part of my story the first time I performed with Bob Munsch. I was nervous! But I didn't freak out. I carried on with the story and worked in, bit by bit, the part I had left out. To this day I don't think Bob or anyone else in the audience knows.

The trick to teach your students is this: Stay calm. Don't panic. Don't dance around. Don't walk out and never *ever* apologize. Until the presenter blabs it to everyone, no one knows something has gone amiss. Students need tactics to help them get around what they forgot. And the best time to practise these tactics is while they are learning and rehearsing their presentations with partners and in small groups. After students have had a few sessions learning their material, have a class discussion on what to do if you forget in front of an audience. Discuss the tactics listed below, then ask students for more suggestions to add to the list.

Using the audience

Tactic #1 Stop and ask the audience what they think will happen next. This stalls for time while you regroup and give yourself a chance to remember. Calling upon the audience has to look intentional. (It is also called faking it.)

Tactic #2 If you forget a fact, name, or number stated earlier in the presentation, ask the audience if they remember.

(These tactics are further developed in Chapter 4, Developing Rapport with an Audience.)

Using improvisation

Tactic #1 Try to work in the missed part during the section of the story you are telling now. Doing this takes fast thinking and a strong sense of where the presentation is going, so other parts are not lost in the process. (See Chapter 8, Improvising, for games on fast thinking and doing two things at once.)

Tactic #2 Stop the story or presentation where you are and add in the missed section using an insert line, such as one of these:

- "Ahhhh, but what you didn't know is . . ."
- "But this character never knew that way back . . ."
- "Let me give you a bit more information here the listener never knows . . ."

Using honesty

Tactic #1 Do not apologize. Simply state, "I neglected to give you this vital piece of information earlier . . ." Then say what you need to and go on with the presentation.

Overcoming the Terror of Forgetting

If you encounter a student who is absolutely sure he will forget his presentation, even after practising and trying relaxation techniques, this student needs visual prompts. Visual aids give the presenter a map to follow and allow him to feel he is not the centre of attention: the audience is looking at the visuals, not him. This is not necessarily true, but the perception works. I have used these tactics with many Special Education students who have experienced great success.

Tactic #1 Use props: stuffed animals, cut outs, toys, puppets, or objects mentioned in the story. The student arranges the props in an order from the beginning to end of the presentation so that the props act as prompts or cues to trigger the student's memory. The student should practise with the props and handle them throughout the presentation so they are a natural part of the performance.

Tactic #2 Assign the student a pattern story to present. The repeated words are easier to remember. Repeated gestures that coincide with repeated words intensify memory triggers. A pattern story is provided in the Appendix, Stories for Students to Tell.

Tactic #3 Illustrate the presentation and display the pictures during the performance. The pictures can be displayed on folded cards that are easily propped up on a table or taped to the blackboard. They can also be clipped onto a clothesline during the presentation. An alternative is to adopt a specialized type of storytelling in Japan called Kamishibai. Using this style the teller stacks the pictures, with the first picture to be seen on the top, and places the pictures in a display frame that stands in front of the audience. As the teller tells the story, the pictures are removed, one by one, revealing the next picture in the stack. The teller must know exactly where to put the pictures each time one is removed, so her hands are free to express the story.

A Time for Recitation

Now, having proclaimed my views on remembering as opposed to memorization, I must admit there are times when memorization is necessary, as in the case of performing poetry. To allow students to paraphrase the words of Yeats, Shakespeare, or Lear is inappropriate. Students must know every word as written by the author and present it as such. This type of memory challenge is good for the brain, just like learning the timetables or a new language. But once the selection is memorized, students should incorporate eye contact, gesturing, tone of voice, stance — all of the elements of good communication — to share the poem with an audience.

An enormous sense of satisfaction and artistic achievement is gained from committing a piece of poetry to heart. Poetry selections tend to stay with us for life. I can still recite poems I learned as a girl because the sound, imagery, and meaning were important to me and still are. The essence of the poem climbed inside me and became a personal way to express myself. "The Owl and the Pussy Cat" by Edward Lear and "Hiawatha's Childhood" by Longfellow still dance in my head and delight my tongue. Poetry is powerful. The very form of it focuses the senses and the emotions. Allowing students to express themselves through poetry is a great gift.

For your students to enjoy and succeed in this lifelong joy, finding the right selection is key. Encourage your students to read through a poetry book searching for a piece that speaks to them. But be sure to give them anthologies designed for their age level, so the themes and rhythms call to them. Instruct students to read their favorites out loud. Performing poetry is very different from reading poetry silently. Some selections scream to be spoken aloud, while others need to be kept in the head or make no sense off the written page. When students find a poem they enjoy and that works out loud, have them use the memory strategies suggested earlier to learn the poem. More time might have to

be spent practising the piece aloud, with the text close by, to get every word correct. Eventually, employ the other focus areas as well to shape the delivery.

Here is a short list of poems I love to recite. Have your students look them up and give them a try.

- "The Jumblies" by Edward Lear
- "Jabberwocky" by Lewis Carroll
- "Stopping by Woods on a Snowy Evening" by Robert Frost
- "Mr. Nobody" (Anonymous)
- "Sarah Sylvia Cynthia Stout" by Shel Silverstein
- "Who Has Seen the Wind" by Christina Rossetti
- "Mrs. MacGee" by Dennis Lee
- "A Thing of Beauty" by John Keats
- "Washing Windows" by Sheree Fitch
- "Tomorrow, and Tomorrow, and Tomorrow" (from *Macbeth*) by William Shakespeare
- "The Cremation of Sam McGee" by Robert Service
- "If I Had a Brudda" by Loris Lesynski

Curriculum Extensions: Mapping

Imaginary Mapping: In pairs or threes, students recall their favorite stories. The stories can be picture books, folk tales, or novels. Discuss where the stories took place. As a team, students create a map of the location of one story.

School Mapping: In pairs or threes, students create a map of the school. On the map they signify the following:

- 1. Places in the school where a student can rehearse stories or speeches without disturbing other classes;
- 2. Ideal locations for different kinds of performances, such as ghost stories told in the furnace room; and
- 3. Source sites, or places where students will find information, research, interview candidates, resources, and interesting facts.

Memory Mapping: Each student is given a large sheet of paper. On the paper the student draws a map of a place about which she has a fond memory. It could have been a place where she celebrated a special occasion, went on a trip, attended a party, or went to play. After creating the map, the student should find a partner and describe this special place in great detail, using the map.

Language Arts/Visual Art

Geography

Mathematics

Student Reflections

Invite your students to consider and respond to some of the following questions in their response journals.

- 1. Which of the memory strategies you tried worked best for you? Why?
- 2. Where else do you use this memory strategy?
- 3. What did you learn from the exploration of remembering that surprised you?

Teacher Assessment

Focus: Remembering

Name:	Date:			
	Accurately	With Assistance		
The student Practised memory strategies				
Remembered				
a short story from print (under one minute) a longer story from print (under five minutes) a self-written speech				
Recited poetry				
individually in a group				
Comments:				

CHAPTER

Developing Rapport with an Audience

She was placed on a stage, complete with lectern, microphone, and lighting. She was well known, too. That's why we all purchased tickets. But after forty minutes of watching her read from her notes, not even looking up once, I was ready to leave whether she was well known or not. I was annoyed. I felt excluded. I wondered why I had even bothered to come. After all, I could have read her notes too, but in the comfort of my cozy living room with a cup of hot chocolate. Next time, I thought, just mail your speech out.

Recognizing the Audience

When something like this happens in the classroom, it is even worse. The "audience students" often have not developed the this-is-boring,-but-I'll-listen-quietly etiquette we adults (especially teachers) have perfected. The student presenter is painfully aware of feet shuffling, coughing, papers scrunching, and the inevitable head down on the desk. "But what do I do?" the unprepared student presenter asks himself. Unfortunately, the student, like my well-known speaker, does the only thing he knows, the same thing, over and over.

If the student (or my speaker) had been presenting a play, the reactions would have been very different. An actor wants an invisible fourth wall separating him from the audience, establishing a "peek at my reality" scenario. The actor pretends the audience is not there. The successful speaker wants the opposite. Presenters, whether telling a story or running for office, need the audience on their side, rooting for them, supporting them, sympathizing with them, and believing them. But how does that magical personal bond happen?

Eye contact and audience participation would have saved my speaker and will rescue your students forever more. These are the simplest and most effective techniques used to establish audience rapport. Of the two, mastering participation is the harder, but it has more dynamic results. Audience participation should not be attempted by the speaker until he is comfortable with initiating eye contact. After all, how can a speaker direct an audience to join in or answer a question if he cannot even look at them?

"I find I look at my friends now when I talk to them!"

Jasmine, Grade 8

"I loved your smile. It warmed the whole room and relaxed us. Thank you for that!"

Comment to student

Pre-test: Making Eye Contact

Arrange students in partners. Instruct them to take turns describing a favorite movie that their partner has never seen. Encourage them to make it sound so interesting their partner would want to see it that night! Ask them to use detailed descriptions of the best scene. Describe the setting and the characters. Observe students as they share.

- Do they actually look at their partner?
- Is there any eye contact at all?
- Where do students hold their focus beyond the partner or on some part of their own body?

Record your observations on a class list.

Technique: Eye Contact

"Look me in the eye when you say that!" My mother used that line on me through most of my elementary school years. She believed, as do most North Americans today, that looking someone in the eye is a sign of sincerity. I could never tell a lie or say something outrageous if I was looking her right in the eye . . . could I? She was sure she would see my indiscretion . . . sense any falsehood . . . know my sincerity. She wanted to be able to trust me . . . and so does an audience. Direct eye contact not only develops trust between the speaker and listener, it also gives the presenter power over the listener, commands respect, makes the speaker appear composed and strong willed, and finally demands that the listener pay more attention before a single word is even spoken.

Unfortunately for many of us, initiating direct eye contact is intimidating. It doesn't matter whether we are sincere or bursting with something important to say — or not. Some world cultures interpret direct eye contact as rude or invasive, so children are discouraged from using it. Therefore, telling a student to "look at your audience when you speak to them" is not enough. The key is to train the students in eye contact *before* they get up in front of an audience.

Refer back to the pre-test above when your oral language project is over to gauge student progress. Ask students to record in journals or share during reflection discussions whether they noticed any changes in using eye contact outside the classroom.

Introductory eye contact techniques

Game: PERIPHERAL VISION CHALLENGE

Benefits: Destresses eye contact, develops observation skills, develops concentration skills, and increases ability to work with new people

Format: If students have never vocally described something, they might need some practice before playing the game. Instruct all students to stare at a single object, such as a desk, book, or plant, without looking away. Then, collectively come up with as many descriptive words as possible. Point out that *fact* words (color, texture, shape) are acceptable descriptors while *judgment* words (ugly, stupid, disgusting) are not. Judgment words do not describe what is there: they state an opinion. This warm-up also discourages students from trying to use this game as a means to hurt or humiliate another student.

Now, have half of the class sit in a circle facing outwards. The rest of the class forms a circle around the first circle and sits facing the inner circle. Partners face each other knee to knee, in cross-legged position with hands in lap so they are visible to each other. The inside circle partner starts. The starter must look directly into the eyes of the partner and describe what they see — facial features, clothes, and accessories — without breaking eye contact. Allow only sixty seconds for starter to describe as much as possible; then it is the second partner's turn to do the same.

After both have had a turn, partners close their eyes and wait for you to announce one memory challenge.

Words to the Wise

When I played this memory challenge game with participants in Japan, they all laughed, because, of course, all of them had brown eyes. This challenge will only work in diversified groups.

Sample Memory Challenges

- How many buttons (or zippers) is your partner wearing?
- Identify a distinguishing feature on your partner's face, for example, a
 mole or freckle.
- Identify which eye is slightly bigger.
- Identify which nostril is slightly bigger.
- Describe the different colors in partner's hair. (Even black hair has red or bluish highlights.)
- Describe one piece of jewellery or form of decoration.
- Recall any lettering on clothing.
- Describe partner's ears.
- Describe partner's collar.
- Identify the color of partner's socks.
- What color are your partner's eyes?

Change partners many times by instructing the outer circle to move clockwise. The game ends when students are back to their original partner. This kind of partnering enables students to work with students they would not normally select and also removes barriers between looking closely at partners of the opposite sex.

Game: OH YEAH?

Benefits: Destresses eye contact and develops concentration, literacy skills, and active listening ability

Format: Allow students to select partners (or select partners for them). Instruct pairs to be scattered about the room so they are not too close to another set of partners. Student A looks into the eyes of partner B and makes an absolutely outrageous statement without blinking, looking away, or smiling. Partner B then responds to the statement by saying, "Oh yeah?" and then tries to top it. The response must be on the same topic. Here is an example:

Partner A: My dog bit my head off last night and it took the doctors at the hospital six hours to sew it back on.

Partner B: Oh, yeah? Well, my brother still hasn't found his head and he's lost ten pounds looking for it, because he can't eat!

The game continues back and forth until someone breaks the rules by looking away or laughing. When that happens, the person who stopped the game must start the game again with a new opening line. Students can make up their own outrageous opening lines, but here are a few for you to copy and hand out to get them started:

Outrageous Openers

I dropped my hand outside at recess today. A Grade 1 student found it and brought it into the office.

On my way to school today, the sky turned black and blue. I think it's bruised.

The principal came to school in his underwear this morning.

My mother served toads and fried worms for dinner last night.

I swallowed a clock the other day and now my stomach keeps waking me up in the middle of the night when the alarm goes off.

My computer yelled at me last night. It said, "Stop hitting my keys so hard!"

I found an elf under my bed and he gave me a wart.

My neighbor has a pet skunk that's grown too big to fit in his garage.

Lightning struck our house last week and my father is still glowing.

My grandparents' swimming pool sank and disappeared. Apparently it resurfaced somewhere in China.

Extension: After playing the game several times with new partners, instruct students to go home and ask family members or look in the paper for an outrageously true anecdote. Play the game again, mixing outrageously true statements with false statements and allowing partners to guess which ones are facts. (*Ripley's Believe It or Not* and the *Guinness Book of World Records* are two more excellent resources for student reference.)

Before students begin creating a cooperative story, establish these rules:

- 1. Do not use names of people in the class.
- 2. Use eye contact.
- 3. If the speaker does not make eye contact with you, call them back to you.

More Opening Lines

- While I was walking home from school, popcorn fell out of the sky.
- When I woke up this morning, my whole family was missing.
- Last night I went for a ride in a police helicopter.
- My new house is made entirely out of glass.
- My sister has a doll that can talk, sing, dance, and do my math homework.
- My grandmother gave me a cheque for fifty thousand dollars.
- I made a snowman once, and he got really angry.
- Santa Claus no longer uses a sleigh.

As the students progress in the "Eye See!" game, enlarge the group until there are up to twelve members playing. Do this over a period of days or even weeks.

Game: EYE SEE!

Benefits: Destresses eye contact, develops concentration skills, literacy skills, and active listening, and fosters creativity

Format: Students form small groups of four to six and sit in a circle. The starter is assigned an opening line. For example: "Yesterday in the park I saw a purple dragon!" As the starter says the sentence, he must look at a member of the group on each word and make eye contact. If eye contact is not made, the player must pause until eye contact is achieved. The group member to get the last look and word advances the game by continuing the story, but must use the word given to her in her sentence. Here is an example.

First speaker says, "Yesterday in the park I saw a purple *dragon*," while looking at a different group member on each word. The last person looked at was given the word *dragon*. This person continues the game and might say, "The *dragon* snatched me up and carried me *away*," making eye contact with a group member on each word. The group member who was looked at last and was given the word *away* continues the story using the word *away* and establishing eye contact on each word.

Be sure to watch for the following common practices and point them out to students:

- Some students will inevitably look down at their own chests and give themselves a word. Tell them not to talk to themselves.
- Students might break up words into syllables and give only one syllable per student. For example, the word "tomorrow" becomes to-mor-row, given to three students. Instruct them to give whole words only.
- Students will try to point at other students with their fingers instead of focusing their eyes on them. Have them sit on their hands. Also, some students will look very chicken like because they will peck at who they are looking at when they say the word. This will pass.

Advanced eye contact technique: The sweep

When your students are making eye contact easily, it is time to take the technique one step further so it will appear more natural. Students must learn to sweep their eyes across the audience, pausing at certain people, making eye contact and then continuing the sweep. They must learn to be conscious of seeing everyone in their audience, not just the people on their right (this is a natural inclination) or just their friends or just the members of the audience that look interested. This technique needs to be practised in larger groups (8–15 members) and can even be played with the whole class. The sweep does not have to be developed at the conclusion of the eye contact portion of your project. If you wish, it can be introduced later, when the class is working comfortably with larger groups or as a whole class.

Game: EYE SEE YOU, YOU, AND YOU

Benefits: Develops selective eye contact, awareness of an audience, literacy skills, concentration, and active listening

Format: This game follows a similar format to the previous game "Eye See!" but in this game, the speaker will say three sentences, instead of one during his turn. While the speaker tells his section of the story, he must "sweep" the members of the group and pause at one person, making direct eye contact at least once in each sentence. Therefore, during his telling he should glance at each member of the audience, but pause and make direct eye contact with three different people. When the speaker pauses and makes direct eye contact, the listener being looked at responds by holding up a finger to acknowledge the speaker has obtained a "hit." This helps the speaker keep track and ensure the members are watching. If the speaker has only made one hit and has already told three sentences, the speaker must keep telling until all three hits are made. The speaker cannot make all three hits in one sentence and pass on the story. The goal for each speaker is to tell longer than one sentence, sweep the audience a few times, and make three direct hits.

One of the biggest challenges in public speaking is being able to manage many things at one time: controlling nervousness, remembering what to say, and keeping alert to the audience. This game is good training in learning to juggle the factors.

Technique: Audience Participation

He looked me right in the eye and asked, "What do you think the character should do?" When I answered him, he winked at me. I nearly fell right out of my chair. He was in Grade 9 and I was the guest instructor. He winked! It took guts, to be sure, but he was in control. I knew it and so did every other person in the room. He was the master of himself and the audience, and it wasn't just the wink that showed us. It was his ability to address the audience and include them, all of them, even me. The most surprising part was that his teacher thought he was quiet and unassuming, not a grab-the-class-by-the-throat kind of guy. He surprised us all. I wonder, even to this day, if he surprised himself. But in retrospect, it only made sense. He was given the tools and the permission. So he did it. And so can your students.

Including the audience in a presentation keeps them focused and thinking, but doing this takes skill and practice. These simple games will enable your students to command an audience at the level they are comfortable with. Variation A is the easiest to execute and variation B the most difficult. Start by teaching your students to play "My Worst Day" and add in the variations as the students are ready. Every time the class replays the game, form new groups so the group dynamics are different. Each variation develops a different method of involving the audience. But be warned: there is enormous power in learning how to manage an audience. It can change students, especially the quieter ones!

Every time a new exercise is added to the game "My Worst Day," an alternative game can be played. Instead of "My Worst Day," the students can play "My Luckiest Day," "My Strangest Day," or "My Scariest Day."

Game: MY WORST DAY

Benefits: Increases awareness of audience, promotes spontaneity, develops sequencing skills, encourages use of humor and exaggeration, develops group cooperation, and strengthens active listening

Format: Students form groups of four to six and sit in a circle. Starter begins telling a story with this opening line: "This morning when I got up I..." Perhaps she fell out of bed or was an hour late for an appointment. The incident could be imaginary. The student to the starter's right continues the story of the day by describing the next thing that happens. The day should get progressively worse.

Ask students to observe these rules:

- Students should strive to remember what other tellers said so details are not repeated.
- 2. Students must continue the story using what was already stated. For example, if the first student says, "When I got to school, . . ." the second student cannot say, "At work I . . ." The story must make sense and be sequential.
- 3. Students may not use names of people in the class.

Variation A: YOU'RE THE ONE

Benefits: Develops ability to ask one member of the audience a question, promotes audience control and management, increases awareness of audience, develops composure, and develops active listening

Format: Play the game "My Worst Day" (or alternative) and add in the following components: during each student's turn at telling, he must stop, look at one member of the group, make eye contact, point to her, and ask her a question about the story. For example: "What do you think I should do now?" or "Has that ever happened to you?" After the group member answers, the teller acknowledges that answer with a comment as simple as "Good answer" or "That's a possibility." The acknowledgment does not have to be long or profound; it just has to validate the response.

All four components are necessary. The eye contact and the point gesture indicate to the rest of the group that the question is meant only for one person. The validation makes it a positive experience for the contributor and makes the teller appear sensitive and accepting.

Systematically enlarge the groups so the students are playing with twelve or more people. Once a student can easily manage the eye contact, gesture, question, and validation, he will have no difficulty executing this kind of audience participation during a presentation.

Variation B: WHICH ONE WILL I CHOOSE?

Benefits: Develops ability to involve entire audience, to control and manage an audience, and to project composure; also increases awareness of audience

Format: Play "My Worst Day" (or alternative) and add in the following components: during each student's turn at telling, he must stop, sweep the group with his eyes, gesture to all of them with an open palm, and ask a question about the story such as "Do you think I should have done that?" or "What do you think I should do now?" The teller then gestures for all to answer the question by

Words to the Wise

Most speakers make the mistake of asking questions to a group in a general way such as "Has anyone . . . " or "Anybody here . . ." Instruct students to address a group as though they are talking to one person, even though they may be talking to twenty people. The speaker says, "Have you ever had that happen?" The eye sweep and the gesture indicate that the speaker is asking everyone, but the words keep it personal.

After students have experimented with the variations using the game format, allow them to use these techniques while storytelling.

Refer to Chapter 12, Developing Content for Performance, and the Appendix, Stories for Students to Tell.

Language Arts/Music

cupping his hands behind his ears, leaning forward and listening, or holding his palms open and sweeping the audience until answers start to emerge. But the teller must decide when to stop the answers and clearly indicate this by gesturing for silence. He can easily accomplish this by raising his hand and freezing it in a police-type motion. When the group is quiet, the teller acknowledges the answers with a comment. The teller can simply say, "Some agree, some don't," or "Good answers," or "There are many possibilities here." The acknowledgment does not have to be long or profound; it just has to validate the responses. Then the game continues.

All six components are necessary when involving a group: the eye sweep and the gesture indicate that the question is for everyone. The next gesture indicates that the teller wants an answer from everyone. The gesture for silence ends the participation.

Systematically enlarge the groups so the students are playing with twelve or more people. Once a student can easily manage the sweep, gestures, question, stop and validation, he will have no difficulty executing this kind of audience participation during a presentation.

Variation C: SAY IT!

Benefits: Develops ability to have audience join in, echo, or repeat a line or phrase; fosters ability to control and manage an audience; strengthens composure; also increases awareness of audience

Format: Play "My Worst Day" (or alternative) and add in the following components: during each student's turn at telling, she must stop, repeat a word or phrase from the story she is telling, such as "he slipped on the melon peel," then sweep the group with her eyes and say, "You say that" and gesture for all of them to speak together, either by using open palms or by cupping the hands behind the ears. Once the line is repeated (or echoed), the teller comments, "Well done" or "That's right."

All four components are necessary. Repeating the line tells the audience exactly what to say. Commanding the audience to speak does not leave them a choice. You never ask an audience, you tell them and they do it, but the tone of the command is inviting and friendly. The gesture indicates they are to do it now. The comment validates the audience's response.

Systematically enlarge the groups so the students are playing with twelve or more people. Once a student can easily manage the repetition, sweep, command, gesture, and validation, she will have no difficulty executing this kind of audience participation during a presentation.

Curriculum Extensions: Call/Response Patterns

Creating Call/Response Patterns: In cultures all over the world, storytellers call out a word and the audience knows they are to respond with another word or a sound. For example, in Jamaica, when a storyteller is speaking, he might suddenly call out, "Crick!" and the audience immediately calls back, "Crack!" In Native storytelling the teller calls out, "Hey!" and the audience calls back, "Ho!" In Africa, if the Swahili speaker says, "Paokwa," the listeners say, "Pakowa." It is a highly interactive, energizing and fun way to keep the audience involved. Instruct students, in partners, to create their own call/

response patterns and demonstrate them to the class. Here are a few examples of student creations:

Shish/Kebob!

Hot/Dog!

Space/Ship!

Advise students that they can create number call/responses, rhythmical patterns, musical patterns, and sound patterns. The patterns do not have to be just in words.

Surveying for Call/Response Patterns: Arrange students in partners or groups of three. Send groups to different classes in the school to survey what cultures and languages are represented in each class. Then determine if a call/response method is used in any of those cultures. Students must learn the call/response pattern as part of their research. Instruct students to compile a graph depicting the results. Each group will then share graph results with the rest of the class and demonstrate any new call/response patterns discovered.

Social Studies/Math

Student Reflections

Invite your students to consider and respond to some of the following questions in their response journals.

- 1. How did you feel about making eye contact with other people?
- 2. When you called for audience participation, what surprised you about the experience?
- Has learning to use eye contact or using audience participation changed the way you are at home or with friends? How?

Teacher Assessment

Focus: Developing Rapport with an Audience

Date:		
Frequently	Seldom	Rarely
iveness		
on 🔲		
	iveness on	iveness

CHAPTER

5

Using Body Language

Many years ago, when I was a teacher, I had a student in Grade 4 who was a natural speaker. His name was Tyler. He had every person's attention before he opened his mouth and it began with his walk. When approaching the front of the room to present his speech, he sauntered. His movement was deliberate, controlled, almost cocky, and it never failed to make me smile. But the best part was when he arrived at the front. He leaned his head back, crossed his arms over his chest, and nodded while looking at us, all of us. And that nodding had every one of us at his beck and call. We were there, just waiting to hear what he would say. We were set up, every time, and we loved it. He was good.

Sending the Right Message

Without a single word spoken, the body conveys messages good and bad. The roll of her eyes indicates how Shelly feels about her friend's new boyfriend. Darrin's hands stuffed into his pockets tell the caretaker how he feels about the lecture. Your crossed legs and tightly folded arms tell your principal how you feel about the new duty schedule. A smile says yes to the date and a wink agrees to the joke.

As public speakers, students need to impart positive messages to their audience. The audience should perceive them as competent, composed, and in control, and students should aim to hold their audience's attention so profoundly that only a bomb scare would make their listeners leave the room. Your students need to know that although their words may enchant the audience, their bodies keep the audience riveted.

Through *stance*, *gesture*, and *facial expression* a speaker can add immense power and passion to a presentation. This statement does not mean every speaker is supposed to use the antics of Jim Carrey. It means a controlled, selected embellishment of the meaning of the words.

Stance is the most important of the three body language techniques. Through stance the speaker conveys a positive or negative attitude towards the audience which ultimately affects how the audience accepts and responds to him.

The second most important technique is facial expression. Reflecting the meaning of words on the face adds conviction to the words. I once watched a

"I talk with my hands, but I learned how to control it. Before it would have been considered fidgeting, but now I make gestures. Everyone says I'm great!"

Samantha, Grade 9

"There is a real magic in enthusiasm. It spells the difference between mediocrity and accomplishment."

Norman Vincent Peale

girl speak about a death and she smiled the whole time. It was unnerving. I realized her smile was a nervous reaction, but it destroyed the impact of her speech.

Finally, simple but meaningful gestures add power to the speaker's words. In the *Vancouver Storytelling Circle Newsletter*, Nan Gregory wrote:

My dad tops my list of good storytellers. I remember vividly the gestures he made while telling them. When God banished Adam and Eve from the Garden of Eden, my dad would point fiercely towards the gate. When God created Adam by breathing life into dust, my dad would puff twice into the cup of his hands. When Androcles took the thorn out of the lion's paw, my dad would take my hand in his, raise it to his mouth and take an imaginary thorn out of my palm between his teeth. My dad's gestures focused the moment of the story for me, and intensified the emotions with it.

Fifty years later those gestures are still with her. With practice, your students can have the same kind of impact.

Pre-test: Telling It Straight

Arrange students in groups of six to twelve. Stand back and observe the speaker in each group. Students take turns standing and describing the nicest or worst bathroom they have ever been in (without saying who it belonged to). They must describe the location, the floor, the toilet, the bath or shower, the lighting, the colors, and the factor that made it the best or worst. The absurdity of this assignment will bring out humor, which will relax the students.

Watch the speakers in each group for stance (how they stand), gesturing (how they use their arms and hands), and facial expression (how they use their faces), the most important of the three being stance, because that technique affects the other two.

Record observations on a class list. Ask students whether they noticed any connections between speaker behavior and audience reactions. For example, what did one student do that made everyone laugh?

Technique: Stance

Class Exercise: HOLD THAT POSITION!

Benefits: Develops awareness of body messages, confidence, and audience management skills

Format: Demonstrate the following ways to address an audience. You can show them yourself or students can hold the positions while you and the class observe.

USING A CHAIR

Position #1 Sit in a chair, lean back against the backrest, stick out your legs, and cross them at the ankle. Ask students what message this position gives them. What could this person be thinking? Is this person excited about being there? How does it make them feel as an audience member watching this message? Do they want to sit forward and listen intently or lie back and tune out?

Position #2 Sit in a chair, perched on the edge of the seat, feet planted firmly on the floor, and lean towards the audience. It should look as if you are going to tell them a secret. Ask students what message this position gives them. What could this person be thinking? Is this person excited about being there? How does it make them feel as audience members watching this message? Do they feel tense or expectant?

Position #3 Turn the chair around, straddle the seat and lean on the backrest, with feet hooked around the front legs. Ask students about this body language. Does it make them feel relaxed or perhaps amused? Compare the reaction to those aroused by the other two positions.

STANDING

Position #1 Stand in front of the class with one foot crossed over the other and hands in pockets. Ask students what message this position gives them.

Position #2 Stand in front of the class with feet planted firmly on the floor, hands at your sides, and lean slightly towards the audience. Discuss the reaction. Do the words intimidated, attentive, or expectant emerge?

Position #3 Stand in front of the class with feet planted firmly on the floor but quite widely spread. Place one hand on a hip and the other hand outstretched. Lean heavily towards the class. Ask students to compare this stance to the other two. Do the words curious or amusing emerge? Which stance do they prefer and why?

ANALYSIS OF POSITIONS

All three positions for sitting and standing give the audience very different impressions. How a speaker is perceived is vital to how she will be listened to.

The #1 positions for sitting and standing are ineffective for public speaking. They give the audience a message of boredom or disinterest. If the speaker appears bored or disinterested in her own material, then the audience will feel that way too.

The #2 poses are power positions. These can intimidate or command the attention of an audience without the speaker saying a word.

The exaggerated, but strong nature of #3 positions makes them suitable for comedic or amusing presentations. These positions attract an audience's attention but still appear relaxed and friendly. The stance a student chooses should be done consciously and for a specific reason. The stance should always reflect the tone of the presentation.

Stance facts

The presenter should always be higher than the audience and be easily seen by every listener. If the speaker cannot see every member of the audience, he should move or move members of the audience so that he can make eye contact at any time.

• *Sitting:* Some speakers are more comfortable sitting. It gives them a sense of security. However, the speaker must *never* sit behind a desk or a table. It distances the speaker from the listeners and the sense of intimacy is lost. If a speaker chooses to present in a sitting position, she must rehearse in that position. The chair should have no arms, so gestures are not limited and the

- chair should not be moveable. (See Chapter 7, Showing Composure, for information on controlling swinging legs and holding seats.)
- Standing: Standing is the strongest position to present from. It is a position of power, as long as the audience is seated. It also enables the speaker to move about, perhaps closer to the audience at times for participation or dramatic effect. The presenter should never stand behind a desk or a table I think it's a mistake even to use a lectern or music stand. The more the audience can see of the speaker, the more confident and controlled the speaker will appear. Standing is, however, the hardest position to maintain. All sorts of nervous tics manifest themselves when a speaker stands in front of a crowd. (Refer to Chapter 7, Showing Composure, for information on controlling fidgets.)
- *Kneeling:* If the audience is sitting on the floor, then the speaker should kneel, so he is higher than the audience but not too high. The fastest way to lose an audience is to not be seen.
- Changing Positions: A change in the position of the speaker attracts an audience's attention. If the speaker started to present sitting and suddenly stands, the audience is jolted into alertness. The same works for moving from a standing position to a sitting position. However, the speaker should not keep moving up and down, as it gets monotonous and loses its effect.

Practising stance

Instruct students to rehearse a story or speech with a partner in both standing and sitting positions. (The Appendix, Stories for Students to Tell, contains examples.) They will discover which position they are more comfortable with. If you want all of the students to stand, then instruct them to rehearse only standing. (Remember, though, that some students would be 100 percent better if allowed to sit.)

Game: SIT OR STAND, THAT IS THE QUESTION

Benefits: Develops confidence, audience management skills, observation skills, ability to determine appropriate stances for different people, and critiquing skills

Format: Arrange students in pairs. One student is A; the other is B. A speaks first from a sitting position. B sits at A's feet to watch. A can make up a story, tell a familiar folk tale, rehearse the speech he is working on, or tell a story from the Appendix, Stories for Students to Tell.

At a given signal by you (e.g., hand clap), A stops speaking, sits on the floor and B takes the chair to speak. B tells his own story or speech (not the same one A is telling). A watches and listens. At the signal, B stops and A resumes her telling where she left off, but this time tells from a standing position. At signal, A stops and B resumes his telling where he left off, but this time tells from a standing position.

The game continues in this manner for several minutes or until the stories are completed. Both partners should have several turns telling from both positions. At the conclusion of the tellings, each partner must determine which stance his partner was more comfortable with and give three reasons why. If the partner thinks he is wrong, she must give three reasons why the other position was more comfortable.

Technique: Facial Expression

Game: LET THE FACE DO THE TALKING

Benefits: Develops awareness of communication through body language, body control, and audience management skills

Format: Arrange students in partners, facing one another. Each set of partners is given an envelope with several slips of paper inside. These slips identify different emotions (photocopy and cut out the list on page 67). Starter student withdraws one slip of paper and depicts that emotion using her face. No sound or use of any other part of the body is allowed. The observing partner then mirrors his partner's expression and guesses which emotion she is expressing. A few guesses might be necessary. Once the emotion is guessed the roles reverse using a new emotion from the envelope.

Game: PASS THE JAM

Benefits: Develops ability to manipulate the face, gestures, active listening skills, and humorous expressions

Format: Talk all students through the following mime exercise to develop awareness of focus and the breaking down of each movement. Students sit on the floor, spaced out so they have room to work alone. Say the following words:

In front of you is a jar. Look at it. Reach for it. Grab it. Slowly pick it up. Hold it in two hands and screw off the lid. Set the lid down. Inside are dill pickles. Smell the contents of the jar. React to the smell. Reach in with two fingers and get a pickle. Pull it out. Hold it up and look at it. Bite the pickle. Chew. React to the taste. Swallow. Set the jar down.

Arrange students in small groups (4–6). Starter student mimes opening a jar, removing food from the jar with fingers, and eating the food. The student's gestures indicate what the food is. The student's facial expression indicates how the food is eaten and what the food tastes like. No words may be spoken. When the student has finished her mime, the others in the group guess the food. Student to starter's left continues the game with a new food from a jar. (To advance the game, students can also mime opening a can and eating the food.)

If students have difficulty remembering foods from a jar, here is a list:

JamPeanutsHoneyHot peppersPeanut butterMayonnaiseOlivesDill picklesPickled eggsHorseradishMaraschino cherriesSpaghetti sauce

Relish

And here is a list of foods from a can:

TunaSardinesBeansRavioliPopSoupDog foodPotatoes

Technique: Gesturing

Game: LET THE HAND DO THE TALKING

Benefits: Develops awareness of communication through body language, body control, and ability to manage an audience

Format: Arrange students in partners, facing one another. Each set of partners is given an envelope with several slips of paper inside. These slips identify different emotions (photocopy the list below). Starter student withdraws one slip of paper and depicts that emotion using her hands. Only her hands. No facial expression or body movement is allowed. The observing partner then tries the same hand gesture and guesses which emotion the hands are expressing. A few guesses might be necessary. Once the emotion is guessed the roles reverse using a new emotion from the envelope.

There are subtle differences between some of the emotions, for example, Hate and Anger, but the students will discover the differences if they work at it and discuss the nature of the emotions.

Eventually, compare this game to "Let the Face Do the Talking" on page 66, which uses the same format, but focuses on facial expression. Students will discover that if they only show emotion on their faces, the bodies tend to remain neutral. So, if a speaker often shows emotion on her face, but reflects no emotion in the rest of the body, she will appear cut off from the neck down. If she puts emotion in her hands, the face will naturally follow and show the emotion too. Therefore, to depict a strong emotion during a presentation, to make a point, or to give emphasis to certain words, lead with a gesture and the face will follow.

Rules

- 1. Students may not touch one another.
- 2. Students must imitate their partners' gesture to experience every emotion in the envelope.

Words to the Wise

This exercise is harder to do than it appears because it is difficult to separate emotions from the face. Emphasize that the face must remain neutral for full results.

Words to the Wise

Just as deliberate gestures can awaken and reinforce emotions, involuntary nervous behaviors, such as knitting your fingers, can aggravate nervousness — something for public speakers to keep in mind.

Horror	Fear	Love	Jealousy
Hate	Joy	Annoyance	Sadness
Frustration	Норе	Gladness	Foolishness
Surprise	Anger	Embarrassment	Giddiness

^{© 2001} Cathy Miyata, Speaking Rules! Pembroke Publishers Limited. All rights reserved. Permission to reproduce for classroom use.

There is often a lot of laughter during "Show and Tell" and that is fine. The more students exaggerate the events of the story, the more they are processing and interpreting what is happening. Initially, the students will "act out" the story independently, but eventually they will silently assume roles (sometimes becoming props or the scenery) and the story will be spontaneously performed as a collaborative effort.

This is an advanced game as it involves audience participation within the group.

Game: SHOW AND TELL

Benefits: Develops freedom in body movement and gesturing

Format: Arrange students in small groups of four to six. Starter student tells a familiar folk tale or reads a version from a book. Other members of the group demonstrate the actions, emotions, and characters with body movement and gesture, but no sound is allowed. After a few seconds, the teller passes the story to the student on his right. The game continues until the story is finished. If the story ends before everyone in the group has had a turn at telling, a new story must be started and the game continues until everyone has had a turn.

Game: TALL TALE TELLING

Benefits: Develops exaggerated expression, humor in presenting, spontaneity, and audience participation skills; increases volume of voice

Format: Read the following story to your students and allow for the participation. Exaggerate the words with your voice and add enormous gestures. The more you ham it up, the more your students will.

There once was a lumber jack named Paul Bunyan. He lived in the forest and he cut down trees. For those of you who have not heard of Paul Bunyan, well, you have to know Paul was a big man. I mean he was tall!!!!! He was sooooo tall. (*Reach your hands up over your head and point to the ceiling.*) I can hear you asking me, "How tall was he?"

Cup hand behind ear and wait for students to ask you, "How tall was he?" then go on with the story.

Paul Bunyan was sooooo tall . . . his hair was always wet from touching the clouds! Early one morning Paul woke up hungry. He stretched and yawned and scratched. (*Perform all of the actions*.) Then he sat real still. He could hear rumbling. A terrible rumbling. Maybe it was storm thunder or a stampede of wild horses. But it wasn't either of those things. Nope. It was his stomach. Paul was hungry. He was sooooooo hungry. (*Rub your stomach*.) I can just hear you asking me, "How hungry was he?"

Cup hand behind ear and wait for students to ask you, "How hungry was he?" then go on with the story.

He was sooooo hungry he could eat seventeen grizzly bears, six horses and a mule! In one gulp! Paul Bunyan got up and strode into the forest. (*Mime giant steps.*) His footsteps shook the trees. They were loud. They were soooooo loud, I can just hear you asking, "How loud were they?"

Cup hand behind ear and wait for students to ask you, "How loud were they?"

End the story here. You have now set up the pattern for the game.

Format: Arrange students in groups of four to six. Starter student begins telling an impromptu story about Paul Bunyan (or continues the one you started). The teller should stand while the rest of the group sits on the floor to listen. Instruct the teller to use enormous, exaggerated gestures to express the story and to call for audience participation. After adding two sections with participation to the story, the teller passes the story to the person on his right. The new teller stands and continues the story.

Words to the Wise

These stories get outrageous and are often worth writing down, but have students record the stories right away or they will forget what was said.

Curriculum Extensions: Miming

Fine Motor Mime Activities: Students sit on the floor, spaced out so they have room to work alone. Instruct students to act out the activity you identify, but in mime only. The movements must be slow, exaggerated, and precise. Facial expression should reflect how the student feels about the activity.

- Thread a needle and sew on a button
- Open a chocolate bar and bite into it.
- Peel an onion and cut it up.
- Finish math homework.
- Wrap a present.

Gross Motor Mime Activities: Students stand on the floor, spaced out so they have room to work alone. Instruct students to act out the activity you give them, but in mime only. Again, the movements must be slow, exaggerated, and precise. Talk them through the exercises if necessary.

- Walk up steep stairs.
- Lift a piano.
- Drive a car.

- Open a door to your surprise party.
- · Take a shower.

Partnered Mime Activities: Observation to detail and cause/effect relationships are the key to these activities. Remind students to keep the movement slow and controlled.

- Have a sword fight. (If the partner sweeps at your feet, you jump over the sword; if she jabs at you, you back up.)
- Wash the dishes.
- · Have tea.
- Carve a jack-o'-lantern.
- Cut down a tree.

Collaborative Mime Activities: Arrange students in groups of four to six. Instruct groups to collaboratively mime the activity assigned, bearing in mind that one thing must go wrong. For example, in the tug of war group, the losers could fall into quicksand. Allow ten minutes for groups to work out the mime sequence, then let them share the mime with the rest of the class. Restricting the movement to slow motion helps students maintain control and precision.

- Play tug of war.
- Rearrange a living room.
- Skip double Dutch.
- Assemble a bicycle.

- Build a raft.
- Give a dog a bath.
- · Put out a fire.
- · Net a crocodile.

Student Reflections

Invite your students to consider and respond to some of the following questions in their response journals.

- 1. Now that you know more about body language, what surprised you?
- 2. How have you changed the way you use your body?
- 3. What have you noticed about people using their faces when they talk?

Drama

Drama

Drama

Drama

Teacher Assessment

Focus: Using Body Language

Name:	Date:		
	Frequently	Sometimes	Rarely
Technique: Stance			
The student displays awareness of body messages and adjusts body for different situations ability to use stance to convey a message			
Technique: Facial Expression			
The student displays ability to use facial expression in everyday conversation ability to use facial expression for emphasis			
during a presentation			
Technique: Gesturing			
The student displays ability to use hands for expressiveness in everyday conversation ability to use full hand and arm gestures for emphasis during a presentation			
Comments:			
	No.5w		

CHAPTER

6 Exploring Voice

"You'd make a great mime," a woman said to me once after a storytelling performance.

I hardly knew what to say. I muttered a thank you, hoping she meant it as a compliment. But me without a voice? The idea made me cringe. My vocal cords are as important to me as a singer's. I protect my voice, exercise it, care for it, and rely on it to get what I need from an audience — a reaction.

Without my voice, how could I make my listeners shiver or laugh? How would I maneuver them into feeling what I want them to feel? How could I persuade them to understand my perspective, motivate them, inform them, or make them weep? Time to make the audience nervous? I whisper. Time to make them think? I talk faster. Time to make them smile? Snort. My voice is my tool for manipulating the audience to where I want them.

I need my voice and your students need theirs if they hope to draw an audience into their world. Sounds and the words made by sounds are fabulous stimulants and the range we carry in our vocal cords is better than any symphony orchestra. Your students have an amazing instrument at their disposal, if they learn how to use it.

Mime? I don't think so. We need to be heard.

Discovering What the Voice Can Do

There are basically four vocal techniques: volume (loud and soft), pitch (high and low), pace (fast and slow), and use of silence. These four techniques can be combined for a multitude of results, each having a different effect on an audience. The trick is to use the right combination at the right time, to get the effect desired by the speaker. If your student is hoping to create suspense and tension, then a high, light, fast voice will kill the effect; a low, intense voice that starts out slowly and builds momentum will get the desired result.

Your students won't know how to do this until they try. Playing with their voices, as they would with a new toy, actually experimenting and exploring, will get results and build confidence in their capabilities. Their voices are just waiting to be discovered.

"The cleansing breaths didn't work for me, but the way it changed my voice was pretty amazing."

Zoya, Grade 6

Pre-test: Talking Off the Top of Their Heads

Arrange students in groups of five to eight. Stand back and observe the speaker in each group to gain a general impression of how students are doing. Students each take a turn standing, putting their hands behind their backs, and describing a pet they have known or heard about without saying what the pet is. Speakers may not use their hands to help in the description. They should include the size, color, and one funny thing the pet has done. They each have to talk for only about a minute.

Listen to the speakers in each group for use of their voice.

- Can he be heard?
- Is her voice monotone?
- Does his voice get higher in front of a group?
- Does she race her words?
- Is there expression in his voice?

Note observations on a class list.

Vocal Warm-ups

Vocal warm-ups teach students how to care for their voices and how to control them. Every student should experience warm-ups at least once, so they can practise on their own. The following warm-ups develop vocal control and power, relax facial muscles and vocal cords, and improve articulation. If you have students with soft voices, these exercises will benefit them enormously.

With your students, stand in one large circle, so everyone can be seen. Lead the exercise by doing the actions and have students follow in movement and sound almost simultaneously, trying to keep up with you. All of the movements need to be exaggerated. During the action, the students will be stretching their facial muscles, tongues, and lips and warming up their vocal cords without knowing it. There is often a great deal of laughter during this exercise which is good, because laughter relaxes the voice.

Begin by sighing, long and loudly.

Yawn widely and loudly. Yawn a few more times and add neck and arm stretching.

Mime reaching into your back pocket and taking out a piece of gum. Unwrap gum, and put it into your mouth and chew. Chew it louder and wider.

Blow a bubble. Blow the bubble bigger and bigger, then pop the bubble. Pick gum off students beside you (as if it has exploded on them) and put it back in your mouth. Chew very, very fast. Slow chewing down till you're chewing like a cow. Swallow gum.

Begin to hum. Make humming sounds high, low, loud, soft, and nasal. Say nonsense words using vowels: LAA LAA, BAA BAA, MAA MAA, LEE LEE, BEE BEE, MEE MEE, LOO LOO, BOO BOO, MOO MOO to the person beside you as though you were having a conversation (wave, shake hands).

Some Vocal Warm-ups

- · Breathe deeply.
- Stretch jaw.
- · Chew.
- · Blow.
- Stick out tongue.
- · Hum.
- Repeat vowel sounds.
- · Say tongue twisters.

Say "What's up?" and stick out your tongue.

Snap fingers and recite tongue twister slowly at first, then faster and faster:

Peter Piper picked a peck of pickled peppers.

How many pickled peppers did Peter Piper pick?

Say "Toy boat" slowly. Say it again with a different inflection, as a command, as a question, as a song. Gradually say the words faster and faster. (It is impossible to quickly and accurately repeat "toy boat.")

This exercise can be repeated often with students assuming the leader role. The list in the margin serves as a guide for vocal warm-up. Record the ideas on a chart and post it in the room. How the actions for chewing, blowing and nonsense words are expressed can be left up to the creativity of the leader. The leader is also responsible for finding a new tongue twister. The actions do not have to go in the order presented on the list, but all should be experienced for a full vocal warm-up.

Technique: Volume

Out of the four vocal expression techniques, volume is the most important. The worst possible scenario for a speaker is not to be heard. Even if a presenter cannot be seen, the audience will listen for a while. Have you ever noticed how even quiet people will shout, "I can't hear you!" when they can't hear the speaker? Take away the sound and the audience's interest disintegrates rapidly. Therefore, it is necessary to put enough power in a voice to make it heard.

I do not recommend that students use microphones. Students would need lessons on how to use them and microphones cannot always be relied upon. Many times I have been promised a mic only to arrive and discover it doesn't work, the cord is too short, or I have to stand on a stage a million miles away from my audience to use it. A good strong voice has always been an asset to me, but I achieved it through exercise and practice, and so will your students.

Exercise: FINDING THE POWER CENTRE

Benefits: Strengthens volume of the voice, relieves stress on vocal cords, and increases brain activity

Format: Instruct students to spread out around the room and lie on the floor. Speak loudly enough that they can hear your voice easily. Talk students through the following exercise.

There is a small muscle at the base of your stomach called the diaphragm. To strengthen your voice you must get enough air into your lungs to push down that muscle. Air is power, but it must come from the bottom of your lungs and not the top of your lungs or you may hyperventilate. Right now you are going to practise filling your lungs. This can make you dizzy, so you will begin by lying down.

First, place the palm of one hand on your stomach and the other palm on your chest.

Now, let out all of your air and draw in a big breath. Did both hands rise, or just one? Do it again — take another big breath. Did your hands go up? Breathe normally while I explain. Sometimes people make their chests

bigger when they take a deep breath and suck in their stomach. This should not happen. If you are forcing the air deep down into the bottom of your lungs, your chest should remain still and your stomach area should expand just like a balloon filling with air. The chest hand should remain still and the stomach hand should rise.

Picture that balloon inside you, just below your ribs, and try the breathing again.

Ready? Let out all your air and take a deep breath, pushing it way down into the bottom of your lungs, expanding that balloon. Now hold it to the count of four. Then let it out slowly. Breathe normally.

Wait a few seconds.

Now, you are ready to practise a breathing exercise to make your voice strong and loud. When I say start, let out all your air, slowly take in a deep breath through your nose to a count of four, then let the air out slowly through your mouth, to the count of eight. Breathe in again to the count of four and out to the count of eight. You will feel as though you are letting out more air than you are taking in, but you aren't. You are simply controlling the air flow. This gives you power and endurance. All singers must do this to hold notes and project their voice. Remember to picture the balloon expanding at the bottom of your ribs.

Ready? Let out all of your air. Breathe in to the count of four . . . and let out slowly to the count of eight . . . Again, in four . . . out eight . . .

Continue this for a few more cycles then instruct students to breathe normally and rest for a few seconds before getting up. This exercise sends more oxygen to the brain and can cause dizziness, especially in students who do not practise any cardio exercise.

Instruct students to sit up and discuss how the exercise made them feel. Some might feel lightheaded, some winded, some exhilarated, while others feel rested. Try the hum and repeated vowel parts to the vocal warm-up now, and students will discover that their voices feel stronger.

Once they have no trouble expanding their lower lungs (not their chest) and can manage the four/eight breathing count, they can try the exercise standing up. Students should place their hands just below their ribs to feel for the lower lung expansion.

This exercise can be practised anytime anywhere and the more it is practised, the stronger the voice will become. It is also a great stress reliever for nervous performers.

Game: FIND THE LIE

Benefits: Increases volume of voice, and develops gesturing and good posture

Format: Arrange students in groups of four to six. Starter student stands and tells the group two facts about himself and one lie. Each statement must be emphasized with a large gesture. Students in group guess which statement is the lie. Student to starter's right continues the game.

If a speaker adds gestures when speaking, the volume of the voice increases. I haven't figured out why, but it works every time. The volume level of this game should increase dramatically compared to other non-gesturing games. Therefore, if a student is soft spoken, encourage her to use more gestures. (Also play "Tall Tale Telling" on page 68 to use gesturing to increase volume.)

Technique: Pitch

Eleanor Roosevelt knew that her voice always rose when she was nervous, so before she uttered a word publicly, she trained herself to consciously drop her voice into a lower range. A high voice is often associated with comical characters, air brains, and fools. Who wants to be associated with that, unless the goal is to make the audience laugh? High voices are also not soothing to the ear or calming to the nerves. High-voiced characters in television sitcoms and on radio shows are usually annoying.

A deeper sounding voice is the goal, especially if nerves tend to make the voice climb. But how does one know how low or how high? Tape your students' voices. Don't use a video recorder, unless the picture is turned off. Students will focus only on how they look if they are watching themselves on a video. When students are rehearsing stories or speeches, they should tape themselves at least once and listen for irritating sounds or habits that detract from their meaning. Before they do that, though, they need to manipulate their voices and discover what they can do.

Activity: FINDING THE RIGHT VOICE

Benefits: Develops vocal agility, creativity, literacy skills, and active listening skills

Format: Have girls and boys work as partners. Assign students the script "No Soup" (next page) to read aloud together. The purpose of this script is to experiment with pitch. There are four characters in the script, so each student has to speak two roles. Allow students about five minutes to read through the script and figure out what is going on. As a team they must answer the questions at the bottom of the script and then find voices for each character, based on their answers. Whoever speaks for Neelah must also play the girl. Whoever speaks for the boy must also play the old woman. If one voice is high, the other must be low. Once students have read through the script several times, using their new voices, allow some partners to share their readings with the rest of the class.

Technique: Pace

Quite often a student speaks quickly due to nervousness. Gaining confidence will overcome this habit, but a student must develop an awareness of how fast he is speaking to determine if the pace is too fast for an audience to follow comfortably. The audience needs time to process the words they are hearing to form pictures and interpret the information. Yet, a speaker who is too slow will drag out a presentation and bore the audience. Ultimately, variation in the pace of a speech is needed and the changes depend largely on what is being said. When the students are working on interpretation and improvisation, by focusing on the meaning of words they will develop a feel for changing the pace. Intuitively feeling out a story and an audience plays a large role in this development, but first, a student must be able to listen to himself and recognize if he is speaking fast, slowly or just right.

Game: THE EXPERT

Benefits: Develops verbal fluency, an awareness of pace while speaking, spontaneity, concentration, and active listening

"No Soup" is mysterious. The students will have to determine several things before finding the right voices. There is no right answer; their own interpretation is the right interpretation. Some students feel Neelah is a ghost or spirit, others an invisible servant; most feel the old woman is a witch. Encourage the students to use spooky, threatening, or creepy voices depending on what they believe.

No Soup

Neelah: They are here, Mistress. The children have arrived! **Old Woman:** Children? Wonderful. I will warm the soup.

Neelah: Come in, children! Come in!

Girl: Hello? Is anybody here?

Boy: Hellllooo?

Old Woman: Oh, oh. What have we here? Come closer so I may see you. Hmmmm. Mmmmmm. Yes. Yes. Perfect. You must be lost. I rarely have visitors. Warm yourselves by the fire.

Boy: Thank you. It got cold so fast.

Girl: Yes, too cold. I don't remember the forest being so cold, but then we came a different way.

Neelah: Cold? Cold? We don't want them cold. Warm them up. Warm them up.

Old Woman: Shhhhhhhhhh. Let me feel your hands. Yes. Too cold. Get closer to the fire. I will fetch blankets from the other room.

Neelah: Blankets? Yes, blankets. Many blankets. Warm their blood. Poor children. Warm their blood.

Girl: Who's there?

Boy: What?

Girl: Don't you hear it? Another voice. In the shadows. Who is there?

Boy: I don't hear anything. Mmmmm. Smell the soup? Maybe she'll give us some.

Neelah: Yessss. Drink the soup, boy. Drink lots.

Girl: Brother, I think we should . . .

Old Woman: Here you are, my dears. Bundle up. Bundle up.

Neelah: She hears. The girl has long ears. She hears.

Old Woman: What?

Neelah: I tell you she hears. She is one of us.

Old Woman: Hmmmmm. Perhaps you would like some soup?

Boy: Oh, yes, please.

Girl: No! Ahhhh, no soup. We must go.

Boy: But, I'm cold. Just wait till —

Girl: No. Now. We have to leave now. Thank you. You are too kind. Thank you. Brother, don't dally!

Neelah: Don't let them leave, Mistress. Stop them!

Old Woman: No need, Neelah. No need. Rest. She will be back. The girl child. She is one of us, indeed. She'll be back soon enough. Soon enough.

Neelah: Soon enough.

Consider these questions when developing appropriate voices for the characters:

- Who is Old Woman?
- Who or what is Neelah?
- Who is older, the boy or the girl?

One person plays Boy and Old Woman; the other plays Neelah and Girl.

Format: Arrange students in partners. One partner is the teller; the other the listener. The telling partner has fifteen seconds to talk, nonstop, about a topic you assign. The teller is the world's greatest expert on the topic and knows more about this topic than anyone else alive. When fifteen seconds are up, it is the listening partner's turn to become the expert on another topic. Gradually increase the speaking time by five seconds until the teller is up to forty-five seconds.

Variation #1: Add a change in the pace. At a given signal (e.g., a hand clap) the speaker must suddenly speak slowly. With another hand clap, the teller must speed up again.

Variation #2: In 10 seconds, the listener must repeat what the teller just said in 20 seconds.

Variation #3: For 15 seconds at a normal speed, the speaker repeats what the partner has already said.

Variation #4: For 60 seconds, both partners speak at once on different topics, without breaking concentration.

Technique: Use of Silence

Sometimes saying nothing at all can be one hundred times more effective than even the most eloquent of words. A well-timed pause is also known as comic timing or suspense building. It can hold an audience breathless. In a story it is usually executed just before a powerful moment when the audience is waiting for a reply, a decision, a reaction, or a fatal blow. In a speech, it is just before the speaker answers a question posed to the audience, delivers the punch line of a funny anecdote, or makes a serious point. A movement during that moment of silence kills the effect, so there is also a moment of stillness. Feeling an audience tense with anticipation is a heady experience, one I hope your students will learn to love and look forward to. The following two exercises develop dramatic and comic timing.

Class Exercise: FIND THE PAUSE

Benefits: Develops dramatic timing using pause and promotes vocal expression through sight reading

Format: Copy and distribute dramatic readings provided on the next page. Arrange students in pairs. Each pair needs a reading selection. Instruct students to read over the selection several times, then take turns reading the piece aloud. Encourage students to compare their reading styles. Who has the most pauses? Are the pauses in different places? Do the differences in style change the meaning of the reading?

Some Topics

Cuckoo birds, peanuts, garbage trucks, designer underwear, dental floss, toilet seats, hair dye, high chairs, computer viruses, coffee making, French class, bacon, apple pie, homework, stuffing a turkey, bed making, elephants, penguins, mold, dust bunnies

If students are working on a speech or story, they can also select a section, preferably the most exciting or dramatic part, and read that aloud, accentuating pauses.

Five Readings to Explore

Reading One

What? You what? You're kidding, right? Oh, no. How could you? Why didn't you tell me sooner? It may be too late now. We'll have to act immediately. Get your coat and hat, we'll have to run. Quickly, now. Quickly!

Reading Two

It has come to our attention that your father's will was, well, shall we say, not accurate. Only days before he died, he wrote another will. It was witnessed, so it is valid. Your father has left his entire estate and all of his holdings to Marnie. Marnie? You don't know Marnie? Well, she's his parrot.

Reading Three

I'm telling you, I heard it. Up in the attic. It started as a sort of low, soft moaning, then it grew louder and louder and higher and higher. Until it was almost a scream. Then it stopped. Completely stopped. I went up there but there's nothing. Not even the dust is unsettled. It's there I'm telling you. It's still there!

Reading Four

It's about your mother. She's ill. Very ill. Apparently she has been sick for a long time, but kept it from everyone. We don't know how long exactly. I tried to talk to her about it, but she won't discuss it. She won't see the doctor and refuses to go to the hospital. We were hoping you might talk to her. Try to convince her to do something before it is too late. Will you? Will you speak to her? Alone?

Reading Five

Hello? Who is this? Who? Samantha? Samantha Connors? But it can't be. You're, you're dead. Hiding? From who? Who would you hide from for ten years? How could you do this to us? Not tell us? Let us think you were dead for all these years? You what? You want me to meet you? Now? Where? Why there? But it's late — hello? HELLO?

Game: I KNOW ONE

Benefits: Develops sense of comic timing, memorization skills, remembering skills, ability to select material appropriate to audience, and active listening skills

Format: The night before, each student must find and learn a joke appropriate to share in class. If the joke is very short — only one or two lines — then the student should bring two jokes. Arrange students in partners. Each student takes a turn telling their joke(s), taking care to build up to the punch line by using the moment of silence. Instruct students to watch carefully for listener reactions. Do they suddenly get still? Do they lean forward? When they hear the punch line, do they smile, moan, giggle or fall over laughing? After each student has shared their joke(s), they should learn their partner's joke(s). New partners are assigned and the previous partner's joke(s) must be told to the new partner. Again, students should watch carefully for a reaction. Now, ask students to determine which joke(s) got a better reaction — the one(s) they brought or the one(s) the partner taught them. Another new partner is assigned and students retell the joke that was the funniest. After the third telling, allow students to share jokes with the class, but point out the buildup and the use of silence.

A few students may arrive without a joke or with something inappropriate to share in a classroom setting. Twelve possibilities appear on the next page.

Curriculum Extensions: Making Sound

The Sound Effects Man: Before television was popular, everyone listened to radio plays. The "sound man" was responsible for supplying all of the sound effects for the play. Arrange students into pairs. One student reads a story, using an announcer's voice while the other student plays the sound effects man. On a given signal, students reverse roles.

The Radio Play: Arrange students in groups of four to six. Instruct students to create, write, and produce a two-minute radio play. The show must be taped, so the rest of the class can listen to the production just as they would on a radio. Every student in the group must read a role and create sounds to enhance the play.

One way to introduce this activity is to bring in an old radio play from the public library for the students to hear. Playing it would allow them to listen to the announcer, an introduction, and commercials which they could imitate.

Sound Places: Arrange students in medium-sized groups of six to eight. Every group is assigned a "place." Options include a haunted house, jungle, dentist's office, hospital emergency room, court room, zoo, concert hall, hockey arena, circus, and baseball park. Students in the group must create that place in sound only. Allow ten minutes for them to rehearse the creation of the environment. When groups are ready, the rest of the class listens with eyes closed to determine what place it is.

Sound Stories: After students have tried the previous activity, "Sound Places," instruct them to create a new environment, but order the sounds so that they tell a story. Possible scenarios include a car accident, school assembly problem, animal escape at zoo, sleepover scare, birthday party disaster, fair ride problem,

If your students are working on speeches or stories, have them select a funny section and read it aloud to a partner, accentuating pauses.

Language Arts

Language Arts

Drama

Language Arts

Jokes

Why did the skeleton *not* cross the road? He had no guts.

Where do zombies go sailing?

The Dead Sea

What do carpenters fish for?

Hammerhead sharks

If Frosty the Snowman married a vampire, what would they name their child? Frostbite.

What do you call a boring dog?

A dull-mation

Why is the Statue of Liberty standing in New York harbor?

Because she can't sit down.

Why did the golfer wear two pairs of pants?

Just in case he got a hole in one.

What is the tallest building in the world?

The library. It has the most stories.

Why was six afraid of seven?

Because seven eight nine.

What do you call two witches sharing a room?

Broom-mates.

A man rode into town on Friday. He stayed three days, then left on Friday. How could he do it? The man's horse was named Friday.

Three men arranged to have a contest. Each one would stand on a hill, throw his watch down the hill, and see who could run down the hill fast enough to catch his watch before it hit the ground. The first man threw his watch as high as he could. He got only half way down the hill before the watch hit the ground and smashed. The second man threw up his watch and nearly got to the bottom of the hill, but the watch hit the ground before he could catch it. It broke into one hundred pieces. "My turn," announced the third man. He tossed his watch into the air and ran down the hill. He ran to the nearest store and bought some groceries, went to the bank, got himself a coffee, and ran back to the bottom of the hill just in time to catch his watch. The other two men were astounded. "How did you do that?" they asked. "Easy," the man answered. "My watch is an hour slow."

tornado on the farm, boat accident, fire, and snowball fight. Again, no movement or visuals are allowed.

Script Writing: Arrange students in pairs. Instruct students to create, write, and perform (through voice only) the next scene for the script "No Soup," on page 76.

Student Reflections

Invite your students to consider and respond to some of the following questions in their response journals.

- 1. Did the breathing exercises change you in any way? How?
- 2. How do you use your voice differently now?
- 3. What surprised you when you were learning to play with your voice?

Music

Teacher Assessment

Focus: Exploring Voice

Name:	Date:		
	Frequently	Sometimes	Rarely
Vocal Warm-ups:			
The student Participates in vocal warm-ups Is aware of and uses diaphragmatic breathing			
Technique: Volume			
The student demonstrates voice power and projection volume variation for effect			
Technique: Pitch			
The student demonstrates pitch variation for effect			
Technique: Pace			
The student demonstrates pace variation for effect			
Technique: Use of Silence			
The student demonstrates pause for effect			
Comments:			
		=,	

CHAPTER

7

Showing Composure

When I was studying theatre, a very talented young man in my class was playing a serious part as a hermit that roamed the woods. In rehearsal, he was stupendous, every word, every facial movement powerfully portrayed. He seemed completely composed and inside his character. It wasn't until dress rehearsal that the problem arose. Once on stage, he was instructed to play the part barefoot, which seemed simple enough at first. But, as became evident quite quickly, he kept his nervousness in his toes. During a scene, his toes would wiggle and stretch and curl as if they were crazed worms. The audience noticed and much giggling and finger pointing resulted. The actor did not even know this about himself.

Shakespeare's old adage "know thyself" comes in handy in many ways, especially when displaying yourself in public. As for the young actor, he ended up wearing shoes for the show and I doubt he ever did beach movies.

Managing Nervous Energy

Composure — sedateness; calmness; tranquillity — is the *outside* goal of a public speaker. Inside, the speaker may be panicky, unsure, terrified, worried, excited, thrilled, or even nauseous, but the audience must perceive composure. Unfortunately, under stress, the body tends to do things we don't want it to and we often look anything but composed. Mary Ann pulls her sleeves over her hands. Shelly constantly slips her hair behind her ears. Andrew wiggles his ankles like they are disconnected. Henry jiggles his knees. Sarah desperately has to go to the washroom and Kellen throws up. None of these antics are apparent in normal conversation, but give these students an audience and presto, nervous energy takes over.

There is no single magic exercise to make nervousness go away, but it would be a big mistake to eliminate it anyway. When the mind is preparing for something important, it preps the body by releasing adrenaline into the blood stream. Adrenaline is a powerful chemical. It pumps up athletes so they can win world records and allows people to perform amazing feats like lifting cars off trapped children. It also provides for the needs of a speaker: more projection in the voice, more memory power, and more energy, lots and lots of energy which is what a dynamic speaker requires.

"I felt eliminating fidgets helped because it makes my presentation not as confusing."

Shane, Grade 5

"I learnt how to stay calm and be relaxed before presenting."

Derek, Grade 6

I have often felt I needed more energy than all of the audience put together. A speaker feeds the audience with her energy, lifts them, carries them, and mesmerizes them. A speaker can't do that without the aid of adrenaline. It is our natural booster. We need it. But energy uncontrolled is a deterrent, because it just becomes two dreaded foes — the fidgets and stage fright.

Three composure tactics will help students learn how to manage nervous energy so they are not paralyzed by it.

The first tactic is gaining an understanding of their own bodies and how nervous energy affects them. Everyone has their own weak points to deal with. Students need to honestly confront their weaknesses and then develop strategies that combat and overcome them.

The second tactic is practice, practice, and more practice. Practising will build confidence which leads to success. But practice doesn't simply mean practising the words. It includes simulating the approach to the podium, getting the audience's attention, using a punchy opening line, building up to a climax, winding down a talk using body language, taking a bow, and rehearsing one's exit. These behaviors are *all* part of preparing a polished presentation, and need to be locked into sense memory to ensure security.

Lastly, students must actively engage in relaxation exercises to develop an awareness of their environment and gain control over their bodies and minds.

Pre-test: Body Language — Deliberate or Uncontrolled?

Arrange students in groups of four to six. Instruct starter students to stand and recite a nursery rhyme. Encourage students to use expression in their hands, voice, and face to get across the meaning of this short, rather silly poem. Observe how students handle themselves. Do they fidget, sway, play with something, fiddle with their clothes or hair, bounce, shake, or stand still as if frozen? All are uncontrolled nervous reactions. Record observations on a class list.

Students are not as familiar with the old folk rhymes as they were twenty years ago. Several of your students may not know any. If this is the case, a sampler appears as a handout on the next page.

Technique: Controlling Fidgets and Fright

Class Exercise: KNOW THYSELF

Benefits: Develops self-awareness, awareness of shared fears and reactions with peers, and confidence towards overcoming fears

Format: A. Discuss with your class situations that bring on nervous tension, for example, making dentist visits or doctor visits, sinking a basket, bringing home a report card, or phoning someone you've never called before. List these situations on a chart.

B. Now, discuss how students react physically to these situations. They may report butterflies in the stomach, stomach ache, eye twitching, shaking hands, and pressure on the bladder.

A Sampler of Nursery Rhymes

Solomon Grundy

Born on Monday

Christened on Tuesday

Married on Wednesday

Took ill on Thursday

Worse on Friday

Died on Saturday

Buried on Sunday

And that was the end

Of Solomon Grundy

Georgie Porgy

Pudding and Pie

Kissed the girls

And made them cry

When the boys

Came out to play

Georgie Porgy

Ran away

Mary had a little lamb

Its fleece was white as snow

Everywhere that Mary went

That lamb was sure to go

It followed her to school one day

Which was against the rules

It made the children laugh and sing

To see a lamb at school

Sing a song of sixpence,

A pocket full of rye

Four and twenty black birds

Baked into a pie

When the pie was opened

The birds began to sing —

Oh, wasn't that a dainty dish

To set before a king?

Peter Peter Pumpkin Eater

Had a wife and couldn't keep her

He put her in a pumpkin shell

And there he kept her very well

Inky Pinky Ponky

Daddy bought a donkey

Donkey died

Daddy cried

Inky Pinky Ponky

C. Ask students if they have ever had the same reaction or similar reactions when they were really excited about something special or out of the ordinary, for example, a party, trip, present, or date.

- **D.** Direct students to list, in two columns, Symptoms of Nervousness and Symptoms of Excitement. Once they have done so, tell them to circle the symptoms they like and put an X beside the symptoms they don't.
- **E.** Discuss the results. Do many students have similar symptoms on both sides of the survey? Are most students weighted on the nervousness side? Do several students have similar symptoms circled? Do several students have the same symptoms marked with an X?

If your students are supportive of one another, you could discuss these symptoms as a class and suggest possible solutions. If an open discussion is a risk, then arrange students in private partners to discuss the solutions. Below are a few common symptoms and possible ways of dealing with them.

Sometimes a simple discussion is enough to alleviate some of these symptoms. Students often feel overwhelmed or controlled by their symptoms, and knowing other students have them as well releases the grip that the symptoms had on them.

Symptom	Possible Solution
plays with hair	Tie or pin hair back.
knees jiggle	Sit down in a chair for presentation.
bladder pressure	Go to the washroom prior to presentation to reduce the discomfort and chance of an accident.
pull on sleeves	Wear short-sleeved shirt.

Game: LITTLE MISS TUCKET

Benefits: Develops creativity, collaborative writing skills, control over fidgets, and control over stage fright

Format: A. Arrange students in partners. Give students ten minutes to rewrite a nursery rhyme into an updated humorous version and practise it with their partner. Partners should also review personal symptoms of nervousness and decide how to combat the worst ones in order to present the rhyme effectively. Warn students they will be presenting this rhyme alone, not with their partner.

- **B.** Arrange the class into two or three large groups (8–12), separating partners so that each goes into a different group. Each student in the large group takes a turn standing and reciting the new rhyme *without* demonstrating any fidgets or stage fright symptoms.
- C. When all students have performed, tell students to return to their original partners. Instruct partners to compare results of presentation. Did each successfully present without fidgeting? Was the nervousness controlled? Did any new symptoms appear? How did the group react to the new version? Encourage students to grade their level of control over their nervousness out of 10.

This exercise can be repeated many times using new partners and new rhymes.

Technique: Effective Openings

A presentation does not begin when the speaker opens her mouth or even when he takes the podium: it begins just before the speaker is announced to come up in front of the audience. During an introduction, or while a student is waiting for her turn at the front of the classroom, the speaker should be working on two things: relaxation and her opening sentence.

The speaker wants to be relaxed before she even stands and walks up to the front so that the walk itself displays confidence and poise. If a student hangs his head and drags his feet to the front, his body language has already betrayed how he feels about the presentation. The audience will make judgments about him based on those perceptions. Therefore, even if the speaker is terrified, bored, or excited about the upcoming performance, the audience must see and perceive only confidence and poise from the moment the speaker stands to walk towards his spot. Displaying good posture — head up, shoulders back, eyes forward, and a relaxed arm swing — says volumes about the speaker's attitude towards what he is going to say. The approach is also not the time for the speaker to fix her hair, tug at the hem of her skirt, clean her nails, or blow her nose. Making students aware of this and imitating some of the things people do while walking to the front brings out the humor in the situation, but also makes students aware of what not to do.

Game: STOP, LOOK AND LISTEN

Benefits: Develops awareness of audience, self-control, and composure, poise, and good posture

Format: Begin with a explanation on where a presentation starts and demonstrate some of the antics of a nervous speaker approaching the front: shaking his head, putting hands over her face, dragging his feet, sighing and moaning. Also demonstrate the antics that manifest themselves once the speaker begins to talk: pacing, hiding hands inside sleeves, pushing at hair, swinging a leg, twisting ankles, pulling at fingers, rubbing the nose, scratching, rocking, and hunching over.

Arrange students in small groups. Starter student leaves the group. She can either sit at her desk or stand a few metres away from the group. When starter is ready, she *composes* herself (takes a deep breath, focuses on opening line) and *approaches* the group. Careful attention is paid to good posture, a secure walk, and a calm facial expression. When the student arrives at the designated speaking spot, she *stops*, *looks* at the entire group with a sweep, and *listens* for silence. She then *speaks* the opening line of her speech or story or of a popular folk tale. When she sits back down with the group, students in the group agree on one step she did well and one step she either missed or didn't do according to the rules. (When starter student's turn comes around again, she must correct the missed step.) The student to starter's right goes next.

It will take several turns around the circle before each student can accomplish all steps of this elimination game successfully.

The two hardest steps tend to be *look* (students can't do it without laughing) and *speak* (students can't do this without using unnecessary additives).

Rules:

- 1. During the *compose* and *approach* phase, the student may not fidget or play with hair, clothes, or hands.
- 2. During the *stop*, the student may not fidget or speak.
- 3. During the *look*, the student may not giggle or crack up.

- 4. During the *listening*, the student may not sigh, fidget, or look away from the audience. (Steps 3 and 4 can be done simultaneously, but one cannot be left out. If an audience member is talking, the presenter must wait until he has everyone's full attention.)
- 5. During the *speaking*, the student may not say "ok," "now," "er," "so," "um," or any other useless verbal additive.

Technique: Polished Endings

Most students want to celebrate the ending of their presentation by getting off the stage as quickly as possible, skipping the applause and post-performance comments or questions. They simply don't know how to finish up, except by saying "the end" and running away. Unfortunately, the ending is all part of the presentation and must be faced, as uncomfortable as it may be.

As a speaker nears the conclusion of the speech, usually the words are the first indicator the presentation is coming to a close. In a speech, there is a summary; in a story, there is a conclusion. Both lead the listener to believe it's nearly over. But there needs to be more, to put the listener at ease. How many times have you been in an audience that started to applaud when the presentation wasn't over? The speaker was embarrassed to be sure, but so was the audience. After all, they did something wrong and mistakenly caused the speaker to be uncomfortable. No one in this situation wins. More clues are necessary to help out the audience and the speaker.

A combination of several different body language and vocal cues are useful in letting the audience know you are drawing to a close. Try demonstrating a few closings to your class. While reciting the last two lines of a popular folk tale, see if your students can pick some cues out:

- Drop voice to a lower register.
- · Slow voice down.
- · Smile.
- Nod.
- Wink.

- Close hands together.
- · Pause.
- Close eyes.
- Drop head down.
- · Bow.

Students can come up with several cues of their own. The only rule they must follow is this: No one may say "the end."

Game: THE END

Benefits: Develops an awareness of body language, self-control, and management over nervousness

Format: Arrange students in groups of four to six. Starter student stands and says the last two lines of a well-known folk tale or story and incorporates at least three body language and/or vocal cues to indicate the end. Alternatively, if students are working on speeches, have them practise with the last two lines of those. Upon concluding, the presenting student must stand quietly to accept applause and then turn and walk away with poise. Students in the group then pick out the three cues demonstrated by the presenter. The student to starter's right continues the game.

Words to the Wise

The applause can get rather loud so instruct students to give silent applause.

Rules:

- 1. If presenting student only gives two cues instead of three, he must demonstrate four on his next turn.
- 2. As students go around the circle they may not present the same three cues each time; they must show a new combination on every turn. The last two lines, however, can remain the same.

Technique: Relaxation

As I mentioned under "Effective Openings," "during an introduction, or while a student is waiting for her turn at the front of the classroom, the speaker should be working on two things: relaxation and her opening sentence." No one need know the speaker is practising a relaxation exercise. Actually, if the speaker is doing it correctly, no one ever will know, because the exercise makes the speaker look more alert and focused. When used effectively, relaxation exercises can regenerate, renew, calm, and sharpen the senses. They can be practised before an athletic competition, a piano recital, an exam, and studying, during a stressful event, or just to unwind at the end of the day. Relaxation as a technique is not just for public speaking: it's for living.

Exercise: I AM READY

Benefits: Develops concentration and focus, sensitivity to body tension and an ability to manage it, an awareness of environment, and sensory awareness

Format: Students sit at their desks or on the floor. Talk them through the following exercise.

Here is an exercise you can practise on your own, anywhere and anytime you need to calm yourself, focus your attention, or feel more in control. It is a good exercise to do just before going up to give a presentation.

Sit up and look directly ahead of you so that your neck or spine is not turned or twisted in any way. (*Pause*)

Take a deep cleansing breath in (in through the nose, out through the mouth) and as you exhale, drop your shoulders. (*Pause*)

Take another deep cleansing breath and as you exhale, gently shake your hands to release any tension.

Take another deep cleansing breath and as you exhale, wiggle your toes. Resume normal breathing and listen to your breath.

Be aware of your stomach and ribs expanding and contracting. (Pause)

Become aware of your body sensations, starting at the top of your head. Can you feel your scalp? Can you feel the weight of your hair? Can you feel your ears? Don't touch them. Just be aware of them. Can you feel your pulse in them?

Move your awareness down your face. Don't move your nose or lips, but be aware of how they feel. Do they tingle? Are they hot?

Direct your attention down your neck and across your shoulders. Do you feel any tension or stiffness? (*Pause*)

If you do feel any tension or stiffness, take a deep breath and see the breath moving into your neck area, like a swirling ball of light, breaking up the tension, swishing it away when you exhale. (*Pause*)

Become aware of your spine, right down your back, down into your legs, down to your knees, and right down to your toes. Release any tension you feel by breathing into that area with the swirling light. (*Pause*)

Focus your attention on the sounds around you. (Pause)

Notice the contrasts in the volume. What do you hear that is loud? What is soft? Remain aware of your breathing.

Slowly, very slowly, scan your surroundings from right to left. Look at the picture in front of you as though you were watching it through a movie camera. Be aware of the color. Is there any movement? Remain aware of your breathing.

Scan right across the room and stop. Listen to your breathing.

Recognize that you belong here. You are in the right place at the right time and you are ready to join in. Take a deep breath and let it out slowly, then smile.

Assign students the exercise during different periods throughout the day without the rest of the class knowing. Instruct them to record their observations and reactions. This exercise has a very different feel when students do it on their own, while the class is busy. It is like watching a movie. Students notice things they don't usually see and hear things they don't usually hear. The exercise is also very relaxing.

The diaphragmatic breathing exercise, "Finding the Power Centre" (page 73), can also be used as a relaxation exercise; so can "Vocal Warm-ups" (page 72).

Curriculum Extensions: Moving in Response to Cues

Movement is a key factor in relaxation, releasing tension and developing body awareness. Students can use any of the following movement-based exercises to develop a sense of control, strengthen physical well-being, and release tension. These exercises will also develop concentration, environmental awareness, and awareness of tension in the body.

Aerobic/Anaerobic Warm-up: Instruct students to spread out around the gym, not touching anyone else. Give students four signals to track. For example: Signal one — a bell; signal two — a clap; signal three — a whistle blast; signal four — a cough. Each signal signifies a speed: bell — fast, clap — slow, whistle — normal, cough — freeze. Start with students working on the spot to make sure they are tuning into the signals. Say:

When I give the first signal, it will be a clap. What speed will you go? That's right, slowly. I want you to run on the spot. Clap.

Let the students run on the spot for a couple of seconds, then cough. All students should freeze. If they don't, repeat the exercise until all students are following directions. When students are ready, give them different exercises to do varying the speeds: hop, skip, run around the room, handstand, jump, roll, kick, dance, sing, play the guitar. All new activities should be assigned during freeze mode.

Tension/Counter Tension Walk: Instruct students to spread out around the gym, not touching anyone else. Emphasize that at no time may students make

Physical Education

Physical Education

contact. Tell them to walk around the room at a normal pace, not touching anyone, and to listen to your voice. Say:

Glance around you. You will see big open spaces on the floor. It is your job to fill the spaces so that the bodies moving across the floor are at all times evenly distributed. Do you see a space? Move into it, but be sensitive to the people around you so you do not bump into anyone. Respect their space. Keep a distance between you and everyone else. Stay light on your feet.

Allow students a few minutes to accomplish this task, position yourself at one end of the gym and then add:

Good work. Keep moving and listen to my voice. I am now going to be a wall.

Hold out your hands to either side of you.

You cannot go past me. I am going to move in and restrict the amount of floor space you can walk on.

Move across the room, reducing the area students can walk in. Keep talking to them about filling in the spaces on the floor and not touching anyone. Continue to move in. Position your arms in a 90 degree angle, indicating two imaginary walls. Box students into a corner of the gym. Keep talking to them about filling in the spaces on the floor and not touching anyone. After a few minutes of movement in the tight space, slowly back up and enlarge the space again until students have full use of the gym floor.

Discuss how students felt during the exercise. Many will say they felt much more relaxed when you let them out of the box.

Tension/Counter Tension Sit: Instruct students to sit on the floor. When you count to three have students tense every muscle in their bodies. Say:

Squeeze feet, thighs, back, neck, shoulders, fists, face harder, tighter. Hold, hold, hold, and release.

Repeat the body tensing three times and discuss how students feel afterward. (They should be more relaxed.) A follow-up to this exercise is to tense only certain parts of the body. Tense the shoulder, hold, release. Tense your thighs, hold, release. Tense your hands, hold, release. In this version of the exercise students often find places in their bodies where they didn't know they were holding tension.

Creative Freeze Tag: Limit the amount of space students can use in the gym or this game goes on too long. Appoint one student as It. On a given signal the student chases other students *in slow motion*. Encourage students to try to discover creative ways to avoid getting tagged, yet they all must remain in slow motion. When a student is tagged, the tagged student must freeze. The game continues until all students are frozen.

Physical Education

Physical Education

Student Reflections

Invite your students to consider and respond to some of the following questions in their response journals.

- 1. Are you less or more nervous than you used to be about giving a presentation? Why?
- 2. Which is the harder part in giving a speech or telling a story the beginning or the end? Why?
- 3. How do you relax yourself before a presentation?

Teacher Assessment

Focus: Showing Composure

Name:	Date:		
	Frequently	Sometimes	Rarely
Technique: Controlling Fidgets and Fright			
The student demonstrates understanding of own weaknesses ability to control fidgeting			
Technique: Effective Openings			
The student demonstrates Ability to stop, look, and listen when presenting to a group to an audience			
Technique: Polished Endings			
The student demonstrates ability to conclude a presentation with more than two tactics ability to accept applause and questioning in a composed manner			_ _
Technique: Relaxation			
The student demonstrates Ability to calm self down using will power using deep breathing using tension/release exercise Ability to remain calm during a presentation			
Comments:			

CHAPTER 8

Improvising

The story I introduced was simple, but powerful. A young woman was secretly a selky seal. A man discovered her secret and hid her seal skin so she could not return to the sea. He forced her to marry him and after several years of living as a human, she begged him to give back her seal skin so she could return home.

"What can you tell me about the man in the story? Oh, but first, give him a name."

"Carlos."

"O.K. What do you know about Carlos?"

"He's strong. I saw him."

"He's a blackmailer."

"He's selfish. He didn't care that she was crying."

"I am going to count backwards from 10 to 1. While I am counting, I want you to melt away and I want to see Carlos appear. I want to see Carlos sitting there where you are. How does he hold his face, his back, his feet. He does he sit? How does he look? Ready? Ten . . . nine . . ."

Before my eyes, the students transform. There is no time for them to prepare, there is no script, they simply are. Many of the students portray hard faces, tight jaws, piercing looks. But one boy lies down on the floor, his hands behind his head, and places his feet in the air, crossed at the ankles.

After Carlos melts away and the students reappear as themselves, I ask them how it felt to be Carlos. The boy with his feet in the air answers immediately.

"I was lying on the bed with my feet up. I wasn't listening to her."

The girl beside him looked at him and said, "Ya, you were ignoring her."

"Yeah," agreed another student, "you're mean."

"My expression is much better and I take more risks. I ad lib more too. I'm more creative."

Laura, Grade 9

A Safety Net for the Public Speaker

Such is improvisation. Living in the moment. Discovering what the moment can bring to you. Letting it happen and yet making it happen. There is no script to

"Only from meeting and acting upon the changing, moving present can improvisation be born."

Viola Spolin

follow. There is no right or wrong way. It is an adventure, a risk — creative, spontaneous and insightful.

Improvising comes in many forms, from playing creative games to surviving a disaster. Thinking fast, reacting, seeing things in new ways, discovering exciting opportunities, and solving problems are all part of improvising. We improvise every day, such as when we don't have exactly the right ingredients for the recipe we are using or need to occupy a small child for hours in a hospital emergency room. Students are masters at it, especially when they have forgotten to prepare a major History presentation and have only ten minutes to get ready or are given the opportunity to become an imaginary character.

To a speaker, being able to improvise is a safety net, a tactic to respond to an unruly or troubled audience, a skill that allows the presenter to track two things at once and to adapt a presentation to suit circumstances or a general feel of what the audience needs.

Developing three techniques, *spontaneity*, *focus*, and *decision making*, will enable students to improvise. Learning the skills of improvisation gives the speaker a gift, a true gift, no other technique or skill can give him: trust in himself. If a speaker memorizes a speech or story and something happens, perhaps heckling from the audience, forgetting a section, stopping to accommodate an emergency, how will he recover? Perhaps the audience is not responding the way he expected them to because they have already been sitting the better part of an hour listening to another speaker who was terribly dull. The list goes on and on because things happen and change is inevitable. But what can the speaker do? Only experience can teach him how to handle many different situations, but improvisation skills will prepare him.

Viola Spolin is North America's guru of improvisation. She firmly believes that improvisation releases the intuitive self. She says:

We must be thrown off-balance and must blank out the intellect (the known): break through the walls that keep us from the unknown, ourselves and each other.

Practising improvisation enables a speaker to not always have to go from point A to point B. There are alternatives. Through improv a speaker learns to trust his own judgment, rely on her own instincts, and know he can handle a situation and not panic if something changes. According to Viola Spolin, "with intuitive awareness comes certainty." Imagine a speaker who has certainty, an air of confidence that comes from deep within. Improvisation for a speaker is freedom.

Pre-test: Getting Down to Business

Tell your students they have five minutes to create a game out of anything they have in their desk. It cannot be a game they have brought with them; it must be something that they create. Observe how many students immediately get to the task, rifling, dumping, searching, and manipulating. Who are the ones that watch the others for clues and ideas and hesitantly attempt to make something? Who sits and watches, unsure and uncomfortable?

Record your observations on a class list.

Technique: Spontaneity

Game: CHANGES, CHANGES

Benefits: Develops observation and decision-making skills

Format: Arrange students in two long lines, facing a partner. Students have ten seconds to observe their partner. On a given signal (e.g., hand clap), students must turn away from their partner and change one thing about their appearance. When they face each other again, students have ten seconds to find the change. Play the game again, only this time students must change three things in their appearance, then five, then ten.

Exercise: THIS IS A . . .

Benefits: Develops spontaneity, decision making, and gesturing

Format: Arrange students in groups of four to six. Give one item to each group. Possibilities include a ruler, pie plate, paper bag, piece of string, bowl, shoe, wooden spoon, bean bag, skipping rope, and Hula Hoop. Starter student holds the object until he decides what else it can be and then manipulates the object using gesture, sound, and/or movement so the rest of the group can guess what it is. (For example, a ruler becomes a flute.) Group members cannot guess until the player is finished improvising. If students in the group cannot guess what the item has been transformed into, the player tries again, using the item slightly differently until the intent is clear. If students still don't get it, the player tells what the object is supposed to be and everyone in the group makes suggestions as to how the item can be manipulated to get across the intent. The item goes around and around the circle many times. After each group member has had at least six turns, a new object can be introduced.

If a student is stuck, encourage her to hold the object out in front of her, move it around, raise it over her head, stand up and put it on the floor, walk around it, in other words, see it from many different perspectives. An idea will come. Sitting still and staring is a trap. Movement and a change in perspective will stimulate the creativity.

Once the students have explored a few items in one group, either create new groups or enlarge the groups. This game should be played many times on different days so students can feel their ability to improvise developing.

Game: ONE WORD AT A TIME

Benefits: Develops spontaneous speaking, ability to contribute to a group, and sequencing

Format: Arrange students in large groups (8–12). Starter student is allowed to say one word to begin a story. Student to starter's right says the second word in the story, third student says the third word, and so on. The story continues around and around the circle with students trying to create an interesting, sequential story.

Student one: "There"
Student two: "was"
Student three: "once" . . .

Changing ten things is harder for the person doing the changes than the person looking for the changes.

Words to the Wise

After two or three turns, students may think they have run out of ideas, but they haven't. Encourage them to persist with the same object for a minimum of five turns.

The more inventive members of the group may try to take the object away from a player who is stuck or try to provide an idea. Don't let them. The stuck student needs to rely on his own creativity.

Words to the Wise

In the original game students are often afraid to end a sentence; thus the word "and" is repeated and repeated. The result is one enormously long run-on sentence. To avoid this, you can limit the use of "and" or start to side coach the students by giving directions. For example: "Sarah, end the sentence," or "Bob, introduce a new character." (See the advanced version of "Where Am I?" on page 99 for more information about side coaching.)

In improvisational games such as the following, there is a danger that students may get carried away in the action. Before you begin, establish these rules:

- 1. No student is allowed to strike another.
- 2. All students must respond to the *freeze* command. (See the advanced version of "Who Am I?" at right.) If one student does not, the improvends immediately. There is no second chance. Improv is based on cooperation, sensitivity, and control at all times.

Variations on the Game:

- · Students can say two words.
- Students can say five words.
- Students can contribute one sentence.
- Each group is given three unrelated objects, for example, a rope, an egg, and a shoe. Students must incorporate the three objects into the story.

Technique: Focus

Game: WHO AM I?

Benefits: Develops ability to assess information being presented and to react accordingly and quickly, strengthens observation skills, furthers vocal agility, promotes spontaneity, and explores characterization

Format: Arrange students in partners. One partner, A, is given a slip of paper on which is written what the partners' relationship will be. (See "Playing in Role" on the next page.) That partner chooses which person in the relationship he will be, but does not tell partner B. B cannot know what the relationship is or who A is. A begins interacting with B. She can speak, move around, even handle objects in the immediate vicinity if it will make who she is clearer to B. How A behaves and speaks to B lets B know who she is and who he is! As soon as B knows who he is, he can respond and enter into the playing of the scene. After thirty to sixty seconds of playing out the roles, the improv ends. A new slip of paper is read by B and the game starts again.

As a variation, arrange students in small groups and ask the members of each group to take turns playing the game as the other group members watch.

Game: WHO AM I? Advanced Version

Benefits: Develops split focus, concentration, characterization, and ability to take direction

Format: Bring up two students to play the "Who Am I?" game in front of the class. Students in the audience watch for clues and try to guess identities. When the relationships are established and the improv students are working together, call out "Freeze." The students in the improv then freeze. Ask students in the audience to suggest a problem that can be introduced for the improv pair to solve. For example, the relationship of the improv couple is husband and wife. If it's suggested that the husband wants to buy a horse to keep in the basement, students in the improv should react as they feel their characters would.

Class Exercise: WHERE AM I?

Benefits: Develops observation skills, spontaneity, ability to assess information being presented and to react accordingly and quickly, and use of gestures and movement

Format: Arrange students in partners. Partner A, given a slip of paper on which a place is stated, mimes an activity that happens in that place: perhaps washing boards in the classroom. When student B knows where student A is, he enters

Playing in Role

Doctor - Patient	Cashier - Customer
Police - Shoplifter	Old Friends
Teacher - Student	Waitress - Customer
Prisoner - Prisoner	Siblings
Parent - Child	Twins
Mugger - Victim	Principal - Teacher
Spies	Grandparent - Child
Bank Robber - Bank Teller	Husband - Wife

Places

Classroom	Bus stop	
Church	Forest	
Funeral home	Cave	
Kitchen	Mountain	
Bathroom	Raft	
Library	Tree	
Gymnasium	Playground	
Bedroom	Graveyard	
Restaurant	Fall fair	

into the scene and does something in that environment. He can help A or do something else typically done in that place. Student B must also relate to student A. From what student B says, student A determines their relationship and responds accordingly. At no time are students allowed to stand and talk; they must always be doing something related to that environment.

Game: WHERE AM I? Advanced Version

Benefits: Develops ability to respond to group situation and contribute, strengthens ability to assess information being presented and to react accordingly and quickly, promotes observation skills, furthers spontaneity, develops characterization, aids concentration, and furthers ability to respond to directions (side coaching)

Format: One student volunteer chooses an object from a collection of items: a ruler, pie plate, paper bag, piece of string, bowl, shoe, wooden spoon, Hula Hoop, bean bag, and skipping rope. The student walks up to the front of the room as a character and uses the object. How he uses the object determines where he is and who he is in relation to the where. For example, a pie plate could become the wheel of a bus and the student is the bus driver. When a student observer realizes who the student at the front of the room is portraying and where he is pretending to be, she can enter into the scene as another character. For example, she might stand to the side of the bus driver, and wave him to stop, then climb onto the bus and interact with the driver. The bus driver responds in role and the scene continues.

Allow five or six students to enter the scene and interact. After thirty to sixty seconds of the scene being played out, the exercise ends and a new scene is begun.

Variation 1: Introduce side coaching. After the students have played the game a number of times and every student has had an opportunity to take part, you can coach students in the improv without stopping it by using the *freeze* method. As a side coach, you give the students directions or a problem to solve while they are in the improv. Students must develop an awareness of staying in the role and in action but still listen to your voice for direction.

For example, to get students to work in unison, you might adopt the following side coaching scenario.

Listen to my voice, but keep the action going. Do not break character. Do not look at me, just stay in the improv and listen to my directions. I am going to add to the scene and you must respond as your character would. The bus is about to hit a bump. No one knows it is coming but the bus driver. Be aware of what he's doing without looking right at him. Bus driver, you can warn your passengers if you want, or just cue them by saying, "Uh oh." It is up to you. But when you hit the bump, react so the passengers know. Passengers, take your cue from the bus driver. When he reacts to the bump, you react. O.K.? Bus driver, give your passengers a couple of seconds to focus, then whenever you are ready, go ahead.

Variation 2: Assign a student to go in and cause a problem. For example, send in a student to hijack the bus.

Words to the Wise

To refocus students or slow the action down, suspend the action of an improv by calling "Freeze." Occasionally, you will have a student who will try to preplan an action or deliberately do something to cause laughter. Remove the student from the improv and explain why. Do not let him re-enter until he has observed others responding accordingly.

The games "Who Am I?" and "Where Am I?" are adaptations of Viola Spolin's Who and Where games found in *Improvisation for the Theater*, Northwestern University Press.

Variation 3: Create a situation that requires more students from the audience to go in and assist. Perhaps the bus crashes and more students have to arrive as paramedics to assist the passengers.

When an improve ends, it is useful to discuss students' observations and reactions. Ask:

- How did you feel when . . . (something in the improv happened)?
- Did your own character at any time surprise you?

Technique: Decision Making

Exercise: IMPROMPTU SPEAKING

Benefits: Develops ability to think on one's feet, skill to quickly distinguish important facts, and ability to convey passion

Format: Arrange students in groups of six to eight. Instruct students to go around the circle and state something they love to do. Have students go around the circle several times so every student states at least four things they love to do.

Tell students they have two minutes to pick their favorite activity out of the four mentioned (or it could be something someone else mentioned that they forgot to say) and prepare a 60-second impromptu speech about it. Encourage students to consider why they love this thing and what they could tell the group that the members might not know.

After the two minutes, starter student stands and shares impromptu speech. The student to starter's left is the official timer; no other student is to watch the clock, only the official timer. The rest of the group must give their undivided attention to the speaker. The timer could give a five-second warning to the speaker to finish up.

When the speaker is finished, members of the group name three things they did not know about that topic. The student to starter's right presents the next speech and the official timer position is passed to the timer's right (to the person who just spoke).

Variation 1: Students can vote for one member to share her impromptu speech with the whole class; however, group members cannot make a student do so.

Variation 2: After students have given an impromptu speech, assign a speech topic for the next day. Again, students must keep to the one minute time line, but this time must prepare an opening and a closing to their presentation.

Variation 3: Increase time limit to two minutes, but allow for some preparation.

Exercise: HOT SEAT

Benefits: Develops ability to make quick decisions based on minimal information, fosters ability to relate in role, and promotes concentration

Format: Read the story "The Wife Who Ate Nothing" to your students. If you would prefer another folk tale, keep it short and make sure the characters are strong and very different from one another.

After the reading, ask students, "If you could ask a character from the story a question, what would it be? What do you most want to know?" Encourage students to state the question and who it would be directed to.

Invite a student to come up to the front of the class as a character from the story. The student may choose who she wants to be. From her walk and the way she sits, students observing should be able to determine who she is before she even speaks. Instruct students to ask one question of the character.

After a number of questions, thank the student and invite up another student to represent a character and take questions.

Variation 1: Let students practise the exercise in pairs.

Variation 2: Let the student in the Hot Seat become a character from any story. The questioning students must determine who he is without coming right out and asking his name or what story he is from.

The Wife Who Ate Nothing

(771 words)

In a small village in Japan there lived a wealthy man who had never married. Everyone in the village wondered why. One evening, as he sat eating a fine dinner with a friend, his friend asked him, "Why have you never taken a wife?"

"Wife?" replied the man, "very simple. I would have to feed her and that would be a waste of money. If I could find a wife who never ate anything, I would marry her right away."

The very next morning a lovely young woman appeared on his door step. "I never eat food," she said. "Please, take me for your wife."

The man was delighted. He married her at once and indeed, she never ate any food.

One night the man finished work earlier than usual and arrived home before he was expected. As he approached the house, he could smell delicious food cooking and he peeked in the window to see what he was getting for dinner. His wife was making rice balls. Hundreds and hundreds of rice balls. He wondered why she would do such a thing. After she arranged them in a great pile across the table, she reached up and began to unbraid her beautiful black hair that she always kept neatly arranged on the top of her head. Her hair fell down around her shoulders. She carefully parted it and there, on the top of her head, was a wide, red gaping mouth. It smacked and licked its lips.

She took rice ball after rice ball and tossed them into the large mouth on the top of her head. The mouth slurped and gulped and made the most horrible sounds. When all of the food was devoured, she fixed her hair back on top of her head and hid the mouth completely.

The man was so terrified at this, at first he only stared. Now, he gulped and said to himself, "It's a Yamamba*!" He backed away from the window and tripped over a stone.

The wife heard him fall and knew instantly that he had been watching. She ran to the door and met him outside, "Oh, husband," she exclaimed, "welcome home. Come in and rest."

Words to the Wise

Villains make great Hot Seat characters, especially if they defend what they did. There is often a strong emotional reaction by the questioning students. If there is such a reaction, after the character leaves the Hot Seat, allow students to discuss how they felt while the character was being questioned.

^{*} Yamamba means monster.

The man was too afraid to run away, so he went inside with her. He thought he would sneak away. But as soon as they were in the house, she grabbed him by the hair, threw him into a chest and closed the lid.

"So, you saw my mouth did you, my dear husband?" she screamed. "All the better, because I will eat you next!"

To his horror the man felt the chest rise into the air and land with a thud on the Yamamba's back.

"She is taking me into the mountains," the husband realized, "to share me with the other Yamambas!"

As she ran along the path that led to the mountains, the man creaked open the chest. Her hair had come down and was flying all around her. All he could see was her great, wide, gaping mouth, licking and smacking its lips. He slammed the lid closed and waited.

Some time later, the chest dropped to the ground and he heard her muttering, "Water, I want water."

He peeked out and saw her a little distance away, scooping up water from a mountain stream. As she dribbled the water into her head, he jumped out of the chest and started to run. He ran as fast as he could, but she was right behind him. He could hear the mouth licking and smacking, getting closer and closer.

Up ahead he saw a swamp. The water was thick and dark and out of it grew many weeds and wild flowers. There was nowhere else to go, so he dove right into the muddy water. When he surfaced, he saw he was in a large clump of Iris flowers. The smell was heavy and sweet.

The man frantically looked around for the Yamamba, but he couldn't see her. He waited and listened. There was no sound, nothing stirred. He stood up and looked around. There, very close to him, stretched out as though trying to grab him was the body of the Yamamba. She was melting, like snow on a hot pan, melting against the sweet smelling Iris flowers. The blossoms had burned right through her. The Irises had saved his life. From then on the man kept Irises growing all around his home and even some on the table. And he never took another wife.

About five minutes to tell

Curriculum Extensions: Acting on Short Notice

Create a Game: Arrange students in small groups. Give each group an envelope containing four paper clips, two straws, one marble, and a piece of paper. Go into role and say,

Well, this is it. These envelopes and the contents are all that's left in the warehouse after the company fire. The Great Canadian Toy Company is in trouble. You are supposed to be the best game creators in the business. Now, we'll find out. You will have to come up with a game to market using only these items or we are all out of a job. You have twenty minutes. Good luck.

Market a Game: After completing the previous exercise, go back into role and say,

Drama

Language Arts

Great work, great work. I applaud you all. However, not every game here can be marketed at once. Only one can be used this year. The Chairman of the Board wants to see every one of them, but he will only choose one. There is a million dollar bonus for the team whose game is selected. The rest of you, unfortunately, will be let go. So, you will have to present your game to the Chairman in the most exciting way you can. Prepare a presentation to show it off. Name it. Play it. Your presentation may even become the commercial to sell it to the public. Perhaps a jingle would help. The Chairman will be here in twenty minutes. Good luck.

Guess who gets to be Chairman of the Board? Enjoy, but give them all the million dollars or you might get run out of the school!

A Character Study: An alternative to students writing a description of a character from a novel is to become the character. Once students choose a character, invite them to find the right clothes, voice, and posture. They should be ready with creative answers as well as answers based on the story, because the students asking the questions will try to trip them up.

Student Reflections

Invite your students to consider and respond to some of the following questions in their response journals.

- 1. How did the improvisation games change you?
- 2. What was the hardest thing you did in improvisation? Why was it so hard?
- 3. How can you use what you learned in improv when you are speaking in front of people?

Language Arts

Teacher Assessment

Focus: Improvising

Date: _		
Frequently	Sometimes	Rarely
ally quence \(\bigcup_{\text{quence}} \)		
story \square		
	ally quence	ally quence \(\text{quence} \)

CHAPTER

Interpreting

"I love my sister" were the words he chose as the opening line to his speech. He was smiling when he said it so his face didn't betray his words. No, it was his tone that gave it away. The class tittered.

"I mean, I really, really love my sister. She's so . . . sweet, and . . . considerate and generous . . . I'd love to . . ." Here was a great long pause. The whole class watched and waited, ripe with anticipation.

"Flush her down the toilet!" he blurted out, and we all broke up.

The Meaning Behind the Words

Tone is everything in communicating intent. You want to sound provocative? Change your tone. How about threatening? Adjust the tone. Sarcastic? Condescending? Loving? You guessed it. Tone. Controlling the tone of your voice controls the message behind the words you say aloud. There is no simpler way to make a disparaging comment, show anger or even delight than to carefully direct your tone. Often, tone is subtle and the receiver has to consider if they are taking the message the right way. But more often, it is blatantly obvious and the results can start an argument, a love affair, or a war.

Out of tone develops an impressionistic technique used to express an overall impact of a poem, story, or speech. We call it the *mood*. However, a speaker does not *have* mood; a speaker *creates* a mood, and he does this through his attitude towards the piece he is delivering. Attitude means to "assume the position of." So, the speaker must first determine what his attitude or position is towards his material, and then create a mood to support that attitude using appropriate tone.

Comment to Student

Pre-test: Making Meaning

Arrange students in groups of four to six. Instruct students to go around the circle as many times as they can, each saying the word "yes" to show a different feeling or meaning.

Observe how willing and able students are to play with their voices. Can students adjust the inflection and pitch to get across new meanings and messages or are they only aware of getting louder and softer? Record your observations on a class list.

"I liked the emotion game where you say your name because it helped me with my expression. I would have liked to do more of it."

Ming, Grade 6

"Nice change in the voice. Very threatening. I knew something was coming."

Words to the Wise

Many students will laugh before they can get out the word. Allow the laughter, but encourage them to still do the emotion. It might take a few attempts before something is actually expressed. Some students may have difficulty expressing certain emotions. For example, a quiet student may be uncomfortable expressing anger. If a student is very uncomfortable expressing an emotion, don't make him do it. Let him pass, but ask him to try the next one. Students will automatically use facial expression and sometimes gestures. Let them, but do not allow touching.

Words to the Wise

Students find it easier to perform the voices when they are allowed to act out the script. But the acting can be a trap. It is good training every once in a while to allow students to act things out, but during a speech or a storytelling, the speaker is not supposed to act. The speaker should never create that fourth wall, but should instead focus always on the audience. Voices and movement are implied, not performed. If, during a speech, the speaker describes a man who drops his head forward in frustration and flops into a chair, the speaker can tilt his head slightly to give the impression of the movement: however, the speaker shouldn't actually throw his head forward and flop into a chair. That is acting out the words. If students tend to get lost in the acting, take them back to the radio play format to accentuate use of the voice only.

Technique: Tone

Class Exercise: MY NAME IS

Benefits: Develops awareness of tone and vocal agility using inflection, pitch, and volume

Format: Ask students to sit with you in one large circle. Starting with yourself, say your name out loud, but say it as though you are shy and sweet. The student to your right says his name, but must use the same qualities in his voice. Each student around the circle, in turn, does the same.

When it comes back to you, start the activity again, but this time, say your name as though you were mad. Let the activity continue around the circle. Every time it comes back to you, change the tone of your voice to reveal a new emotion or quality: haughty, sexy, embarrassed, afraid.

If students have no difficulty imitating you, arrange them in small groups. Assign one student as the starter. He can say a color or a number and students around the circle must repeat the word and the intent. Once everyone has tried the word, the student to starter's right says a new word with a new emotion.

Here is a list of more emotions for students to demonstrate: frustrated, joyful, sinister, depressed, bored, sarcastic, hopeful, loving, nervous, sad, interested, eager, delighted, surprised, threatening, bossy, arrogant, sly, sophisticated, snobby, perky.

Exercise: LEMON DROP?

Benefits: Develops communication through tone and ability to discern intent and subtext through vocal quality

Format: Arrange students in pairs. One partner is A; the other is B. Instruct students to read through the script provided. Allow students to decide who the two characters in the script are and have them read the script.

Hand out slips of paper, one for each partner, designating new roles for the script. Instruct pairs to read through the script again, changing their tone to depict the new roles. Here are some possibilities.

Doctor — Patient	Bank Robber — Bank Teller
Police — Speeder	Cashier — Customer
Principal — Student	Old Friends
Prisoner — Guard	Party Guests (don't know each
Parent — Child	other)
Mugger — Victim	Strangers (waiting for a bus)
Spies	Old, Old Person — Nurse
Joggers	

Encourage students to act out a scene using the script and the assigned roles. Pairs may demonstrate the scene to the rest of the class when ready.

The Lemon Drop

A.	Hi.
B.	Hi.
A.	How are you?
B.	Fine, and you?
A.	O.K. Would you like a lemon drop?
B.	Sure
A.	Here.
B.	Thanks. Well, I have to be going.
A.	Bye.
B.	Bye.

Technique: Attitude

Creating a mood is a great deal of fun. It is reflected in facial expression, eyes, body movement, and gestures but especially in the voice. Usually the text of a selection will indicate a mood, but it is up to the speaker to decide how to portray it. This gives her an enormous amount of artistic freedom and it is exciting to explore many possibilities before making a final choice on the delivery.

Class Exercise: CREATING A MOOD

Benefits: Develops ability to match meaning and overall impression, facilitates interpretation using vocal technique, fosters poetic appreciation, strengthens analytical skills, and widens vocabulary

Format: Arrange students in pairs and give each pair a poem. Instruct students to read through the selection and determine the emotional tone: happy, sad, frightening, urgent, sarcastic, thoughtful, romantic, humorous, mysterious, horrifying, threatening, whimsical. (An example appears next page.) Alternatively, if students are working on stories or speeches, instruct pairs to determine the mood of their material and select sections of it that directly illustrate that mood. Once the emotional quality is established, they can determine how to express the overall mood. What kinds of sounds and rhythms do they need to give the feel to the listener? What words need to be emphasized? Where should the pauses go?

Instruct students to practise reading their material aloud, to depict the mood. Encourage them to work towards reading it aloud to the rest of the class.

Curriculum Extensions: Setting the Mood

Poetry Writing: Instruct students to create a free verse poem depicting a mood. As a starting point, have students recall a time they felt a strong emotion, positive or negative, and write about that incident. Making a list of words, colors, and comparisons that reflect the mood of the incident will give students a resource to create from.

Dramatic Styles: Arrange students in groups of six to eight. Assign each group a familiar folk tale (for example, The Three Little Pigs), and instruct the members to prepare a scene from the story. Everyone in the group must have a speaking role. When scenes are nearly ready, have one member from each group choose a slip of paper that indicates the *style* of the presentation: opera, martial arts, musical, wild west melodrama, or robotics. Let students rework their scenes in the assigned style and then share the scenes with the rest of the class.

Language Arts

Drama

DARK MOMENT

	whisper the word listening the trees, dark trees, bend listening; — slow and low
	the trees, dark trees, bend listening; — slow and low
	on the hemlocks moon-dew glistening
	shivers and stops, — pause
	quivers and drops — pause
	as the thing from the night goes past us all right — speed up and look around
	under trees, dark trees, bowed listening
	so we crouch in the chill and try to keep still while we each hold our breath
	and try to keep still together and gust
	while we each hold our breath
	under trees dark as death
nue /	is it gone? did it hide? another voice another voice frightened can it see? has it spied voice
voice voice	can it see? has it spied voice
0000	where we shiver and try to keep quiet inside? — voice gets higher & higher
	now the moon, pale moon, comes listening — calming down
	over clouds that drift past glistening
	as my heart flip-flops
	hear it start? steps? stops — staccato
	let the thing from the night go past us all right hush! as moon-touched clouds part, listening \ relieved
	echo fade 4 times away
	4 times away Jim Bennett

one

Student Reflections

Invite your students to consider and respond to some of the following questions in their response journals.

- 1. When do you notice people's tone of voice most? Why do you think that is?
- 2. How could you demonstrate your attitude towards a story, poem, or speech before speaking?
- 3. How has your ability to interpret the mood of a poem, story, or speech changed?

Teacher Assessment

Focus: Interpreting

me: Date:			
	Frequently	Sometimes	Rarely
Technique: Tone			
The student demonstrates variety of inflection and pitch in voice to reflect tor communication of intent through tone in conversation in stories in speeches			
Technique: Attitude			
The student demonstrates understanding of mood in poetic selections in speech in stories creative portrayal of mood ability to portray different moods (e.g., sad, humorous, tender)			
Comments:			

CHAPTER

10 Critiquing

Once during a television interview, popular contemporary novelist Lynda Simmons was asked about writers criticizing other writer colleagues. Her answer was insightful: "Writers do not criticize other writers. Only someone who creates nothing and risks nothing will criticize. Writers critique each other's work."

Critiquing Versus Criticizing

There is a distinct difference between criticizing and critiquing. According to Webster's dictionary a critic is one who judges. Anyone, skilled or unskilled, can subjectively say, "this was awful" or "this was great," relying purely on personal taste. Unfortunately, criticizing is almost always negative and the person making the judgment created nothing, risked nothing, and remains safely untouched by their own words.

A *critique*, however, is defined as a process, a "careful analysis of an artistic production." It is an act founded on knowledge and experience. The analysis should be a result of an educated eye. Commentators provide good examples of active critiques. A commentator for the Olympics, for example, not only describes what is happening, but comments on the moves, the gestures, and the plays out of knowledge. Often, the commentator has been in the athlete's place. He also demonstrates a sensitivity, an awareness towards the athlete's emotional and physical state. This comes from having taken the risks himself. The commentator has been there.

In your classroom, you want to build individuals who can critique, not criticize. You want to create coaches, not critics. If you allow your students the time they need to develop their skills as speakers, then all of the students will have created and all will have risked something. Out of that experience they will be able to suggest, comment on, and assist their fellow risk takers. In this focus area, students will learn how to select criteria on which to base opinions, use a nonjudgmental vocabulary, and explore the art of constructive commenting. Combining these three techniques of critiquing and their own personal experience will allow them to respond to each other with intelligence and sensitivity.

"Devon's a good coach. He tells me how to be better but he doesn't, like, embarrass me."

Ramsese, Grade 6

Pre-test: Checking for Subjectivity

Instruct students to write a one-paragraph review on a current popular sitcom. Ask them to state three things that make it a hit and three things that could make it better. Collect the reviews and flip through them to see if any students used knowledge of acting or writing as a basis for their judgments or judgmental words, for example, good, bad, funny, great, super hot, and cute.

Preliminary Exercise: Building a Criteria Base

This class exercise develops awareness of public speaking skills and techniques, strengthens ability to prioritize skills and techniques, and helps establish a criteria base on which to assess speakers.

Begin by arranging students in groups of four to six. Assign one student as recorder who will write down everything that is mentioned. Students have ten minutes to go around the circle as many times as they can, stating skills and techniques that a public speaker must show to be successful. When ten minutes are up, instruct students to decide, as a group, the top five on the list and circle them. After words have been circled, instruct students to arrange the top five in order of importance.

Bring the groups together. Call upon one person from each group to share their results with the rest of the class. Compare the results. Is the most important skill the same for every group or are they all different? Are the first five the same, but perhaps listed in a different order? Out of all of the skills listed, can the class agree on five or six skills that are crucial? At the end of this process you will have a list of skills on which to critique students' work, selected by the students themselves. Below is one student group's list.

- 1) Speaking
- 2) gestures
- 3) (eye contact)
- 4) addience praticapating
- 5) {vocie}
- 6) (facial exp.)
- 7) no fidiging
- 8) (pause)
- q) stance
- 10) commands
- 11) mimeing
- 12) sit up
- 13) don't pace
- 14) plant your feet
- 15) stand up
- 16) posture
- 17) (memory) *

Words to the Wise

This exercise is difficult for students if they have had no previous experience presenting speeches or stories to an audience. They have nothing to draw from. If you want critiquing skills developed before any of the other focus areas, students will need to observe a presenter before doing this exercise. You have several options: bring in a motivational speaker or storyteller, watch film clips of past presidential/prime ministerial speeches, contact your local Toastmasters Club for a demonstration, or request a speaker from your local Chamber of Commerce.

Most classes cannot agree on the single most important skill or the order of importance. Aim to agree on a top five but don't list them by priority.

The three-to-one method of critiquing protects the presenter from being overwhelmed with negative criticism, yet constructive comments for improvement are made. Using this format, students are not afraid to rehearse together. This game builds critiquing skills but more importantly, it builds trust.

Technique: Nonjudgmental Critiquing

Class Exercise: I LIKE, I HATE, I SEE

Benefits: Develops discrimination between judgmental and critical comments and allows students to critique their peers' work more effectively

Format: Hold up an article of clothing (dress, sweater, or pants). Ask students to comment on the clothing and record what they say. Encourage students to come up with as many words as possible. Then hold up another item of clothing (if possible, something useful like a warm scarf or work boots). Add comments about this clothing to the same list. Develop a list of at least twenty comments. On your list you will have words like ugly, stupid, cool, out of date, nice, pretty, sucks.

Ask students to circle any words on the list that are factual, anything that accurately describes the clothes. (There will probably be none.)

Ask students to box any words that show dislike or distaste for the clothing. Ask students to mark in triangles any words that show favor or a liking towards the clothing.

Explain that the boxed and triangle words are judgments based on personal taste, cultural differences, and economic background. In the work that students will be doing together as critics, there will be no room for judgments. All judgment words are banned, especially the words good and bad. Students will base all comments on facts, and the facts will be based on the understanding they gain as a result of their work in the focus areas.

Using the rule *No judgment words*, instruct students to once again comment on the clothing pieces. They will find this difficult at first. Encourage students to ask questions about the purpose or usefulness of the item to enable themselves to make insightful comments.

Game: THREE TO ONE

Benefits: Develops awareness of the power of positive, negative, constructive, and destructive comments, as well as sensitivity towards fellow students' position

Format: Arrange students in groups of four to six. Starter student tells part of her speech, story, or whatever she is working on. Only about one minute of presentation is necessary. The student may tell her favorite part, the opening, or a section she is developing. The student should stand or sit in a chair as she will when presenting to a large group.

Listening students make mental note of several skills/techniques achieved during the presentation and one skill that was weak or missing.

As a team, group members share their observations with the presenting student. For every suggestion for improvement, they must make three positive comments on achievements. No group member may use a judgment word, especially "good" or "bad." Contributors should say specifically what worked and what didn't.

Group members must be alert and aware of the ratio of positive comments to negative comments. If no more than three positive comments can be given, then only one suggestion for improvement can be made. If six praise comments can be given, then two suggestions for improvement can be offered. (If your students are young or immature, simply limit the commenting to three positive, one

negative and leave it at that.) It is the listeners' responsibility to keep track of the comments and to ensure that the presenter is given the correct amount. Three to one: three positive, one negative — that is the rule.

Once everyone in the group has had a turn, direct them to go around the circle again. The presenting student may repeat the selection done earlier or choose another part to present, but the same previous comments must be remembered by the group. If the student this time around shows the skill previously missing, the group praises her achievement and one new suggestion for improvement may be given. The game continues around the circle with each taking as many turns as possible in the given time.

Curriculum Extensions: Rapping

Performing Rap: Rap is a fascinating form of modern poetry: a simple collection of words that rhyme, follow a beat, and almost always depict a pet peeve. Raps are criticism pieces. Below is a rap for students to experiment with. In partners, they can find the beat and perform the poem.

All I Wanna Do

Teacher says,

"You gotta finish your poetry assignment" Line up all the words, till they are in alignment

"Do not shirk, girl," she says

"Your responsibility

Grow up

Be like me!"

Yeah.

Slow, fat and ugly

All this homework

All this stuff

Cramming in my head

My head it feels like lead

I only want to go to bed

Everywhere, I see red

All I wanna do

Is wear my Nike hat

Play Nintendo, eat some snacks

Hang out everyday

With my friends down by the mall

Eat nachos till I'm tall

As Vince Carter

Make him my alma mater!

Stay up all night and watch my hero

Tom Greene

Play jokes

Be crazy

Get paid to be mean!

Language Arts

I just wanna sleep in Sleep till noon, is that a sin? Listen to Shaggy, Brittany Spears and Emenin

Wear my head phones all day long Not be the one that's always wrong Get PAID to baby-sit My bratty brother Tom

I wanna leave my room a mess
I confess
I like a mess
I wanna sit around all day —
BUT I CAN'T!

'Cause I have to finish my poetry assignment

Creating Rap: When students are comfortable with the pattern, instruct them to create their own rap. They can be as judgmental as they wish, as long as they do not hurt or humiliate a peer.

Student Reflections

Invite your students to consider and respond to some of the following questions in their response journals.

- 1. What do you think are the most important attributes of a speaker?
- 2. How did you feel when your classmates were giving you comments and suggestions?
- 3. How did the way you felt affect the way you treated the other members of your group when it was their turn?

Music

Teacher Assessment

Focus: Critiquing

Name:	Date:		
	Frequently	Sometimes	Rarely
Technique: Criteria Selection			
The student displays knowledge of public speaking techniques and skills			
an opinion on the importance of one skill compared to another			
Technique: Nonjudgmental Critiquing			
The student displays awareness of judgmental and nonjudgmental commenting a nonjudgmental vocabulary			
Technique: Constructive Commenting			
The student displays accurate suggestions based on criteria in critiquing situations sensitivity towards the work of others sensitivity towards the feelings of others a balance between positive and negative remarks			
Comments:			

PART B Performance Matters

As the chart below summarizes, all three stages of my model for public speaking lead directly to performance in front of an audience.

A Model for Practising Public Speaking

Without an audience, there is no performance, only the potential for personal satisfaction. The audience does not have to be large for the student to qualify as a performer rather than as a presenter. But there are requirements that make a presentation a performance, and not a simple sharing. For example, the speaker should not be at the same level as the listeners and should speak for at least one minute.

The goal of performance is to satisfy the audience and in achieving that satisfaction, the performer is satisfied. This goal is very different than that of expressive language. Explorations of expressive language focus on participation and personal development — no audience is needed in order for expressive language to be fully experienced and successfully attained. Performance, on the other hand, is a giving of the presenter to an audience. It is a gift. By acknowledging the give and take of presenter and receiver, a relationship can begin to unfold and develop. This relationship is fundamental to the success of the performance, for without it there is no significance in the communication.

CHAPTER

111 Evaluating Oral Language Performance

I was once working in a school in Ontario with a class of Grade 4 students and noticed the teacher frequently sat at his desk to mark papers. I suggested to him that he could be watching his students with a clip board in hand, making notes on students' progress and minor achievements.

He shook his head. "Why bother?" he asked. "I'll grade them when they get up to perform."

"But what if the student is having a bad day? What if he's totally flustered by outside circumstances that he can't control? Even in university, the grade of an entire semester isn't based solely on one exam. The professor takes into account attendance, contributions, essays, labs . . . " my voice trailed off.

He nodded, but did not pick up a class list. No anecdotals were taken, at least not while I was present. I'd like to think he wrote something down after class, in reflection. I pray he did, or all of the concentration, decision making, confidence building, technique and skill development — everything that his students and I had worked on for six weeks — would have counted for nothing. Their term grade would be based on a five-minute performance.

Working with a Rubric

Oral communication is a process. Students do not suddenly understand the concept of speaking in public, as they can with a math or grammar concept. There is no "Oh, I get it" moment. Oral communication is a learning, refining process that evolves through experiencing the skills and techniques needed, then practising them again and again with new audiences. It takes time, sensitivity, and maturity to progress successfully.

If I had my own way, there would be no grade assessment of this process, only anecdotals citing achievements and personal breakthroughs. Student journals would also play an integral part in determining the personal growth and success level of each student. But I also feel very strongly that, as a teacher, you need to have a set of criteria and standards on which to base your assessment of their progress. For this reason, I have developed two four-point rubric scales. These scales were not designed to judge a final performance. They are a tool of awareness. If there is a section on the rubric you do not wish to use, just cross it

off and keep it in mind for the class next year. Not every class will want or need the same skills.

Several teachers I have worked with told me that giving the students the rubric produced a more concentrated effort during the development stages as well as stronger performances. I am sure this works with students who are adept at goal setting; however, I would not expect every student to be able to do this. As the teacher, you will have to decide whether or not to give your students a copy of the rubric. Personally, I feel giving the students a standardization scale can only assist them. Students know what to aim for and can choose to produce or not produce.

Evaluating a storyteller

The first rubric, pages 122–23, evaluates a student on the *delivery* of a story, not on the story itself. If a student has followed the guidelines on material selection (page 133), there is no need to re-evaluate the material during presentation.

Evaluating a speech maker

Unlike storytelling, a student cannot separate the writing of a speech from its presentation. The two aspects tend to go hand in hand, unless the speech is formally written out word for word and marked as a composition by the teacher, which most teachers do not do.

Therefore, half of a speech evaluation is on the speech itself and the other half of the evaluation is on the delivery. It is possible for a student to score poorly on the creation of a speech, but score very well on its delivery and vice versa. If enough time is spent on the preparation of both, it is more likely a student will do well in both. (See Chapter 12, Developing Content for Performance, for more information on creating speech material.)

See the rubric on pages 124–25.

Peer Evaluation

Orally commenting on a presentation gives immediate feedback to the presenter, and positive comments are, of course, crucial to the presenter's ego. A written evaluation, however, is also a valuable tool. Many students can't remember what was said to them after the performance because they were too nervous to take it all in. The evaluation on paper works as a record. Once the adrenaline has stopped pumping, a presenter can look back in a more objective state to evaluate his performance and use the written evaluations as insight.

Written evaluation is also important to the peer giving the assessment, because it carries a much heavier weight of responsibility. Every writer knows, as your students will soon discover, once something is in print, you can't take it back. It's essential to be accurate and fair.

I do not recommend that everyone in the class evaluate the student giving the presentation. The speaker needs to connect with his audience, see their eyes, and hear their reactions; if every student is busy writing down comments or ticking off boxes, audience rapport is lost. The audience also needs the opportunity to simply listen and enjoy the experience. Assigning five student evaluators for each student presentation moves around the responsibility and frees the rest of the class to act as the audience.

Storyteller:		
Story:	Date	

	EXCELLENT	GOOD	SATISFACTORY	NEEDS IMPROVEMENT
Communicating Ideas Use of Words	You used words and sentences your audience could understand yet you challenged them with new vocabulary.	You used words and sentences your audience could understand easily.	Your audience understood most of what you said.	Your audience did not understand most of your story.
Memory	You remembered the entire story in sequence without fumbling.	You left out part of your story but corrected yourself during the telling.	You forgot some of your story.	You did not complete your story.
Sentence Structure	You used proper sentence structure all the way through the story.	You used proper sentences most of the time with only a couple of repeated words.	You used several incomplete sentences and repeated words more than four times.	You consistently used incomplete sentences and repeated the words and, then or uh.
Pronunciation	You pronounced all of your words clearly and properly.	You mispronounced two words.	You mispronounced three words.	You mispronounced several words.
Composure Control	You looked calm and secure and appeared to enjoy the experience.	You looked calm.	At times your nervousness detracted from your presentation.	You appeared nervous or flustered most of the time.
Posture	You held your spine erect and your shoulders open, and you displayed a strong stance.	You held yourself up tall.	You held up your head but crouched over.	You slouched and hid your face.
Audience Awareness	You were aware of your audience's reactions at all times and responded to their involvement in your story.	You reacted to your audience at times.	You appeared aware of your audience's reaction to your story but did not react or relate to them.	You ignored your audience.
Use of Expression Gesturing	You used full hand gestures and arm movements.	You used hand gestures consistently.	You used your hands once or twice.	Your hands did not express the story.
Facial Expression	You consistently used exaggerated yet appropriate facial expression.	Your face reflected the story most of the time.	Your face changed in some way to reflect the story.	Your face did not change during the story.

^{© 2001} Cathy Miyata, Speaking Rules! Pembroke Publishers Limited. All rights reserved. Permission to reproduce for classroom use.

	EXCELLENT	GOOD	SATISFACTORY	NEEDS IMPROVEMENT
Use of Voice Pitch	Your voice varied in pitch.	Your voice demonstrated some range in pitch.	Your voice demonstrated very little pitch variance.	You demonstrated no variance in pitch.
Volume	Your voice varied in volume.	Your voice demonstrated some change in volume.	Your voice demonstrated very little volume variance.	Your audience could not hear the story.
Pace	Your voice varied in pace.	Your voice demonstrated some change in pace.	Your voice demonstrated very little change in pace.	You demonstrated no change in pace.
Silence	You used pauses consistently for effect.	You used pauses sometimes for effect.	You used a pause once for effect.	You did not use pauses for effect.
Emotional Quality	Your voice conveyed a variety of emotions.	Your voice conveyed some emotions.	Your voice conveyed one emotion.	Your voice conveyed no emotion.
Developing Rapport with an Audience Eye Contact	You consistently swept across your audience and made eye contact with most members.	You looked at the audience most of the time and made some eye contact.	You looked at your audience some of the time.	You did not look at your audience.
Audience Participation	You involved your audience physically or vocally.	You involved your audience more than one way.	You involved your audience with a question.	You did not involve your audience.
Style Creativity and Originality	You demonstrated a creative and unique style.	Your presentation was unique.	You demonstrated something slightly different.	You demonstrated no originality.
Risk Taking	You exercised great personal risk.	You took a chance trying something out of the ordinary.	You attempted something you would not normally do.	You did not try anything new.
Believability and Enthusiasm	You clearly demonstrated believability and enthusiasm.	You sounded like you believed your story and showed some enthusiasm.	You appeared interested in your story.	You maintained a distance of disbelief from your story.
Opening Competence	Your opening showed polish, confidence, and control of the audience.	Your opening showed confidence.	Your opening showed some confidence.	You did not gain your audience's attention when you began.
Closing Competence	You executed an ending using several tactics, polish, and confidence.	You used one closing tactic and demonstrated some confidence.	You indicated the close by telling the audience it was over.	You left your audience unsure whether the presentation was concluded.
Accepting Applause	You confidently remained in front of your audience to accept your applause.	You remained in front of your audience for your applause.	You left your station before you could be thanked.	You did not conclude your presentation.

^{© 2001} Cathy Miyata, Speaking Rules! Pembroke Publishers Limited. All rights reserved. Permission to reproduce for classroom use.

Speaker:				
Topic:	Date:			

	EXCELLENT	GOOD	SATISFACTORY	NEEDS IMPROVEMENT	
Organization of Content Opening	You created an enticing opening that grabbed the audience's attention.	You caught the audience's attention.	You made an attempt to catch the audience's attention.	You did not catch the audience's attention in the beginning.	
Body	You shared at least three main points with supporting ideas and illustrations.	You shared three main points but did not support them thoroughly.	You shared two main points and supported them.	You shared a main point but did not support it with ideas or illustrations.	
Conclusion	You summarized your main points and drew an interesting and unique conclusion.	You summarized most of your main points and concluded your speech.	You did not summarize your speech but you did conclude it.	You did not summarize or conclude your speech.	
Interest Level	You demonstrated enormous enthusiasm for your topic.	You demonstrated interest and some enthusiasm for your topic.	You seemed interested in your topic.	You did not appear interested in your topic.	
Visual Aids	You used a variety of visual aids to enhance your topic.	You used two visual aids to enhance your topic.	You used a visual aid to enhance your topic, but it was difficult to see.	You did not use any visual aids to enhance your topic.	
Style Creativity and Originality	You demonstrated a creative and unique style all of your own.	Your presentation was unique.	You demonstrated something unique in your speech.	You did not attempt anything original or unique.	
Risk Taking	You exercised great personal risk.	You took a chance to try something out of the ordinary.	You attempted something you would not normally do.	You did not try anything new.	
Communicating Ideas Use of Words	You used words and sentences your audience could understand yet you challenged them with new vocabulary.	You used words and sentences your audience could understand easily.	Your audience understood most of what you said.	Your audience did not understand most of your speech.	
Memory	You remembered the entire speech in sequence without fumbling.	You left out part of your speech but corrected yourself later in the presentation.	You forgot some of your speech.	You did not complete your speech.	
Sentence Structure	You used proper sentence structure all the way through.	You used proper sentences most of the time with only a couple of repeated words.	You used several incomplete sentences and repeated words more than four times.	You consistently used incomplete sentences and repeated words such as <i>and</i> , <i>then</i> or <i>uh</i> .	

^{© 2001} Cathy Miyata, Speaking Rules! Pembroke Publishers Limited. All rights reserved. Permission to reproduce for classroom use.

	EXCELLENT	GOOD	SATISFACTORY	NEEDS IMPROVEMENT	
Pronunciation	You pronounced all of your words clearly and properly.	You mispronounced two words.	You mispronounced three words.	You mispronounced several words.	
Composure Control	You looked calm and secure and appeared to enjoy the experience.	You looked calm.	At times your nervous- ness detracted from your presentation.	You appeared nervous or flustered most of the time.	
Stance	You held your spine erect and your shoulders open and you displayed a positive body language.	You held yourself up tall and used a positive body language.	You held up your head but crouched over.	You slouched and hid your face.	
Audience Awareness	You were aware of your audience's reactions at all times and responded to their involvement in your speech.	You reacted to your audience at times.	You appeared aware of your audience's reaction to your speech but did not react or relate to them.	You ignored your audience.	
Use of Expression Gesturing	You used full hand gestures and arm movements.	You used hand gestures consistently.	You used your hands once or twice.	ds Your hands did not express your words.	
Facial Expression	You consistently used exaggerated yet appropriate facial expression.	Your face reflected the speech most of the time.	Your face changed in some way to reflect your words.	Your face did not change during the presentation.	
Use of Voice Pitch	Your voice varied in pitch.	Your voice demonstrated some range in pitch.	Your voice demonstrated very little pitch variance.	You demonstrated no variance in pitch.	
Volume	Your voice varied in volume.	Your voice demonstrated some change in volume.	Your voice demonstrated very little volume variance.	Your audience could not hear the presentation.	
Pace	Your voice varied in pace.	Your voice demonstrated some change in pace.	Your voice demonstrated very little change in pace.	You demonstrated no change in pace.	
Silence	You used pauses consistently for effect.	You used pauses sometimes for effect.	You used pauses once for effect.	You did not use pauses for effect.	
Emotional Quality	Your voice conveyed a variety of emotions.	Your voice conveyed some emotions.	Your voice conveyed one emotion.	Your voice conveyed no emotion.	
Developing Rapport with an Audience Eye Contact	You consistently swept across your audience and made eye contact with most members.	You looked at the audience most of the time and made some eye contact.	You looked at your audience some of the time.		
Audience Participation	You involved your audience physically or vocally.	You involved your audience in more than one way.	You involved your audience with a question.	You did not involve your audience.	

^{© 2001} Cathy Miyata, Speaking Rules! Pembroke Publishers Limited. All rights reserved. Permission to reproduce for classroom use.

The following peer evaluation form is a version of one designed by Heather Borthwick, a Grade 4 teacher in Mississauga. Her students use the form to evaluate each other after every performance and then discuss the results.

Name	Communicating the Story/Speech	Composure	Use of Expression	Use of Voice	Relating to the Audience	Style	Total
Rachel	G	G	G	g	G	E	G
Monica	G	N	N	g	N	N	N
Hanreen	G	E	G	g	E	G	G
Nida	G	E	E	g	Ε	G	G/E
Jim	E	E	E	E	\mathcal{G}	E	E

Code: E = Excellent; G = Good; N = Needs improvement

Self-Evaluation

For some of us, our hardest critic is ourselves. Perhaps we don't take into account how far we've come or simply expect nothing less than perfect. Am I suggesting that we not evaluate ourselves to avoid this harsh judgment? Not at all. Someone once told me, "Only in reflection is there growth," and I believe it. We need to consider our actions and performances so we can assess what worked, what didn't, and how things could be handled for next time. We don't just learn from our mistakes; we also learn from our achievements.

Some students believe they are perfect and can't improve in the least. Unfortunately, the know-it-all can't grow because she has nowhere to grow to. If you have a student like this, the self-evaluation form will always be glowing.

Yet, there will also be students who are truthfully thrilled with their own achievement and will have built enough confidence to praise themselves when they deserve it. Watch for these students. They need and deserve *your* praise too. As for the know-it-alls, well, be patient. Eventually, reality will teach them.

The following self-evaluation form is designed to be gentle on the self, yet fair, citing successes and failures. A form completed by a student storyteller is shown also. I recommend that every student fill out a self-evaluation form after a presentation and keep it for reference when preparing for the next presentation.

Oral Communication Self-Evaluation

Name: Date:		
Presented to:		
Did I speak clearly, loudly, and slowly enough?	Yes	No
Did I stand/sit tall and hold up my head?	Yes	No
Did I hide my nervousness and not fidget?	Yes	No
Did my audience understand what I was saying?	Yes	No
Did my speech/story sound interesting?	Yes	No
Did I use full hand and arm gestures to emphasize my story	? Yes	No
Did I enjoy this experience?	Yes	No
Did this make me feel better about myself?	Yes	No
		ccellent
reacted when I		ē
ervous when		
ed when		
	Did I speak clearly, loudly, and slowly enough? Did I stand/sit tall and hold up my head? Did I hide my nervousness and not fidget? Did my audience understand what I was saying? Did my speech/story sound interesting? Did I use full hand and arm gestures to emphasize my story Did I enjoy this experience? Did this make me feel better about myself? I feel I earned the following level for my effort and achieve Needs Improvement Satisfactory Good reacted when I ervous when	Did I speak clearly, loudly, and slowly enough? Did I stand/sit tall and hold up my head? Pes Did I hide my nervousness and not fidget? Did my audience understand what I was saying? Poid my speech/story sound interesting? Poid I use full hand and arm gestures to emphasize my story? Poid I enjoy this experience? Poid this make me feel better about myself? Yes I feel I earned the following level for my effort and achievement: Needs Improvement Satisfactory Good Extracted when I

STORYTELLING PRESENTATION

(Self Evaluation)

Name: Alas	18 Marrison Date: Feb. 70, 2001.		
Story: Martimor			
Presented To:	My class		
	Check Off About Your Presentation		
VOTOR	YES NO		
VOICE:	Did I speak clearly, loud enough and slowly?		
POSTURE:	Did I stand erect and firmly?		
COMPOSURE:	Did I <u>look</u> calm and secure?		
CLARITY:	Did my audience understand what I was saying (presenting)		
GESTURES:	Did I use natural, full hand movements?		
EXPERIENCE:	Did I enjoy this experience?		
CONFIDENCE:	Did this make me feel better about myself?		
GRADE:	I feel I earned this grade for my effort and accomplishments.		
G	OCD VERY 4001) EXCELLENT		
What would I o	change for next time?		
	time, I would like to be coloner		
and	not as scared.		
If you	want to talk to Mrs. Miyata about your		
5+0×4 - P1	want to talk to Mrs. Miyata about your lease do. She loves to hear about your experiences.		

Reflective Evaluation

Probably my favorite part of the communication process is communicating with the self: that tuning inward to measure one's own sense of accomplishment. Such reflection allows us to understand how far we have come and to aspire to new goals.

The self-evaluation form provided earlier touches on this, but sharing ideas, feelings, and observations with others has even more potential for provoking thoughtful reflection. Ask your class to consider the following questions, or arrange the class in small groups to discuss the points more intimately. After some discussion, let students respond in their journals.

- How did you feel after you started your performance?
- During the performance, did you ever step outside of yourself and see yourself presenting?
- Were you ever aware of thinking of two things at once?
- At what point in your performance did you notice the audience was really with you?
- When did you first see a facial reaction on a listener? How did it make you feel?
- How did you feel when your presentation was over?
- How do you feel now, looking back on it?
- What was the most important thing you learned from this experience?

Allowing your students time to mull over and talk about their efforts validates the hard work and stress they encountered and conquered. Evaluation can be a gift.

CHAPTER

12 Developing Content for Performance

She was not loud, angry, or even that animated, yet the flash in her eyes and the conviction of her tone were compelling.

"I am not," she said and took a breath to steady herself, "I am not interested in creating a generation of mindless future taxpayers!" Her voice climbed on "taxpayers," she paused, and then finished with her fists clenched. "I am interested in creating a future generation of citizens that will contribute to a healthy happy society."

The room was silent. Every educator there nodded, whether from Canada, the United States, or Sweden. Her beliefs, her energy, her commitment to the educational arts program she was defending consumed us. She was a singer/songwriter, not a speech maker, but she was brilliant, because what she said mattered to her — and now it mattered to us too.

Purpose Backed by Passion

Whether a student is choosing a topic to speak on or a story to tell, one key factor is needed — passion. The student must *love* the topic or story. Having an interest in it is not enough. Enthusiasm and a strong desire to share the material make the difference between a lukewarm presentation and one that sets the audience on fire. When you can get an audience to forget where they are and who they are with and to see and hear only you, to feel what you feel, and want what you want, then you are truly impassioned . . . and so is the audience.

All presentations serve at least one of four basic purposes: to inform, motivate, inspire, and entertain. The category *inform* includes explaining and teaching. The category *motivate* includes persuasion and selling. To *inspire*, according to Webster's dictionary, is "to communicate divine instructions to the mind of" or "animate by supernatural infusion," which implies a subject of a spiritual nature or one pertaining to some outside force. Entertainment is different than the other three purposes but also needs clarification. Do not assume that *entertain* means only to make the audience laugh. To entertain means "to engage" or "hold the interest of." Moving an audience to tears or terror is also a valid means of "engaging."

The study of any presentation by a great speaker, notably Abraham Lincoln, Martin Luther King, Jr., Winston Churchill, Mahatma Gandhi, or even Socrates, proves that almost every presentation has a bit of all or most of the purposes

"I was amazed at how passionate you were about your subject. I have never seen you so excited!"

Comment to Student

woven into the fabric of the delivery. A great speech is inspirational, entertaining, and still persuasive. A wonderful story may be entertaining, yet informative and motivating. But, even though several purposes might be intertwined, *one* should be set clearly in the mind of the presenter before she takes the stage.

Students need not decide on the main purpose of their presentation *before* they select their material, but eventually they must determine, after working with the material, which main purpose their presentation serves. Then they can be very clear in their intent towards the audience.

Selecting a Speech Topic

Students know what they love, what they care about, and what angers them. These are their passions. Use the quiz exercises below to get students to identify their passions.

Exercise #1: 10 THINGS I LOVE TO DO

Format: Ask students to list on paper the ten things they most love to do. When they have finished their list, instruct them to circle the best three, then put a star beside the very best one. They now have a list of possible topics, already prioritized.

Exercise #2: 10 THINGS I HATE TO DO

Format: Ask students to list on paper the ten things they most hate to do. (Advise students to not list people, only activities. I once heard an award-winning speech given by a boy about his sister and what a pain sisters can be, but this sort of topic needs a deft touch of sensitivity and humor to work. Avoid it at first and deal with it later if it comes up at an appropriate time.) When students have finished their list, instruct them to circle the worst three, then put a star beside the very worst one. They now have a list of possible topics, already prioritized. An extension of the I Hate list is a Pet Peeve list. To generate this list, ask students to write down what or who annoys them most in the world. Both the I Hate list and the Pet Peeve list tend to spark funny speeches.

However, identifying a topic that generates passion is only the beginning. The student must support the topic with research and information.

Selecting a Story

My favorite place to find a story to share is in the 398 section of a public or school library. On those shelves is an abundant supply of stories of various lengths, entertainment values, cultures, and ages. Introduce your students to the collections of the Brothers Grimm or Joseph Jacob and they will discover humor, pathos, horror, mystery, and whimsy. They will also find world creation myths; Greek and Roman myths; legends from all around the world; fantastic ghost, monster, and goblin stories; and so on. These stories have been passed on for hundreds, in some cases thousands, of years and were created to be spoken aloud. How can a student go wrong with a story that has been told, shaped, retold, and enjoyed for centuries? I also tell the students to look for collections that have no illustrations so they can create their own imaginative pictures.

Instruct your students to read five stories from a collection and then rate the stories out of 10 using the questions provided in "How to Select a Great Story to

"I want to scare them [the audience] out of their wits."

Henry, Grade 5

"I'm going to write about sisters, 'cause mine is a real pain and she does really stupid stuff. It would be funny!"

James, Grade 8

The Appendix, Stories for Students to Tell, features five stories I have used successfully with student tellers. Each story offers strengths in different areas of presenting.

I once worked with a student who insisted he wanted to perform his comic book. He didn't understand that "I'll get you!", "Wham!", and "Bang" simply had no narrative quality to hold an audience's interest. After I performed the comic book to him, he finally got it.

I realize there are always exceptions. If you have a student who really wants to write his own material and you feel he can, then by all means, let him. But warn him it will be twice as much work and be prepared to edit the piece for him which is more work for you.

"My faverite thing was piking a book."

Cody, Grade 4

Tell" on page 133. Once students have selected a story that really appeals to them, they must decide what audience their story is suited for. This is an issue of censorship and is discussed at length in "Knowing Your Audience" on page 135–36. For now, just get them interested in finding a story that really appeals to them personally.

It is crucial that students find a great story. A director can select the world's best stage performers for a new Broadway play, but if the lines are poorly constructed, the jokes flat, and the structure of the play slow and tedious, no amount of skilled acting will make up for it. The play will flop. Storytelling is no different. The material must be great. Many storytellers believe that liking the story or selecting a story that has a special meaning is enough. It isn't. That story might be an excellent choice for reading, but several elements are necessary to make a story a good piece to perform.

Instruct students to read "How to Select a Great Story to Tell," and use it to evaluate several stories.

In the 398 section of the library, the students will also find many illustrated versions of fairy tales, folk tales, myths, and legends. Advise students to carefully count the words in these stories because they can be much longer than the versions in anthologies and collections. If the word count is acceptable, such a retelling could be great to tell, as there is always more description and detail than in the anthology versions.

Selecting a picture book is a good alternative, especially if it's a story the student remembers and loves. Stories by Robert Munsch make great performance material because they were written to be said out loud. However, there is one major drawback to using a picture book as a source. Sometimes, the pictures in the book tell the story; if the pictures aren't there, the story doesn't make sense. Make sure students are aware of this before they begin to learn the materials. A few added words may cover the missing picture, but at other times, the student would have to rewrite the whole story.

Should students' perform their own stories?

I am very clear on this point and completely unmoving: *I do not recommend that students perform their own stories*. As a professional storyteller, guest speaker, and novelist, I know that performing one's own materials is the hardest thing to do, and creating a narrative that will hold an audience's attention is near impossible for the age levels we are working with. In every class I have ever worked, a student has been absolutely certain she could write a story better than all of the choices available on the library shelves. She couldn't.

For a few years I worked on an ongoing project with Grade 10 students. The teachers organized the term so that four weeks were spent researching and studying myth, then students had to create a myth and publish the story in a bound book with illustrations. The second month of the term was then devoted to learning how to take their original myth into performance. This was as close to success as I've ever witnessed, yet it had drawbacks. The students who could write well produced a "good" story and therefore had good material to work with. But the students who tried, yet didn't quite get the story where it needed to be for an audience were still doomed to learn it, share it, and get a poor mark.

For a student to be able to produce good material, he must be willing to research the structure of a story that performs well, write the story, have it edited, rewrite the story, have it edited again, and rewrite the story. The student would have to spend at least two weeks creating the story and going through the

How to Select a Great Story to Tell

Consider every one of the ten elements of a good story listed below. Ask yourself the question provided about that element and then check it off if it is a yes. Add up the check marks and rate your story out of 10. A story that rates a 7 out of 10 or higher is worth learning.

1.	Interesting Characters ☐ Do I really like or really hate one or more characters?
2.	Pace ☐ Do things happen often or is there too much description?
3.	Action ☐ Do the characters just sit around and talk or do they go places and make things happen?
4.	Surprise ☐ Are there any surprises in the story I didn't see coming?
5.	Dialogue ☐ Do the characters talk to each other or to themselves so I can make up voices for them?
6.	Conflict ☐ Is there a problem to solve or big decisions to be made by the characters?
7.	Description ☐ Can I picture the setting and/or any interesting details in the story easily?
8.	Emotion ☐ Does this story ignite feelings, like happiness, sadness, or fright, in me?
9.	Drive ☐ Am I compelled to finish the story to discover the conclusion?
10.	Meaning ☐ Is there a special meaning or significance to this story?

editing process. It is much easier and usually safer for a student to select an already published work that has stood the test of time.

Words to the Wise

Warn students to be aware of their pace during rehearsals. Adding an audience tends to make students rush which shortens the length of their presentations considerably.

Managing the Length of the Material

A student is responsible for figuring out how many words are in the presentation, how long it will take to express those words in an interesting fashion, and how to factor in any extras like participation and visuals. It is much easier for a student to know this *before* he writes his speech or selects his story. I have worked with many students who began working on the delivery of their material only to discover after several days or even weeks of learning the words, adding gestures, and developing the interpretation that the selection was far too long. They then had to begin the difficult process of editing. In the long run it was easier for them to start over with a new story, which cut into their rehearsal time and created much unnecessary homework.

Using a stop watch and several hundred stories, I discovered that in a performance people speak about 150 words a minute. This figure takes into account vocal expression, pause, and gesturing which all slow a presentation down. In public performance we do not and should not speak at the same rate we do for a normal conversation. Following this simplified rule, a five-minute performance should not exceed 750 words. This fact is a great shock to students (and teachers) because the average number of words on a page of printed text is about 300. (Of course, font size alters this number dramatically, but students learn to spot that too.) Therefore, a story that is only five pages long in a book may seem very short to a student when reading it silently, but take ten minutes to perform.

Students must decide how long they want to spend presenting. Every minute of performance takes that much more energy, memory, and control. Other factors that affect the length of a performance are the use of visual aids, props, or audience participation. If a student who is given a five-minute limit prepares a five-minute talk and then intends to show a diagram or a chart, he will go over the time limit.

When students are researching a story to tell, show them how many words fill up an average page in a book. I have demonstrated how to work out the average number of words on a page using multiplication: number of words in the top line times the number of lines down the page. Of course, the student could count every word on the page, but most don't want to.

Another method of developing awareness of presentation length and word count is to assign a timing partner. One student reads a story out loud with expression and the timing partner keeps track of the exact amount of time it took for the reading. Again, students are always surprised how long it takes when the material is read aloud. After much practising, the story should be timed again; as familiarity with the material increases, the presenter tends to speed up the pace.

Students writing a speech must also be made aware of how many written words usually take up a page. The average number of typed words on a page, double spaced, is 250. Little warning bells should go off if students find they are still writing their speech after page six. More often than not, though, they are loathe to fill up one page. However, if the topic is important to them and they are directed where and how to find supporting ideas and aids, they can easily get too much information. (See "How to Create a Speech," on pages 137–38.) Discovering that they have a lot to say is just part of the process of speech writing

"I hated counting the words."

Roshan, Grade 5

"I timed mine. It's O.K., not too long."

Samia, Grade 6

and students will figure this out; from the outset, make the students aware of how few words are really needed.

How to Write a Speech

Before students focus on delivering a speech, they have to write one. Keeping the process as simple as possible, a six-step outline to assist students in the creation of a speech appears on pages 137–38. This outline can be given out for reference.

How to Use Cue Cards

Many speech makers use cue cards. Unlike storytellers who can use props or a clothesline method of presentation as prompts, speech makers may rely on cue cards to serve as maps. A map cannot show the scenery, weather conditions, or any of the adventures along the way but, like cue cards, it will keep the driver going in the right direction.

Suggestions for using cue cards appear as a handout on page 139.

Developing a Relationship with the Material

The material — the words, ideas, and feelings that make up a good speech or story — is like a friend: it can't be known in a day. A student may memorize a speech or a story in a day, but can't *know* it. I tell students it takes a *minimum* of two weeks to get to know material, and getting to know it is not just remembering the words. It involves a deep understanding of the words, a feeling for the pace, the development of a sense of how the audience will react (which only comes from rehearsing with an audience), and finally, a knowledge of purpose — truly knowing why they chose this material over thousands of other choices and then getting that intent across through enthusiasm for the material.

Using the games and exercises provided in the focus area chapters with the students' speeches or stories will bring them closer to their material. The more they explore it, try the delivery a different way, adapt the ending or the beginning, and practise with a friendly audience, the more they will see in the material and be able to provide a stronger delivery.

When you are going over a student's selection prior to performance, ask what he discovered about his material after working with it: Was one part funnier or sadder than he first thought? Was the introduction too long? Was the ending a bigger surprise than he expected? Did one of the anecdotes in his speech turn out to be a real downer and need to be changed? As I've stated before, reflection is growth. Get the students to reflect on their insights so they can recognize how far their material developed and just how well they came to understand it.

Knowing Your Audience

Any presenter, young or old, must clearly know who their audience is and consider their tastes, interests, and attention span. Telling a story or giving a speech in a classroom stipulates certain rules about language, imagery, and content. Students know this, but inevitably one or two have to be reminded. What the students might not realize is that they are totally responsible for the effect they have on their audience. Public speakers are forever accountable for their

"I think I will always remember it. It's stuck in my head now."

Tavinder, Grade 5

"The most important thing I learned was that your speech should not be racist and your lines should not put people down."

Kim, Grade 6

opinions and messages. Politicians are always getting themselves in trouble for saying the wrong things or giving a wrong message. The classroom is no different. Presenting material without bias, prejudice, or offensive content is vital to the success of a presentation. If a student misuses the responsibility of speaking to a group and crosses the boundaries of appropriateness — or example, by making fun of another student — that student must be stopped in the act and forbidden to continue. Public address is not to be taken lightly, even in a smaller, rather secluded setting such as a classroom. Students are totally responsible for what they say, especially in front of a group.

Essentially, a performing student must act as a public censor. If a student intends to present a speech or story to a younger grade, perhaps the Grade 1 students, that student must seriously consider whether or not the material is *suitable* for that age level. I have often worked with intermediate students who wanted to present a really scary story. This question was always put to them: "Who is your intended audience?" In my experience, students have always accepted the responsibility of telling frightening stories only to children of Grade 4 or up and some students have felt very strongly their material was suitable only for their own grade level. I have always been impressed and touched by this kind of ownership of the material.

Matching Passion with Receptivity

For a keynote address, I have been known to don an eighteenth century bonnet, hooped skirt, and parasol and dance in as Mother Goose. It has always succeeded in drawing a laugh and getting the audience on my side. Well . . . almost always. I have met the occasional crowd that did not respond as I'd hoped they would. They were what I call a "reticent crowd." Unlike P. T. Barnum, who said "every crowd has a silver lining," I missed the mark in what made them shine. Perhaps I was too enthusiastic. The audience needed a more subdued form of coaxing and the style I chose did not suit their temperament.

As an adult, I am responsible for "reading" my audience and adjusting my presentation to suit them, but it is unreasonable to expect students to do this. It takes years of experience to be able to adjust to the feel of an audience. It is enough that your students consider the suitability of their material for the audience they face.

At this stage of development, the audience is responsible for receiving and encouraging the speaker in whatever style she chooses to present. A learning environment based on respect and acceptance makes the difference between students taking creative risks, presenting the same old thing, or not performing at all.

The more receptivity the students demonstrate as a respectful and appreciative audience, the more passion and freedom the speakers will be willing to express. Use the exercises featured in Chapter 2, Listening Actively, and Chapter 10, Critiquing, to develop this sense of encouragement. Doing so will pay off tenfold.

And if you're ever in the audience when I dance in as Mother Goose — laugh, please!

How to Create a Speech

STEP ONE: Select a topic.

- a. Consider topics that are important to you. For example: writing.
- b. Create a web diagram representing what you know about the topic and what you want to know about it.

STEP TWO: Locate and gather more information about your topic.

- a. Check all resources available to you: books at home, resources at the public and school libraries, the Internet. Can you interview anyone who has first-hand knowledge of your topic? Search for facts and figures, interesting information, anecdotes (little stories about the topic), and possible visual aids, such as diagrams, charts, photographs, samples, and drawings.
- b. Record information that interested or surprised you. Keep notes and lists. Jot down new words and their meanings and find someone who can pronounce them properly. Put everything together in a folder or notebook to keep track of it.
- c. Clip together any information or little humorous stories that you can use. Amusing your audience keeps their attention and makes the presentation more interesting. For example, if you were making a speech about writers, you might note: "Some writers are more superstitious than bingo players. One writer has to drink out of the same mug when she writes or no ideas come into her head." Interviewing someone who has knowledge about your topic can provide funny personal anecdotes. Simply ask the person you are interviewing to tell you a funny story or to describe an unusual experience.

STEP THREE: Be specific.

- a. Now you have to consider the information you already knew and the information you collected and make some decisions about what you should present. Are you overwhelmed? Is there just too much to know? Maybe your topic is too broad. Try to narrow it down. What do you *really* want to know and share about your topic? This step is the hardest.
- b. Decide the purpose of your presentation. Do you want to inform, motivate, inspire, or entertain? For example, you might decide that you want to inform the audience on how to get published.
- c. Once you have narrowed down your topic, look at the structure of the speech and how you can put your information together in a logical, informative, and entertaining way.

How to Create a Speech (Continued)

STEP FOUR: Understand the structure of a speech.

A speech follows a pattern so it is organized and easy to listen to. There are only three parts to a speech, but each part does different things.

The opening: Catch the audience's attention by beginning in an exciting way. Let the audience know what the speech is about. Give the audience some idea of what the speech will cover.

The body: Here you can present all of the interesting information. You should have a minimum of three main points and should support those main points with facts, anecdotes (true life stories), a demonstration, an example of something, and maybe visual aids.

The conclusion: Offer a brief summary (just a sentence or two) of the main points you spoke about and think of a fresh and interesting ending. Don't say "the end."

STEP FIVE: Organize your information into the structure of a speech.

Make a final selection of the information you want to share and organize the information to follow the pattern of a speech. See the outline below.

The opening

- 1. Find something they will want to listen to (I will have to think about this some more).
- 2. My topic: Writing and getting published
- 3. Main points: There are three ways to get your manuscript published.

The body

Main point #1: Some writers self-publish. Explain what is. Show an example of a self-published book. Explain what is good and bad about self-publishing.

Main point #2: Some writers contact a publisher on their own. Explain what happens to the manuscript when that happens. Show a calendar explaining how long it can take. Tell a funny anecdote about superstitious writers. Explain the good and the bad reasons for contacting a publisher on your own.

Main point #3: Some writers have agents. Explain what an agent does. Show a listing of agents from a book. Tell a funny story about writers from the agent I spoke to on the phone. Explain the good and bad reasons for having an agent.

The conclusion

- 1. Review the three ways to get published.
- 2. Tell them which way I am going to get published based on what I learned.
- 3. Show the audience my collection of lucky charms to help me become a published writer.

STEP SIX: Write your speech.

Write out your speech word for word on the computer or in long hand. It doesn't matter which. You need to know exactly what you want to say. You will not be memorizing your speech word for word, but you need a text to work from. When the speech is written, you are ready to work on delivery using the techniques and skills of great presenters.

How to Use Cue Cards

- Limit cards to five or less.
- Number them in the top right hand corner, so if you drop them, you can reorder them easily.
- *Do not* write out your speech on them. Reduce your speech to a twelve to twenty sentence outline, then reduce each sentence to a word or a phrase that will remind you of what that section is about.
- Print your words or phrases in point form on your cards, no more than five points on a card. (This way you can see the point you're looking for with a glance. If your points are in sentences or more than five appear on a page, you will have to read down the card to find your point; that will slow down your presentation and break the relationship you have established with your audience.)
- · Highlight really important points with a marker.
- When you are practising your speech and different focus areas, use the cue cards as though they are a prop, or they will deter your use of gestures and affect your stance.
- If you are featuring a direct quote, print it out word for word and put it on its own card.
- Design your own system of symbols to cue yourself for extra reminders.
 - For example: *
- ask the audience a question here
 - H give out the handout now
 - S tell small story or anecdote
 - V show visuals
- If you are using any visuals, know exactly where you are going to put the cue cards for that time period.

CHAPTER

An End . . . and a Beginning

I will always remember an incident with a Grade 6 student named Josh. He was a chubby, dark-haired boy who had been selected by his class to perform in the school storytelling festival and he had accepted the challenge. He turned out to be the first student to perform in the festival. His story was a Greek myth and the names were difficult to remember. He stumbled over a few, but he persisted. At one point during his performance he looked right at me. I smiled and nodded. He never stopped telling.

When the show was over and the tellers gathered around for comments, he sighed and rolled his eyes. "I wasn't great," he whispered.

I was thoughtful. No, he wasn't great. Some of the others were remarkably animated, enthusiastic, and entertaining.

I smiled at him. "But Josh," I said, "did you forget your story?" He shook his head no.

"Did you get embarrassed and run off stage?"

He shook his head again.

"You did well, and remember, you were the first. You had the hardest job because you had to warm up the audience."

He smiled faintly.

Other students moved in to ask me questions and Josh's moment was over, but his face still bothered me. In my heart I knew Josh felt he had failed somehow.

When the tellers were gathering up their things to leave the gym, I called Josh over to me. Some of the other tellers stopped to listen. I put my hands on his shoulders.

"Josh," I said, "did you know that there were three more Grade 8 girls scheduled to perform in our show today?"

He shook his head.

"They came to me yesterday and told me they had changed their minds. They didn't want to perform. They were too scared. So I took them out of the program."

Josh just stared at me.

"You're only in Grade 6, aren't you?"

"Yeah."

"Well, those girls are in Grade 8 and they couldn't do it. They represent the oldest kids in the school and they couldn't pull it off. Yet, here you are, only in Grade 6, getting up in front of one hundred people including teachers, the principal, and all the Grade 8s and you did it, didn't you?" His eyes brightened.

"Josh, you have courage. You are a risk taker. Can you imagine what you'll be like by the time you get to be in Grade 8? There's no stopping you now. This is just the beginning."

Josh beamed. He marched out of the gymnasium with his head up and his shoulders back, and I wept for joy. No, Josh's performance hadn't been great, but he was a success and finally, he knew it.

"Nothing succeeds like success."

Alexandre Dumas the Elder

Words to the Wise

Having said all that, I must emphasize that a student must want to perform publicly. Forcing a reluctant child is courting disaster. Running off a stage in embarrassment, wetting oneself in public, or throwing up are not situations would-be performers get over or forget. Such moments haunt us the rest of our lives. Be sensitive to your students' wishes and this kind of nightmare can be avoided. Should a student suddenly bow out of a scheduled performance, he might regret his decision later, but usually vows to do it next time.

Words to the Wise

If a student simply can't present to the full class, arrange for a reduced audience of perhaps 12 or 16 members. Find the student's comfort zone and encourage him. Do not allow the student to perform to a self-chosen audience of friends or members of the same sex. The student must take some risks to achieve an earned measure of success.

Raising the Stakes

According to Webster's dictionary, *presentation* means "to show" or "be in view of, as opposed to being absent." The definition of performance, on the other hand, is "to accomplish" and "give an exhibition of skill." The goal from the beginning was for students to perform in front of a large group, not just be there. The skills of performance they know. They have developed them through the focus areas. Now it is time to demonstrate those skills and prove their accomplishment.

Designating a presentation as a performance, even if it is only in front of their own class, earmarks the occasion as something out of the ordinary. Does this make students more nervous? Perhaps. But the more that is at stake, the more we care. So the question is, How much do you want your students to care? Will they feel they have really accomplished something if a special occasion is made of their appearance? Most definitely. The performance is not just for a mark or a chance to show off a new pair of Nikes, it is a celebration of all they have learned and achieved. A final performance is both the culmination of a series of smaller successes and the preparation to go on to something even bigger. An end and a beginning. A rite of passage. A turning point. Everyone has to get over hurdles.

The difference this time is that they're prepared. Yes, there will still be jitters, stomach aches, and hyperactivity, but if the students have worked through the focus areas, they have the techniques and the skills to overcome their fears and perform. The only way to prove it to themselves is to do it.

The guidelines below will help you to set minimum expectations for a performance.

- The student should be higher than the audience so all audience members can see him/her easily.
- The student should perform solo, demonstrating five skills/techniques of a good speaker.
- Material should be committed to memory no reading allowed.
- The student should present a minimum of one minute to the whole class.

Arranging for a Practice Audience

Allowing a student to perform her entire speech or story in front of a practice audience of eight members or more builds confidence and control. Prior to the final performance, the student can practise techniques such as the sweep, manage audience reactions such as laughter, and control major fidget fits that come

"The thing I liked best was practising the story with my partner and telling the story to the kindergartens."

Beatrice, Grade 4

"Can we watch more stories today?"

Brett, Grade 6

"When I performed, I learned that storytelling isn't a piece of cake."

Matthew, Grade 5

"My parents think that I relly did a good job and I think I did a good job too."

Kamaljit, Grade 4

from working in front of larger groups. A practice audience should be friendly and supportive.

Students often have enormous success performing for younger students. If this can be arranged, send out your performers in partners or trios, so there is a support group for the performer, to give feedback and even write an evaluation for the teacher. If all of the students are going to present to the younger class, never send out more than three performers at one time. The audience must be fresh and their attention span not taxed so that the last performer will have as interested an audience as the first performer had.

Choosing the Best Time for Performance

Arranging for performances to be held directly after a recess break or class change ensures that the audience is fresh and not restless. If students are particularly boisterous, take the class through a relaxation exercise just before the presentation begins. Doing this focuses the whole class, not just the performers. If possible, schedule a minimum number of performances a day. An announcement like "Settle down class, we have to get through *all* the presentations today" puts an enormous burden on the audience and drags down the performers. If you are tired of watching and listening, be assured the students are twice as tired. Scheduling no more than four speakers before a break is reasonable.

Making the Performance Something Special

Even if the performances take place only in the classroom, try to build an atmosphere of celebration and accomplishment. You can create a performance area that spotlights every speaker, for example, a large table set on its end or a divider from somewhere in the school draped with a black sheet as a backdrop. I have also lit a candle to signify the opening of the event. The effect has always been wonderful and the students have responded accordingly. It never seemed to matter that the ritual had to be repeated several times. The respect for the occasion was always apparent.

Rewarding students with a certificate of achievement at the close of each set adds further significance to the event. To some students the certificate isn't that important, but to others, it is the Olympics. Overcoming fear and achieving effective communication is a major breakthrough and they know it.

There's a television commercial I'm quite fond of. It doesn't make me hold my sides laughing or tell me how to save my life. It affirms my view on critiquing. The picture on the screen shows a woman working with a young soccer team and the voiceover states: "This year, let me be a coach and not a critic."

"You gave me more confidence to perform in a bigger audience."

Colleen, Grade 7

"What an enormous risk you took, getting the audience involved like that. You deserve another clap!"

Comment to Student

As far as "anything else needed" goes, I once had a child bring in her cat and we had to figure out who would hold it and where while she spoke.

"It looks pretty, like a wedding. I'm excited now."

Danielle, Grade 4

Coaching Performers

To coach effectively, you first need to know what specific skills are necessary to reach a standard of excellence. The summer I spent coaching a girls' baseball team I knew nothing of the skills of baseball. How to *properly* field a ball? Use glove techniques to catch a fly? Slide safely? I had my own children take me out regularly to teach me the fundamentals, so I could, in turn, coach the girls on my team. It was a crash course in baseball and I was unsure of myself 90 percent of the time. Not a good summer.

You, however, already have some experience relevant to coaching in oral communication. A coach must be able to transfer skills into step-by-step procedures to teach them to learners. As a trained teacher, you already know how to transfer new learnings into understandable language, how to assess student needs, and when to encourage students to take a risk at the next level. All the skills and techniques necessary for your students to reach a standard of excellence in public speaking have been provided for you in this book. You are ready.

Finally, as a coach, your role is to ensure ongoing development through continued suggestions of refinement and positive reinforcement. Simply observe each speaker carefully, make note of what is missing, point out *one thing* to work on, and praise what she can already do. The student will grow.

As coach, you are also your students' troubleshooter. If a few of your students will be performing outside the classroom, perhaps for a festival, arrange for those students to go into the venue beforehand to walk through their order of performance. Each student should also practise leaving their seat, going up to the front, and speaking the opening of their material. Doing that will allow them to adjust to volume and spatial changes. Insist that students preset any props, their chair if they intend to sit, or anything else needed during their presentation; they should know exactly where any item will be and how to handle it. Make note of any changes that need to be made before performance and speak to the emcee to be sure your students will be well taken care of.

Performing Outside the Classroom

A public performance is a treat, something out of the ordinary that instills confidence in the performer and respect and role modelling for the listener. Perhaps your division is planning a storytelling festival or your board would like to host a public speaking contest. Every step outside of the classroom setting requires that much more work in organization and timing.

A divisional or school-wide program needs to be planned at least one term in advance. The gym, library, or music room can be used as the venue. If the audience is kept on the floor, no chairs need to be set up and therefore no risers are needed for the performers. Decorating the classroom for presentation might be an extravagance, but in a gym, library, or music room, it is a necessity. Once again, the table on the side or a divider can be used for a backdrop and covered with a sheet. A rope of ivy or netting looped from corner to corner adds a splash of color. No charts, lists of names, or posters should decorate the backdrop. The speaker must be the focus. If fake plants sit in the school foyer, borrow them for the day and place them on either side of the backdrop or use small draped tables. Doing this frames the performer's area.

The event needs a host. I recommend a teacher, not a student. Students are the performers, so let an adult handle crowd control, troubleshoot, and reassure the performers. They will need it. If you think students get nervous in front of their own class, wait till you see them in front of three or four classes or an auditorium of hundreds.

The hardest part in setting up a divisional performance is turning down the students who really wanted to be in the show and couldn't be. You must keep a strict limit on the number of performers. I recommend no more than eight performers, which works out to about a 50- to 60-minute show if the selections run approximately five minutes apiece. That's enough. If you absolutely must have more performers, have two or more shows.

The audience should also be kept to a maximum of about 100. This way the performers can be heard easily without a microphone and the audience does not overwhelm the performers. I worked in a school in Burlington that had every class in the school involved in storytelling and wanted every class to participate in a festival, even if it was as a listener. We had *seven* shows that day! It turned out to be a fabulous experience for all and even parents showed up. The camcorder recorded every show so the students could watch themselves and classes could use the tapes as reference for future projects.

A regional program needs at least one year to organize, the most important planning detail being the booking of the hall, gym, or stage where you would like the program to take place. You will need a committee to take care of the organization. Consider the following headings as a guideline:

Timeline organization

Criteria for presentations/Criteria for judging (if it's a contest)

Venue set-up: staging, chairs, placement of performers, order of performers Emcee

Length and content of the program (including number of participants) Invitations for participants/Invitations for the public

Selecting and inviting judges and/or special guests

Awards/Press coverage/Sponsors

Cleanup and thank you

Public Speaking for Life

The man I was talking to had to have been in his fifties.

"Why," I asked him, "would you take a leadership course now?" I wanted to say "at your age," but I remembered my tact.

"I've never been comfortable in front of people," he answered thoughtfully. "It's something I'd like to get over."

"Thank-you. I really enjoyed this experience. It raised my confidence level and improved my public speaking jitters."

Words to the Wise

A student should never be forced

to perform in a public venue. The

class might want, or even vote, a certain student to perform a

to, the issue is closed. We each

As the teacher, you can

encourage the student to sleep on

the decision, promise to help him prepare for the event, even

discuss the possibility with the

student's parent, but in the end,

speech or story to a bigger audience, but if she does not wish

know our limits.

the decision is his.

Stephanie, Grade 6

Maybe that's when I decided to write this book.

Students shouldn't have to wait till their fifties to "get over" their fear of performing in front of people. The students I've worked with keep saying the same things over and over again: "I feel better about myself," "I'm less nervous," and, my favorite, "I have confidence now."

I can think of no other gift I would rather give a student than confidence.

Appendix: Stories for Students to Tell

The Contest Between the Wind and the Sun is a good example of a fable. Fables are short, easy to remember, poignant, easy to understand, and entertaining. I wrote this version of the Aesop fable in first person. Students enjoy its "tall tale" feel and often tell it wearing a jacket for effect. Challenge your students to rewrite fables for themselves.

About 2 minutes to tell (346 words)

The Contest Between the Wind and the Sun

One day, I was walking along the road, minding my own business, when I heard the strangest thing. At first, I couldn't believe I was really hearing it. The sun and the wind were having a disagreement. Really.

The sun said, "I am too!"

The wind argued back, "Most definitely you're not. I am."

I wondered what they could possibly be arguing about so I stopped to listen.

"I can toss great ships at sea!" boasted the wind.

"Humph," snorted the sun, "my rays are so powerful they can reach the tiny seed deep under the ground and cause it to grow into a gigantic tree!"

"Oh," I said to myself and started walking again. "They are arguing about who is stronger. How silly."

Then, the wind gazed down at me and announced, "We will settle this once and for all. See that traveller down there on the roadway?" he asked the sun.

"Yes."

"Well, we will have a contest. Whoever can make that traveller take off her jacket is the stronger."

"Jacket?" I asked myself. "My jacket? But this is my favorite jacket. No one is making me lose my favorite jacket." And I closed it up tight.

"Me first!" exclaimed the wind and he began to blow. The wind got stronger and stronger. I thought he was going to blow my hair right off my head! But I held onto my jacket. It didn't come off.

"Uh, hum," interrupted the sun, "it's my turn."

The wind stopped blowing and the sun began to shine. She beamed and shone and brightened the day so much that it got blazingly hot!

"Whew," I said, "it sure is a scorcher." I slipped off my jacket and laid it over my arm.

"There!" huffed the sun. "You see? I am the stronger."

The wind had to agree.

"Well, I'm sure glad that's over." I sighed and went on down the road.

Might is not always the stronger.

The Big Turnip is a good example of a pattern story. It also lends itself well to audience participation, where the audience echoes or joins in on the repeated lines. I have seen student tellers bring up members of the audience to form the line of characters trying to pull out the turnip. Be warned though . . . in one festival, the participants pulled so hard that they fell down and knocked over our display table.

About 4 minutes to tell (558 words)

The Big Turnip

One fine fall day, while Grampa was digging up the garden, he spotted the top of a turnip that hadn't been pulled.

"Mmmmmm," Grampa said, "turnip stew!" He grabbed the top of the turnip and he pulled. Nothing happened. He placed his feet on either side of the turnip, grabbed the leaves, and pulled and pulled. The turnip wouldn't budge.

"This must be a mighty big turnip," said Grampa, as he scratched his head. "Gramma! Gramma!" he called. "Come help me pull up this turnip!"

So Gramma set down the pile of wood she was carrying and ran across the garden to help. Gramma took hold of Grampa and Grampa took hold of the turnip. Together they pulled and pulled. The turnip wouldn't budge.

"This must be a mighty big turnip," said Gramma. "Little Granddaughter! Little Granddaughter!" called Gramma. "Come help us pull up this turnip!"

So, Little Granddaughter dropped the apples she was picking and ran across the garden to help. Little Granddaughter took hold of Gramma and Gramma took hold of Grampa. Grampa took hold of the turnip and they pulled and pulled.

The turnip wouldn't budge.

"This must be a mighty big turnip," said Little Granddaughter. "Puppy! Puppy!" called Little Granddaughter. "Come help us pull up this turnip!"

Puppy tossed the bone he was chewing and raced across the garden to help. Puppy took hold of Little Granddaughter, Little Granddaughter took hold of Gramma, Gramma took hold of Grampa, and Grampa took hold of the turnip. They pulled and pulled. The turnip wouldn't budge.

"This must be a mighty big turnip," yelped Puppy. "Kitty!" barked Puppy. "Come help us pull up this turnip." Kitty stopped chasing the butterfly she was after and scampered across the garden to help.

Little Kitty took hold of Puppy, Puppy took hold of Little Granddaughter, Little Granddaughter took hold of Gramma, Gramma took hold of Grampa, and Grampa took hold of the turnip. They pulled and pulled.

The turnip wouldn't budge.

"This must be a mighty big turnip," meowed Kitty. "Grey Mouse! Grey Mouse!" purred Kitty. "Come help us pull up this turnip."

Grey Mouse stopped curling her whiskers and skittered across the garden to help. Grey Mouse took hold of Kitty, Kitty took hold of Puppy, Puppy took hold of Little Granddaughter, Little Granddaughter took hold of Gramma, Gramma took hold of Grampa, and Grampa took hold of the turnip. They pulled and pulled. The turnip wouldn't budge.

"This must be a mighty big turnip," squeaked Grey Mouse. "Black Beetle! Black Beetle!" called Grey Mouse. "Help us pull up this turnip!"

Black Beetle gulped down the crumb he was lugging and scurried across the garden to help. Black Beetle took hold of Grey Mouse, Grey Mouse took hold of Kitty, Kitty took hold of Puppy, Puppy took hold of Little Granddaughter, Little Granddaughter took hold of Gramma, Gramma took hold of Grampa, and Grampa took hold of the turnip. They pulled and pulled and . . . POP!

The turnip burst out of the ground. Grampa fell on Gramma, Gramma fell on Little Granddaughter, Little Granddaughter fell on Kitty, Kitty fell on Grey Mouse, and Grey Mouse fell SMACK! on the ground because Black Beetle jumped out of the way so he wouldn't get squashed.

Can you guess what they had for dinner that night?

Here is a traditional "jump story." In such a story, the teller gets quieter and slower during the telling and then, on the very last line, jumps towards the audience and shouts the last three words. The audience jumps up out of their chairs.

This type of story is a great alternative to stories with a lot of gore which students often think is necessary to make a story scary. The Golden Arm is a sure-fire success, with listeners always intrigued by the central image.

About 4 minutes to tell (536 words)

The Golden Arm

There once was a man who travelled the land in search of the perfect wife. He met young and old, rich and poor, pretty and plain, but none were to his liking. Then one day he met a woman that caught his fancy. She was young, as fresh as wild flowers, but her youth did not interest him. She was fair, her hair as light and soft as spun silk, but her fairness did not interest him. She was bright, well educated, and even rich, but none of those things delighted him in any way. No, what he loved about her, above all her wonderful traits, was that her right arm was made of solid gold.

He married her at once and brought her to his home. She was caring, gentle, and sweet. She loved him to be sure, but the man, although he appeared loving and acted as a good husband, did not really love her at all. What he loved was her golden arm.

He loved the way it shone in the sun. When they walked together, he would always take her by the arm and hold her close, not to be affectionate, no, but because he loved the feel of the arm against his skin.

Alas, for all of the wife's beauty and good graces, she was a frail thing and soon after they married, she took ill. Within the year, she died.

The husband put on the blackest of black clothes. He pulled the longest, most sorrowful of faces and he thanked all those who came to her burial with great ceremony. But after the burial, when all was quiet and night had set in dark and cold, he crept back to the graveyard carrying a spade and a velvet bag. He dug up his sweet wife's coffin and pried open the lid with the sharp edge of his digger. Out of the velvet bag he pulled a long silver knife, and with it, he hacked off his wife's beautiful golden arm. He stuffed it into the velvet sack and carefully reburied the coffin.

Once again at home, he hid the sack and he waited. One day, two days, he waited and on the third day he could stand it no longer. He brought out the sack and took out the magnificent golden arm. He loved the feel of it, the weight of it, the coldness of it. It was his treasure. He couldn't leave it alone. That night he slipped the golden arm under his pillow and laid down to go to sleep. He had just drifted off when the creaking of his bedroom door woke him up. He sat up. At first he saw nothing but a cloud of mist. Then a shape began to appear and there before him stood his dead wife, all tattered and torn and decayed.

He hid his fear and began to speak, "My dear wife, what has happened to your lovely silken hair?"

- "All withered and wasted away," she said.
- "And your beautiful face, what has happened to that?"
- "All withered and wasted away," she said.
- "And your lovely golden arm? What has happened to it?" he dared to ask.
- "YOU'VE GOT IT!"

This Ukrainian pattern story, taught me by a Grade 5 immigrant child, works especially well as a clothesline story. Animal characters can be easily drawn and cut out for use as clothesline props, and animal noises provide a simple way to involve the audience. I recommend this story for Special Education tellers looking for a structured story with props.

About 3 minutes to tell (401 words)

The Picky Little Mouse

One bright, sunny morning little Meeshetsa Mouse was busy sweeping the steps of her doorway. Swish, swish, swish.

"What's this?" she gasped, for there on the step was a lovely golden pebble.

"Oh, how wonderful!" exclaimed Meeshetsa. "I will take this bright pebble to the shop and trade it for the loveliest of red bows. Won't I look grand?" Off she scurried.

The very next morning Meeshetsa sat proudly on her doorstep wearing her lovely bow about her neck.

Just then a donkey came kicking by. Seeing how beautiful she looked, he asked in his braying donkey voice, "Hee haw, hee haw. Will you marry me?"

And Meeshetsa answered him, "Marry you? You are too smelly."

The donkey went away with tears in his eyes.

The next morning Meeshetsa was outside watering the flowers, proudly wearing her bright new bow.

Just then a bear came lumbering by. Seeing how beautiful she looked, he asked in his booming bear voice, "Grrr, grrr. Will you marry me?"

And Meeshetsa answered him, "Marry you? You are too fat."

The bear went away sniffling.

The next morning Meeshetsa was outside hanging up her laundry to dry, proudly wearing her pretty bow for all to see.

Just then a frog came hopping by. Seeing how beautiful she looked, he asked her in his grumbling frog voice, "Crrrroak, crrrroak. Will you marry me?"

And Meeshetsa answered him, "Marry you? You are too ugly."

The frog jumped away weeping.

Watching from a rooftop next door was a sleek grey cat. "Now it's my turrrrn," purred the cat. Early the next morning he took a hot bath, curled his whiskers, and put on his finest wedding suit. When Meeshetsa stepped out onto her porch wearing her lovely bow, the handsome grey cat was sitting there waiting.

He bowed to her, smiled, and asked, "Will you marrrrry me?"

"Oh, yes," exclaimed Meeshetsa. "You are perfect." They were married that morning.

In the evening, the cat asked Meeshetsa if she would make him some dinner.

"But of course!" she squeaked, "I am a marvelous cook." She quickly stirred up a pot of vegetable porridge and held it in front of the cat.

"I don't want that," snapped the cat.

"Why ever not?" demanded Meeshetsa.

"Becausssse," hissed the cat, as he leaned closer to her and licked his lips. "I'd rather have YOU!" And he gobbled her up bow and all.

This Native tale has an eeriness that children find fascinating. The strong imagery helps both teller and listener, and the audience reacts with a distinct "Oh, that's who they are!" at the end of the story, leading to wonderful discussions if the teller asks if the story is true. The dialogue between the two characters offers exciting opportunities for vocal characterization.

Young Man and Old Man

Long, long ago an old man wandered across the earth. His hair was white and long and flowed behind him like a river. Everywhere the old man stepped, the ground grew hard as stone. His breath was cold and he loved to blow on the trees, then watch the leaves shrivel and fall. The plants and flowers withered and died when he came near. The animals hid away from him, and the birds flew far, far away.

Old Man built himself a lodge of ice and snow. Inside the lodge he built a strange white fire that gave no heat. One afternoon, as Old Man dozed by his fire, the air became thin and light. It was difficult for him to breathe. Old Man looked outside and saw that the snowdrifts were melting and the ice on the river was splitting apart.

"What is happening?" wondered Old Man. But he did not leave. He knew his magic was strong. He sat beside his fire and waited.

Suddenly, there was a knocking on the entrance to his lodge. "Go away!" shouted Old Man.

The knocking came again, only louder and harder. The ice on the walls of his lodged cracked. Some smashed to the floor and splintered like glass. Suddenly, a young man stepped through the door of the lodge. He had long, thick, black hair and he carried a green stick. He sat down beside the strange white fire and smiled at the old man.

"Leave here," demanded Old Man, "or I will freeze you with my breath."

Young Man did not answer. Instead, he thrust his green stick into the fire and stirred the flames. The fire glowed white, then turned bright red. It gave off heat. Tiny beads of sweat formed on Old Man's forehead and dripped down his face.

Old Man's eyes flashed with anger. "Do not touch my fire!" he shouted. "I will show you," and he drew in a great breath. He blew at Young Man, but all that came out was a thin white mist.

Young Man laughed. "Do you not know who I am, Old Man? Wherever I walk the snows melt, the ground becomes soft and moist, and the grasses grow. Green leaves bud for me and flowers bloom."

The sweat poured down Old Man in streams and his body began to shrink. He opened his mouth, but no words came forth. His sweat poured down as he grew smaller and smaller, until he melted into a puddle on the floor. The walls of the lodge also melted and washed away the fire. The sun shone bright. The birds sang and the animals rejoiced, for Young Man Spring had defeated Old Man Winter once again.

Professional Resources

Drama Resources

Barton, Bob. 2000. *Telling Stories Your Way: Storytelling and Reading Aloud in the Classroom*. Markham, ON: Pembroke.

Boal, Augusto. 1985. *Theatre of the Oppressed*. Lexington, NY: Theater Communications Group.

O'Neill, Cecily, and Alan Lambert. 1990. *Drama Structures: A Practical Hand-book for Teachers*. Cheltenham, GL: Stanley Thornes.

Spolin, Viola. 1999. *Improvisation for the Theater: A Handbook of Teaching and Directing Techniques*. 3rd ed. Evanston, IL: Northwestern University Press.

Swartz, Larry. 1995. *Dramathemes*. Markham, ON: Pembroke. Watts, Irene N. 1992. *Making Stories*. Markham, ON: Pembroke.

Public Speaking Resources

Alder, Mortimer J. 1997. *How to Speak, How to Listen*. New York: Simon & Schuster Trade.

Applewhite, Ashton, William R. Evans, III, and Andrew Frothingham. 1992. And I Quote: The Definitive Collection of Quotes, Sayings & Jokes for the Contemporary Speechmaker. New York: St. Martin's Press.

Carnegie, Dale. 1990. *The Quick and Easy Way to Effective Speaking*. Garden City, NY: Dale Carnegie and Associates.

Greenwood, E. F., and Alberta Peck. 1974. *The Art of Speaking*. Lexington, MA: Ginn.

Hamilton, Elaine, and Lyndall Hill. 1986. *Speak for Yourself*. Melbourne, Australia: Oxford University Press.

Miyata, Cathy. 1995. *Journey into Storytelling*. Hamilton, ON: Tree House Press.

Walters, Dottie, and Lily Walters. 1997. *Speak and Grow Rich*. 2nd ed. Englewood Cliffs, NJ: Prentice Hall.

Index

as safety net, 94-95

```
interpreting, 105–11
active listening. See listening actively.
activities. See exercises.
                                                            Kamishibai, 48
adrenaline, 83-84
audience, 8, 10, 52, 75, 87, 95, 119, 130, 135-36,
  141–42. See also performance; rapport, developing
                                                            life skills, 8, 144
                                                            listener, responsibilities of, 33–34, 35
  with audience.
                                                            listening actively, 33–40
body language, 14, 33, 34–35, 62–70, 84, 88
                                                            microphone, 73
                                                            mood, 105, 108
Carnegie, Dale, 41
coaching performers, 143
                                                            multiple intelligences, 44
                                                            Munsch, Robert, 132
communication. See oral communication.
composure, 83–93
                                                            oral communication, 9, 10, 12, 13, 33, 120
  managing nervous energy, 83–84
confidence, 12, 15, 144
                                                            passion, 130-31, 136
creativity, 14–15
                                                            peer evaluation, 121, 126
critiquing, 112–17
                                                            performance, 13, 119, 140-44
  v. criticizing, 112
                                                            performance material
cue cards, 139
curriculum extensions, 31, 38–39, 49, 59–60, 69, 79,
                                                              developing relationship with, 135
                                                              re: audience, 135-36
  81, 90-91, 102-3, 108-9, 115-16
                                                              managing length, 134–35
                                                              student-written, 132-33
evaluating oral language performance, 120–29
exercises, 19–26, 34–35, 36, 45, 63–64, 73–74, 75, 77,
                                                              See also speech; story.
                                                            presentation, purposes of, 130-31
  84, 86, 89–90, 97, 100–102, 106, 108, 114
                                                            pre-tests, focus areas, 17, 34, 43–44, 53, 63, 72, 84, 95,
  preliminary, 17–18, 113
                                                              105, 113
expressive language, 13, 119
                                                            public speaking
                                                              fears of, 7-8, 47, 142, 144
games, 35, 36, 37–38, 53–56, 57, 58–59, 65, 66, 67–68,
                                                              model for, 13, 119
  74, 75–77, 79, 86, 87, 88, 89, 96–97, 99–100,
  114-15
                                                            rapport, developing with an audience, 42, 52-61
  related benefits, 11-12
                                                            recitation, 48-49
Gardner, Howard, 44
                                                            reflections, student, 11, 31, 39, 50, 60, 69, 81, 92, 103,
                                                               110, 116, 126, 129
imagination, 14–15, 26, 35, 44
                                                            remembering, 41–51
  in touch with, 16–17
                                                              forgetting, 45, 47, 48
  understanding, 15–16
                                                              7 strategies, 45–46
imagining
                                                              v. reciting, 41-42
  color, 19-20
                                                            risk taking, 8, 112, 140-41
  inspiration, 24–26
  problem-solving, 22-24
                                                            rubric, 120-21
                                                              public speaker, 124-25
  sensory, 20-22
                                                              storyteller, 122-23
  using a story, 26–30
improvising, 94–104
```

self-evaluation, 126-28

skill. *See* technique.
speech
how to create, 42, 135, 137–38
how to select topic, 130, 131
Spolin, Viola, 95
stage fright, 9, 84
story
for telling, 26–30, 43, 101–2
how to select, 130, 131–32, 133
storytelling, 26, 142

teacher assessment checklists, 32, 40, 51, 61, 70, 82, 93, 104, 111, 117
techniques, 11, 12, 13, 62, 71, 95
attitude, 108
audience participation, 57–59
controlling fidgets & fright, 84, 86
decision making, 100–102
effective openings, 87–88
eye contact, 53–54, 56–57

facial expression, 66 focus, 97-100 gesturing, 67–68 giving and receiving image, 35–37 nonjudgmental critiquing, 114-15 pace, 75, 77 pitch, 75, 76 polished endings, 88-89 positive body listening, 34–35 questioning, 37 relaxation, 89-90 spontaneity, 96–97 stance, 63-65 tone, 106-7 use of silence, 77-79 volume, 73-74

visual prompts, 47 vocal warm-ups, 72–73 voice, using, 71–82